WITHDRAWN

I'LL BE HOME FOR CHRISTMAS MOVIES

THE DECK THE HALLMARK PODCAST'S GUIDE TO YOUR HOLIDAY TV OBSESSION

BRANDON GRAY, DANIEL PANDOLPH & DANIEL THOMPSON
WITH **ALONSO DURALDE** FOREWORD BY **KRISTOFFER POLAHA**

RUNNING PRESS
PHILADELPHIA

Running Press
Hachette Book Group
1290 Avenue of the Americas, New York, NY 10104
www.runningpress.com
@Running_Press

Printed in China

First Edition: September 2021

Published by Running Press, an imprint of Perseus Books, LLC, a subsidiary of Hachette Book Group, Inc. The Running Press name and logo is a trademark of the Hachette Book Group.

The Hachette Speakers Bureau provides a wide range of authors for speaking events. To find out more, go to www.hachettespeakersbureau.com or call (866) 376-6591.

The publisher is not responsible for websites (or their content) that are not owned by the publisher. Unless otherwise noted, all movie still images have been provided by Photofest, and all food and author images are courtesy of Eli Warren (eliwarren.com).

Print book cover and interior design by Alex Camlin.

Library of Congress Cataloging-in-Publication Data
Names: Gray, Brandon, author. | Thompson, Daniel (Podcaster), author. | Pandolph, Daniel, author. | Duralde, Alonso, author. | Polaha, Kristoffer, 1977–writer of foreword.
Title: I'll be home for Christmas movies: the Deck the Hallmark podcast's guide to your holiday TV obsession / Brandon Gray, Daniel Pandolph, & Daniel Thompson with Alonso Duralde; foreword by Kristoffer Polaha.
Description: First edition. | Philadelphia: Running Press, 2021. | Includes index.
Identifiers: LCCN 2020053423 | ISBN 9780762499359 (paperback) | ISBN 9780762499335 (ebook)
Subjects: LCSH: Christmas television programs—United States—History and criticism. |
Made-for-TV movies—United States—History and criticism. |
Hallmark Channel (Television network) | Deck the Hallmark (Podcast)
Classification: LCC PN1992.8.C5 G73 2021 | DDC 791.45/634—dc23
LC record available at https://lccn.loc.gov/2020053423

ISBNs: 978-0-7624-9935-9 (paperback), 978-0-7624-9933-5 (ebook)

RRD-S

10 9 8 7 6 5 4 3 2 1

Bran: To my wife, for being the Wagner to my Polaha.

Panda: To Hayley and Lily, the best things to ever happen to me.

Dan: To Sarah, the love of my past, present, future, and forever, and to my two kings, Ray and Jay. Yes, I love you; yes, I'm Decking the Hallmark; and yes, I'll be home before bedtime.

Alonso: For Bibbs, who opened my eyes, and Dave, who rolled his.

CONTENTS

THE *DECK THE HALLMARK* GUIDE TO 116 HALLMARK CHANNEL CHRISTMAS MOVIES THAT WE LOVE, LIKE, AND DESPISE

'TIS THE SEASON TO BE JOLLY: THROWING YOUR OWN HALLMARK CHRISTMAS PARTY

Foreword

It was a balmy and muggy Saturday—July 7, 2018. I was in Florida with my family for the summer and, well, I think it's only fair to start this foreword by giving you all the facts.

My father-in-law, Max, had just passed away that April, and it was the first death in the family that my three boys and my wife had lived through. We were grieving. Hard.

It was also the summer my mother-in-law thought that she had lost her wedding ring down the toilet. I made sure the ring wasn't stuck in the porcelain bowl, and I hired a man with a camera to follow the pipes all the way to the septic tank. Then I hired another man to drain the tank, only to find out that he couldn't accomplish the task because dirt had found its way into the mess through a hole a tree root had made in the lid. All that to say, I volunteered to search for her ring by emptying out the septic tank, with a shovel, by hand. A pretty bleak summer indeed.

Until that hot July night, when I opened up my DMs on Instagram and found a message from a perfect stranger, a guy named Brandon Gray.

Brandon and his two friends Dan and "Panda" were starting a new podcast, and the very first movie they reviewed was *Rocky Mountain Christmas*. RMC was my second Hallmark holiday movie, and it happened to do very well with the viewing audience, so I was curious what comments these guys would make about this little gem. More like dubious.

Three guys reviewing Hallmark Christmas movies? What. The. Heck. And the name, *Deck the Hallmark*? What was that supposed to mean? Like, punch Hallmark in the face? What was this podcast going to be?

Brandon asked me, over DM, if I'd listen to their pilot episode, and if I liked it, would I be their first-ever guest on the show? Well, amid suffocating grief, overwhelming heat, and the back-breaking work of shoveling out human waste by hand in a hazmat suit, I listened to their pilot episode late that night while I lay in bed, expecting to be mocked for trying to make a living as an actor.

Instead, I was brought to tears. Tears of laughter flooded my face, and the joy and revelry these three men expressed while talking about the TV movie I'd made lifted my spirits in a way I'd never expected. They had done it. They had brought a male perspective to the female-driven Hallmark

movie cultural juggernaut, and it was brilliant. Brandon loves the movies. Panda likes them. Dan despises them. Their podcast is biting, irreverent, hilarious, full of heart, and poignant. Literally, all the things you'd want when listening to a podcast about a Christmas movie.

I've said it before: every generation has a voice. If Christmas movies are the artistic expression of our generation—which one could argue that they've become—Brandon, Dan, and Panda are the voices of that generation. Uniting us by balancing out the "feels" with humor and levity, they allow us to float into the Hallmark bubble while providing an anchor to reality. At the same time, they offer an entirely different way to escape the sadness and heat and drudgery of our day-to-day lives, by living the example of true friendship and teaching us how to laugh at all the things life has to offer—even the unthinkable work of shoveling out a septic tank—with levity and heart.

I, for one, am a fan. I am also, now, a friend. I hope you enjoy the book you are about to read. I promise it will lift your spirits and make you laugh. And friends, I think we can all use a good laugh.

—**Kristoffer Polaha**
August 18, 2020, London, UK

Kristoffer Polaha in Rocky Mountain Christmas

Kristoffer Polaha is an actor whose credits include *Jurassic World 3* and *Wonder Woman 1984*. More relevant to our purposes here, he is a leading Hallmark hunk, whose many films for the network include *Double Holiday, Hearts of Christmas, Rocky Mountain Christmas,* and *Small Town Christmas,* all of which are reviewed in this book. Speaking of books, he is the coauthor (with Anna Gomez) of *Moments Like This.* Let the record show that Mr. Polaha is such a stand-up guy that he is still speaking to all of us. Even Dan.

Growing up, I would circle September 16 on my calendar. Why? Because I could officially dust off the 100 Days Until Christmas countdown board that I had made for myself.

It wasn't fancy—literally just a white board with numbers on it and horrible drawings of Christmas trees and reindeer. I would pull out the cassette tapes that I used to record the radio station that played nothing but Christmas music. Every year, I called the radio station on a daily basis, trying to find out when they planned to make the switch. When I finally got a day and a time, I recorded the transition on a cassette tape so I could listen to it throughout the year. It was magical.

September 16 is also the day I would blow the dust off the flimsy, three-foot Christmas tree that I had bought with money I'd saved from mowing lawns.

You would think I would grow out of these habits, but I didn't. When I was in high school, I got together with a friend of mine to record my own Christmas album. It was awful, but I loved it. The next year, we did it again. And again the year after that. We still do it to this day. I love Christmas.

I shouldn't love Christmas as much as I do. I'm an adult who grew up in Florida, dreaming of a Christmas below eighty degrees, much less a white Christmas. Nevertheless, I can't help myself. The closer the calendar gets to September 16, the more excited I become. It's been this way for as long as I can remember.

When I discovered Hallmark Christmas movies, it wasn't a huge surprise that I became obsessed. I had them playing all holiday season long. It was a dream come true—instead of having to wait for a Christmas movie to come on network TV, I could just flip on the Hallmark Channel at nine a.m. and keep it going all day. This was quite a few years ago, before Hallmark Christmas movies really became a "thing." I began to think of Hallmark Christmas movies as something I could look forward to, starting on September 16.

Eventually, Hallmark Christmas movies became the thing I looked forward to the most. They include everything I love about the holiday season—the traditions, the snow, the decorations. I didn't always associate troops coming home with Christmas, but I do now. *And I love it!* So much so that when Hallmark started playing Christmas movies in July, I didn't think twice about making some hot

chocolate and diving into *The Mistletoe Secret* for the hundredth time.

People ask me all the time how the podcast *Deck the Hallmark* started. I typically hate it when people say "people ask me all the time," because we all know that isn't true. In this case, it is. I've been asked that question hundreds of times, and I always start by saying, "It was March, and I was bummed that Hallmark Christmas movies weren't on." People laugh because they assume I'm joking. I'm not.

For me, the first few months of the year are the worst…and my birthday is in January. I get really sad when Christmas is over. *Deck the Hallmark* was birthed out of my desire to watch Hallmark Christmas movies all year long. But just like Christmas, I knew that it would be better with friends. Little did I know that other people wanted to watch these movies all year too.

I joined my first Hallmark Christmas movie Facebook group in March of 2017. An entire community of people who loved these movies as much as I did! Could there really be this many people who wanted to talk about them? Who were content watching the exact same plot unfold the exact same way by the exact same actors, over and over again? It was then that the idea hit me: I should start a podcast.

There's something you should know about me—I've said the phrase "I should start a podcast" a couple dozen times. And I have. I started a podcast about aliens. I started a podcast where I could interview my favorite bands. I started a podcast where I could talk about my love for the Orlando Magic. But a podcast about Hallmark Christmas movies? This one felt special.

I did a quick search for podcasts about Hallmark movies. There were a few, some of them really great. *Bubbly Sesh. Hallmarkies Podcast.* Did the world really need another Hallmark movie podcast? Well, no. But I decided to call my friends and do it anyway.

We have had the opportunity to do so many amazing things thanks to *Deck the Hallmark.* We've been on *Good Morning America* multiple times, recorded live shows in some incredible cities that I had never been to, and gotten some absolutely remarkable emails from listeners about how the podcast has helped them get through the holiday season. But my favorite part is still watching the movies with my friends.

The feeling I get when watching a Hallmark Christmas movie is the same feeling I got listening to the radio station transition to Christmas music. It's the same feeling I got putting up my own little tree. It's the same feeling I get from creating my own Christmas music. These movies feel like Christmas.

September 16 is still a day I look forward to every year. I still count down to Christmas. But I also start a different countdown—the start of Hallmark Christmas movie season. I'm not sure which one I get more excited about, but there's one thing I know for sure: these movies will be here long after we stop recording this podcast, and I'll still be there watching with my hot chocolate. I can't wait to watch *The Mistletoe Secret* another hundred times.

Why? Because I *love* Hallmark Christmas movies!

—**Bran**

"HEY, I'M PANDA.
And I Like Hallmark Christmas Movies."

I gave up my job as chief engineer when I was a senior in high school, at the age of seventeen. I gave up the job I had held for as long as I could remember, so I could hang out with a few friends. Or was it to watch a movie? Or to eat lunch with a couple of buddies?

Whatever it was, it wasn't worth it. Because as soon as I had given up the job, I missed it.

Christmas has always been incredibly magical for me. My mom and dad would decorate the living room and fill it with all sorts of ornaments and festive fare. We would pull out the same artificial tree, which was color-coded by layer, year after year.

I helped put the bottom layers on first. My dad added each layer that I couldn't reach, until we placed the star at the top. The tree towered over me as a kid, and I stared up at it in all its grandeur. Each year I got taller and assembled more and more of the tree, until I could finally put the star on by myself. Each year we would step back, plug in the lights, and admire our work, our construction.

And then my dad would look at me and say, "Good job, my chief engineer."

The very thing that makes the holidays so great is also what makes Hallmark Christmas movies simultaneously maligned and passionately enjoyed: tradition.

Each Christmas my family pulled out the same artificial tree, hung the lights, listened to the same songs, drank the same brand of eggnog, heard some variation of the same Christmas sermon, shopped at the same stores, and enjoyed the same holiday foods. It became almost a liturgy of sorts. These rituals were ingrained in me and provided a sense of rhythm to the entire season. If one of the elements were to be left out, the season just wouldn't feel the same.

No one will ever accuse Hallmark Christmas movies of being too daring. From the very first aerial shot of the big city—which our heroine will inevitably leave to return to her roots—we are treated to a feast of traditions, jam-packed in like gifts in a stocking. The tree farm, the decorating or baking montage, the almost-kiss, the awkward dopey "other" boyfriend, the sweet family members offering sage advice, the carriage rides, snowball fights—it's all there. And if it weren't, things just wouldn't feel right.

When we started *Deck the Hallmark*, I was excited to watch some cheesy Christmas films, have a few

laughs with friends, and then move on. What baffled me is why people would watch thirty to forty new ones. With the same plot. Every year. When I told an acquaintance that I was doing a Hallmark Christmas podcast, he responded, "Oh, the one where the girl meets the guy, moves from the big city, falls in love and breaks up with her boyfriend and kisses the new guy, and they live happily ever after." He laughed. I laughed. It was a whole thing.

Since then, I've heard that joke roughly three thousand times. I don't laugh anymore. Not because it isn't true. It is.

I don't laugh anymore because Hallmark knows exactly what we are looking for. Comfort. Safety. A place to enjoy traditions. You know what you're getting when you start one of these movies. You aren't looking for new and exciting, dang it. Just give me the good stuff, Hallmark! Give me my Christmas cookie crawls, doting aunts, charming small towns, galas, and royals from San Senova. Give me my traditions.

Because far too often, as we grow older, those traditions slowly fade away. Life gets in the way. We get busy. We run out of time. And then, looking back, we regret it.

We aren't our dad's chief engineer anymore.

After graduating from high school, I went off to a college in Georgia, where I was resolved to make my own path, away from my parents, for the first time. The way I was going to do this was to stay away from home as long as possible my first semester.

Three months away from home, and I had become my own man. Bold. Adventurous. Wise. And I had never wanted to be home more in my life.

So when Thanksgiving break rolled around, I submitted my last paper, hopped in my car, cranked up my iPod to Perry Como's "(There's No Place Like) Home for the Holidays," and cruised home.

I missed the smell of Christmas candles burning, the warmth of our fireplace, and the taste of eggnog. I couldn't wait to see my dog, and to hug my mom and dad. I wanted to tell them everything that was going on in my life over a nice home-cooked meal of my mom's legendary enchiritos (because we are all obsessed with Mexican food, even during the holidays).

Then, we pulled out the Christmas tree, and I helped my dad construct it. I wanted to resume my rightful place as chief engineer. Because that's the thing about traditions—those beautiful liturgies—you don't realize how much you miss them until you stop doing them.

Perhaps that is why when Hallmark's Countdown to Christmas finally starts, I don't mind that I have thirty-plus movies to watch. It's like coming home. So I watch Hallmark movies each year with a thankful heart. The traditions I have grown up with have shaped me and made me who I am. They will shape my daughter as I pass them on to her.

We will pull out the same artificial tree, hang the lights, listen to the same songs, drink the same brand of eggnog, hear some variation of the same Christmas sermon, shop at the same stores, and enjoy the same holiday foods.

And as we plug in the lights on the tree and step back to admire our work, I'll look over and say to her, "Good job, my chief engineer."

—*Panda*

"I'M DAN, and I Despise Hallmark Christmas Movies."

I've got a confession to make: I despise Thanksgiving dinner.

The food itself is placed on a pedestal it simply did not earn. Turkey as the star of the show? Dressing? Cranberry sauce? Why are we eating these things? And if these delicacies are so good, why aren't we eating them all the time?

When I was growing up, every year at Thanksgiving my mission wasn't to participate in Thanksgiving dinner. It was to survive it. If I somehow managed to do that, I was most handsomely rewarded with my grandma's world-famous chocolate pie, a chocolate pie so good it deserves a paragraph of its own.

Each year for the holidays, grandma made three desserts: banana pudding, prune cake (spice cake for you Yankees), and a chocolate pie. Truth be told, Grandma's chocolate pie wasn't world-famous. It was routinely passed over by everyone that wasn't a grandkid. And of the grandkids, I was president of the Chocolate Pie Fan Club. Could it have had anything to do with the fact I didn't eat any dinner beforehand? Maybe. Everything I said after "chocolate pie" is kind of a blur, if I'm being honest. Regardless, Grandma made the chocolate pie every year just for me, her overly picky, overly critical grandson.

A little insight into Dan for you readers: the ratio of criticism to praise for Thanksgiving foods tends to hold steady in my everyday life. I'm critical of quite a number of things, but I really hold tight to the things in which I find value. Is it a flaw? Could be. I choose to look at criticism as a necessary, beneficial, and fruitful part of life. Most people think criticism has to be negative, but the reality for me is that through criticism, I find beauty in the truly valuable things. It's how I observe and analyze.

All that background leads us here, to this moment. Gang, I've done the research. I've watched hundreds of Hallmark movies, and I've got some bad news. I can unequivocally say that they do *not* pass Dan's critical-eye test. Every year, we're treated to a buffet of eighteen to fifty-five Christmas movies from the world's cheeriest TV network. They may have started as special scripts, novels, or brainchildren years ago, but all that's left is a reduction sauce of bleh. I wish no one ill who works on these movies. I've had the opportunity to meet many of the people that make the

films, and all of them are wonderful individuals. That doesn't change my mind about the product.

So why, Dan? Why keep subjecting yourself if you don't like the movies? The problem is that while I honestly, earnestly despise these movies, they give me the opportunity to exercise my ever-critical brain in a positive manner. They allow me to spend time with some of my best friends, laughing, making a podcast, and bringing joy along the way. More importantly, I've discovered that while I have no tolerance for Hallmark movies, there are so, so many people who do.

For millions of Americans, Hallmark movies are their chocolate pie. In a sea of unpredictability, heartbreak, and loss, Hallmark movies are the oasis of normalcy that they dive into every night. Some people don't want to go to the theater or check out the latest prestige drama on television; they want to cuddle up under a blanket and watch a movie with a guaranteed stamp of predictability. They watch Hallmark movies to forget the tough times and remember the good times. I watch them because they're a critic's dream.

If my opinion of Hallmark movies has changed at all in the last few years, it's on this front: I originally despised them, and now I *love* to despise them. Finding the hilarity in these movies makes them worth watching. Experiencing the movies and then talking about them with friends and fans around the world is exhilarating. If you find yourself having to endure another Hallmark movie for your loved one, I encourage you to watch *them* instead of the movie. Find joy in their joy. Seeing others being happy reminds us that life is short.

And because it's short, fleeting moments of joy, even shared joy at watching a downright terrible movie, are all the more special.

A few years ago, my grandma was diagnosed with dementia. The changes were slow at first, but gradually they worsened, and eventually we had to put her in a nursing home designed for memory care. And just like that, so many traditions were gone. Gone were Thanksgiving and Christmas Eve dinners at Grandma's house. Gone were her wry wit, great stories, and legendary laugh.

Gone was my chocolate pie.

Now, each Thanksgiving night, after miles of traveling to see family, after eating underwhelming food, and after getting cranky, spoiled twin boys into bed, I get to experience a new memory. Each year my loving wife—my high school sweetheart, my forever partner, my life raft in a sea of heartbreak and loss—attempts to re-create that one-of-a-kind chocolate pie. My wife does this just for me, allowing me to remember and relive, to forge forward and to make new memories, while also rediscovering my love of the beauty in criticism.

Yes, I despise Hallmark movies. But there's something about them that sparks joy. Their essence is a calming salve to people who want to forget, people who want to remember, and, yes, even people who want to be critical. Somehow, against all odds, Hallmark movies manage to produce joy even in this critical soul.

Merry Christmas.

—*Dan*

(L to R) Panda likes, Dan despises, Bran loves.

"...AND THIS IS THE *DECK THE HALLMARK* PODCAST!"

Honestly, who thinks about Christmas in the middle of April?

Brandon mother-elfin' Gray, that's who.

It was a sunny day in South Carolina in April of 2018, and Brandon was lost in thought. Was he thinking about the beautiful spring weather in the Palmetto State? What about his wife and kid? Nope. He was thinking about how much he missed Christmas and how far away it seemed. Most people have long forgotten their yuletide spirit by mid-April, but for Bran, it felt as if the tree had just been taken down yesterday.

Like millions across the world, Bran did the only thing he knew to do—he turned on a Hallmark Christmas movie. In doing so, he temporarily sated his desire for Christmas, but Bran still longed for others to have that same festive feeling year-round. He wanted to share in that Christmas craziness with his friends. It was this feeling that inspired an idea . . . an idea that would change everything. An idea that would give Bran his ultimate Christmas wish: celebrating the season all year long.

The idea was simple: three dudes talking Hallmark Christmas movies. One loves them, one likes them, and one can't stand them. Bran didn't waste time as he got out his phone and shot a text to his good buddy Daniel Thompson, known

affectionately as Dan. Bran and Dan used to teach at the same school, the school where Dan was now the principal. Bran pitched the idea; Dan rolled his eyes and lazily agreed to record an episode during his summer break. Never (and we mean never) did he think anything would materialize past that.

Daniel Pandolph, aka Panda, was a no-brainer as the middle chair of the podcast. Panda is a likable guy who is up for anything. Bran, Dan, and Panda had spent years teaching school together, becoming friends, and making each other laugh. They have a natural chemistry. Panda agreed to do the podcast on the spot, Dan came up with the name *Deck the Hallmark*, and the guys set off on their Christmas journey . . . in the middle of summer.

In reality, these three guys loved each other's company, and when they worked together as teachers they became the closest of friends. After Bran and Panda left the school, and all three guys had kids, there just wasn't a lot of time for them to hang out anymore. The podcast became their weekly appointment to spend time together. On Wednesday nights at ten p.m., they'd gather in Bran's dining room with some old microphones and a computer. Half of what they said never made

it to air, but they rarely stopped laughing. That fun was more contagious than they realized.

In their first episode, the boys reviewed the 2017 classic *Rocky Mountain Christmas*. And for whatever reason, people listened. The star of the film, Kristoffer Polaha, agreed to come on the show for an interview, thus cementing the presence of *Deck the Hallmark* in the Hallmark podcasting universe.

Things didn't slow down from there. As the boys put out more episodes, an audience found them and latched onto their unique take on these made-for-television favorites. Pop culture publications began to notice as well. The boys were featured in the magazines *Southern Living*, *Country Living*, and *O, The Oprah Magazine*, to name a few. A write-up on the website PopSugar turned out to be their big break. (If this were a Hallmark movie, you would cut to someone in an office saying something like, "Did you see this article on the line? It's going viral.")

In early November, a producer at *Good Morning America* saw the PopSugar piece and mentioned it at a production meeting, and the podcast was mentioned on GMA the following morning. In a whirlwind twenty-four hours, the boys were flown to NYC and did GMA live before being flown back to South Carolina, carrying with them a top-ten podcast and a throng of new listeners.

In 2018, *Deck the Hallmark* reviewed every new Christmas movie released on Hallmark Channel and Hallmark Movies & Mysteries. And while Dan thought that meant his nightmare was finally over, it was clear that there was a market for their podcast year-round, and so the boys kept reviewing movies in 2019. Eventually, the podcast required so much of their attention that Bran and Dan made it a full-time gig, launching the Bramble Jam Podcast Network in 2019.

Deck the Hallmark continued to grow at an exponential rate. The boys traveled the country for Christmas conventions, live shows, and even just to eat kringles. (They mounted an entire road trip from South Carolina to Wisconsin to tour a bakery responsible for making the ring-shaped holiday treat that's the Badger State's official pastry.) They reviewed every new Hallmark Christmas movie released in 2019 and 2020. *Deck the Hallmark* attracted over three million listeners in its first two years of existence, and more find the podcast each day.

All of this so that Bran could find his Christmas-in-April people. Whether you're a year-round listener, or you just hop on for the season, thank you for taking this sleigh ride with us.

Hallmark's very first foray into TV was, appropriately enough, a Christmas show: 1951's Amahl and the Night Visitors.

A BRIEF HISTORY OF HALLMARK AND CHRISTMAS AND TELEVISION

The Hallmark Channel, which hosts the popular Countdown to Christmas every year, is a twenty-first-century phenomenon. But the history of Hallmark and Christmas on television dates all the way back to the dawn of the medium.

In TV's earliest days, it was common for families to gather around their set to watch a sponsor-branded program like *The Alcoa Hour* or *The Chevrolet Tele-Theatre* or *The Kraft Music Hall*. The last vestige of those of ad-in-the-title shows is *Hallmark Hall of Fame*, which for decades was a towering colossus on the small-screen landscape, winning eighty-one Emmy Awards, nine Golden Globes, and various Peabody Awards and Humanitas Prizes.

These days, it's a title generally bestowed on a Christmas movie with a slightly higher budget and more recognizable star power, but there was a time when a *Hallmark Hall of Fame* offering drew not only impressive ratings but also critical praise. The very first *Hallmark Hall of Fame* show, as it turns out, was actually Hallmark's first Christmas program, as well as the first opera composed for American television: Gian Carlo Menotti's *Amahl and the Night Visitors*. Performed live on December 24, 1951, from Studio 8H at Rockefeller Center, *Amahl* tells the story of a young boy and his mother who have a memorable encounter with the three

magi as they are on their way to Bethlehem. Five million viewers tuned in—the most for a televised opera at that point—and *Amahl* was performed annually on TV throughout the following decade.

Unsurprisingly for a program sponsored by a greeting-card company, *Hallmark Hall of Fame* would periodically revisit holiday themes over the ensuing decades. "Every couple of years, they would do a Christmas production, but it was either an opera or a type of variety special or a collection of narrative shorts or another kind of musical," notes Christmas TV expert Joanna Wilson, author of *The Christmas TV Companion* and *Tis the Season TV*. "Sometimes they were an hour long; sometimes they were two hours long. They aren't what we would call a movie—probably more of a TV-special feel."

That same level of Christmastime experimentation carried over to the early years of the Hallmark Channel, a cable network that came into existence in August 2001, taking the place of the now-defunct Odyssey Network. Hallmark Movie Channel followed in 2004, becoming Hallmark

Movies & Mysteries in 2014, and Hallmark Drama launched in 2017. (Hallmark Channel movies skew more toward romantic comedy, while Hallmark Movies & Mysteries and Hallmark Drama titles tend to fall more on the heartwarming and poignant side, although movies have been known to hop from one channel to another.)

In the early years of the Hallmark Channel, "you can see that in terms of their holiday programming, they're throwing all kinds of spaghetti at the wall to see what sticks and what works," Wilson told us. "We're all familiar with Countdown to Christmas as this umbrella holiday-programming block [starting in 2009], but they had a previous programming block for years that they called Home for the Holidays." (Home for the Holidays has since been repurposed to promote Hallmark Drama's Christmas programming.)

Hallmark Channel's first quartet of Christmas movies in 2002 was a mixed bag of genres, including an adaptation of Hans Christian Andersen's *Snow Queen*, the comedy *Santa, Jr.*, the dramatic *A Christmas Visitor*, and the WWII-set *Silent Night*. But over the following years, the "spaghetti" being thrown at the wall by the network included animation, variety specials, and events like the Tournament of Roses Parade and the National Christmas Tree Lighting.

Wilson points to 2006's *The Christmas Card* (page 39)—voted Favorite Hallmark Christmas Movie by *Deck the Hallmark* listeners in 2018—as a film that set the tone for the channel's eventual reliance on female-focused holiday romance; its ongoing influence remains apparent, as it is one of the few Hallmark Christmas movies of the 2000s that has stayed in regular rotation on the network.

Christmas Under Wraps (page 86) broke Hallmark Channel ratings records in 2014, and that film's success seems to have locked in many of the key tropes for movies to follow. It's about an ambitious big-city woman who finds herself stuck in a small town, where she falls in love with a blue-collar hunk, learns about what's really important in life, and, perhaps most significantly, regains her love of Christmas. (Oh, and there's a twinkly old man who might be Santa Claus.)

Four Christmas movies in 2002 jumped to a dozen in 2010; with each passing year, the number of new titles grows, with thirty-nine new Christmas movies released in 2019 and forty in 2020. Blocks of Christmas programming originally shown exclusively in December became 24/7 Christmas marathons kicking off in late October. Christmas movies made their way into July, and even to weekly, year-round time slots. More and more, viewers turn to Hallmark's Christmas programming—whether they love it, like it, or despise it—for a little bit of respite from the real world.

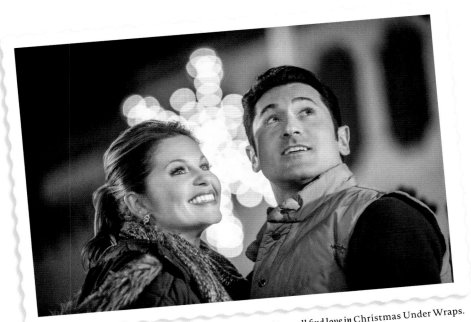

That's Garland for ya: Candace Cameron Bure and David O'Donnell find love in Christmas Under Wraps.

THE DECK THE HALLMARK GUIDE TO 116 HALLMARK CHANNEL CHRISTMAS MOVIES THAT WE LOVE, LIKE & DESPISE

Each episode of the *Deck the Hallmark* podcast includes the following four main sections. To keep this book from being ten thousand pages long, we've included one or two of them for each title:

"HOT TAKES": IN WHICH ALL THREE HOSTS (AND ANY GUESTS) GIVE A QUICK SUMMATION OF THEIR OPINION ABOUT THE MOVIE

"All the Feels": **elements of the movie that gave the hosts warm Christmas feelings**

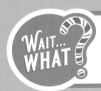

"Wait, What?": **lines of dialogue, plot points, costume choices, and more that seem baffling**

"What the Hallmark?": **elements of the film that require further explanation or perhaps might inspire a sequel**

We started the show in 2018, but we've reached back to discuss favorite films from earlier years that our listeners have asked us to review. (OK, they demanded it, but they were really nice about it.) And sometimes on the podcast, we've been lucky enough to interview some of the actors, writers, and directors behind these films; we've included some of their behind-the-scenes observations alongside our reviews.

ANGEL FALLS: A NOVEL HOLIDAY

PREMIERED DECEMBER 15, 2019,
ON HALLMARK MOVIES & MYSTERIES.

STARRING JEN LILLEY AND CARLO MARKS.

WRITTEN BY SAMANTHA HERMAN.
DIRECTED BY JONATHAN WRIGHT.

Jen Lilley in Angel Falls: A Novel Holiday

In this follow-up to *Christmas in Angel Falls* (page 50), angel Anthony (Eric Close) helps bring together small-press publisher Hannah (Lilley) and her former high school rival, now a literary marketing whiz, Ryan (Marks). As the two fall in love, they provide inspiration to author Tina (Rachael Crawford), who hasn't written a word since the death of her beloved husband.

Hallmark makes you feel good. They're formula rom-coms—we know in a romantic comedy, they're going to end up together—but I want to watch the ride, and I want to make popcorn, and I want to watch with my family. And then as far as Christmas goes: man, I love Christmas. I normally put my Christmas tree up in October. **—Jen Lilley**

HOT TAKES

"A LITTLE BIT BORING."
—Bran

"A REAL SNOOZER."
—Panda

"ATROCIOUS."
—Dan

WAIT... WHAT?

Dan: Jen Lilley's mom is maybe a decade older than her. They want to bring on someone to work at the publishing company, and they say, "You could be our special consultant," and the other person goes, "Ooh, that sounds like an exciting title." No, it doesn't; it sounds like a title you give your eight-year-old on Bring Your Daughter to Work Day.

A BLUE RIDGE MOUNTAIN CHRISTMAS

PREMIERED NOVEMBER 7, 2019,
ON HALLMARK MOVIES & MYSTERIES.

STARRING RACHAEL LEIGH COOK
AND BENJAMIN AYRES.

WRITTEN BY RICK GARMAN, BASED ON THE NOVEL
A CHRISTMAS BRIDE, BY HOPE RAMSAY.
DIRECTED BY DAVID WINNING.

Benjamin Ayres and Rachael Leigh Cook in A Blue Ridge Mountain Christmas

Willow (Cook), a hotel manager for a big hospitality chain, returns home to Virginia for her sister's wedding. When the venue becomes unavailable after snow collapses the roof, Willow finds a local inn, run by widowed dad David (Ayres), who is in the process of selling the property. He's hesitant at first, but Willow convinces him that decorating the inn for a Christmas wedding will make it more attractive to prospective buyers.

HOT TAKES

"IT JUST KIND OF WAS."
—*Bran*

"LACKS ANY SORT OF CHEMISTRY."
—*Panda*

"AN UNMITIGATED DISASTER."
—*Dan*

ALL THE FEELS

Bran: I think we can all agree, right?

Dan: There were no feels!

WAIT... WHAT?

Bran: David's a bright guy; he's a lawyer. He never thought about turning a barn into a wedding venue? Like, have you been on Pinterest? Even once in your life? It's just full of barns; they should call it Barnterest.

A BRAMBLE HOUSE CHRISTMAS

PREMIERED NOVEMBER 19, 2017,
ON HALLMARK MOVIES & MYSTERIES.

STARRING AUTUMN REESER, DAVID HAYDN-
JONES, AND TERYL ROTHERY.

WRITTEN BY JAMIE PACHINO,
BASED ON THE NOVEL BY C. J. CARMICHAEL.
DIRECTED BY STEVEN R. MONROE.

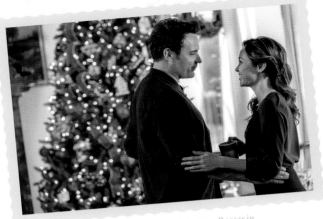

*David Haydn-Jones and Autumn Reeser in
A Bramble House Christmas*

Home health-care worker Willa (Reeser) and her son Scout (Liam Hughes) have just inherited $100,000 from Mr. Conrad, a dying man Willa had tended to during his final months. The inheritance also includes a Christmas visit to Bramble House, a B&B where Mr. Conrad spent several years as a child. News of the inheritance reaches Mr. Conrad's estranged children, Finn (Haydn-Jones) and Molly (Julia Benson), who assume that Willa took advantage of a helpless old man. Finn travels to Bramble House to confront her.

HOT TAKES

| "WANT TO WATCH IT AGAIN RIGHT NOW." —Bran | "BIG FAN." —Panda | "TOP FIVE HALLMARK." —Dan |

WAIT... WHAT

Panda: This entire movie moves from one scene to another where people ask overly invasive questions and then are like, "Did I go too far?" It's a really weird bit. Every scene, someone walks in and says, "It's great seeing you! Who's giving you all this money for your vacation?"

Bran: I have a couple of Wait, Whats, especially related to skating. Finn teaches Scout—which, very confusing, because they both have little-kid names, although Finn is not a little kid—how to skate, and Finn does this thing where he just says, "OK, let's go: pizza, pizza, glide."

Dan: I have the quote. Literally, his training, these are the words he uses. They're squatting and wiggling, and he goes, "Pizza, pizza, glide, French fries." Later he goes, "Remember: pizza, pizza, French fries," which is a weird sentence to ever say, but also you missed the glide step, I think?

CHECK INN TO CHRISTMAS

PREMIERED NOVEMBER 26, 2019,
ON HALLMARK CHANNEL.

STARRING RACHEL BOSTON, WES BROWN,
CHRISTOPHER COUSINS, AND RICHARD KARN.

WRITTEN BY ANNA WHITE.
DIRECTED BY SAM IRVIN.

Richard Karn and Rachel Boston in Check Inn to Christmas

Lawyer Julia (Boston) comes home to Colorado for Christmas and runs into Ryan (Brown). The two have never been particularly close since their families each own a local inn and have been rivals for decades. When a big resort company comes to town and threatens to put both families out of business, Julia and Ryan must bring the warring clans together.

"FIRST HALF WAS A LITTLE SLOW, BUT IT STUCK THE LANDING FOR THE MOST PART."—**Bran**

"NOT QUITE AS SCORCHING AS I WOULD WANT, BUT I LIKED IT A LOT."—**Panda**

"JUST BAD; FELT REALLY LONG."—**Dan**

Bran: You know, going into Hallmark Christmas movies, there are going to be baking montages and a Christmas tree decorating scene. This movie kind of stayed away from those traditions and added some new ones. So we have the snowball toss. We have the Christmas trivia; we had the bake-off. Those different types of competitions worked for me. It felt a little bit different, even though the snowball toss was dumb.

Panda: There's a scene when Julia and Ryan first meet, he comes up to the sign and says, "The map's right—you *are* here." That's a joke I've told before. And that joke is a riot. So that gave me feels.

Dan: I liked that the kissing happened early, and I liked any scene that had Ted from *Breaking Bad* and Al Borland from *Home Improvement* in it together. They're clearly having fun, they do not take it too seriously, and I appreciated that.

BIRTH OF A BIT
"THE CRYSTAL DANCE," FROM *CHECK INN TO CHRISTMAS*

Panda: At the end, the bakery wins the decorating competition with real crystals. What are they selling at that bakery, is my question, to have that kind of money?

Dan: I looked up crystals; they're actually not that expensive. What I don't understand is: the judges said the reason this bakery won is because they used "actual" crystals to refract the light through. How did the judges know that? How did they know it was a real crystal and not a fake one?

Bran: They probably asked.

Dan: And then the judges took him at his word. Because you can refract light through glass. It doesn't have to be crystal. So whoever designed this used real crystals—which do cost money, as opposed to glass—but they spent money on it, and then they said they'd done it, and the judges believed him, or they used some sort of crystal test. I don't understand.

Panda: Well, there is the crystal test.

Dan: How does that go?

Panda: Uh . . . you stir it once. Shake it twice. Clap, clap.

Dan: You were going to clap three times, and then you realized me and Bran had started to work on it. [Sings.] "And that's the crystal dance. Cry-crystal dance. So you stir it once . . ."

Bran & Panda & Dan: "You shake it twice, you clap three times . . ."

Dan: "It's the crystal dance!"

Panda: Then finally, there wasn't a time listed when to meet at Eddie's Pub at the very end.

Bran: "It's the crystal dance."

Dan: "You stir it once . . ."

Bran & Panda & Dan: "You shake it twice, you clap three times, *it's the crystal dance!*"

Dan: "Hey guys and girls, around the world, I got a crystal dance, it's gonna give you a twirl! You gotta stir it once, shake it twice . . ."

Bran & Panda & Dan: "*You clap three times, it's the crystal dance!*"

A CHEERFUL CHRISTMAS

PREMIERED DECEMBER 15, 2019,
ON HALLMARK CHANNEL.

STARRING ERICA DEUTSCHMAN
AND CHAD CONNELL.

WRITTEN BY BARBARA KYMLICKA.
DIRECTED BY MARITA GRABIAK.

Chad Connell and Erica Deutschman in A Cheerful Christmas

Sisters Lauren (Deutschman) and Colleen (Tianna Nori) are "Christmas coaches" who make their clients' holidays magical. They are hired by the Andersons—"53rd in line to the throne"—to plan a Christmas party, but stuffy James Anderson (Connell) doesn't want anything out of the ordinary. Lauren takes it upon herself to teach this straitlaced aristocrat how fun the holidays can be.

HOT TAKES

"SNOOZER, BUT THERE WAS REAL SNOW."—*Bran*

"SO BAD, BUT THERE WAS REAL SNOW."—*Panda*

"DUMPSTER FIRE."—*Dan*

ALL THE FEELS

Panda: There are a couple things they do in this movie that I have not seen in a Hallmark movie before. She walks into rooms and then visualizes what the room is going to look like with the Christmas decorations. I like that.

Dan: That's the one good scene in the movie. This movie has real snow. Their breath is cold, and you can see them outside. It feels like a winter movie; it feels like a Christmas movie. There's snow everywhere—it's real snow, it's not artificial—and that made me happy, and it made me sad that they wasted it on this particular film.

CHERISHED MEMORIES: A GIFT TO REMEMBER 2

PREMIERED NOVEMBER 24, 2019, ON HALLMARK CHANNEL.

STARRING ALI LIEBERT, PETER PORTE, AND TINA LIFFORD.

WRITTEN BY TOPHER PAYNE AND PEYTON MCDAVITT, BASED ON THE NOVEL *A GIFT TO REMEMBER*, BY MELISSA HILL. DIRECTED BY KEVIN FAIR.

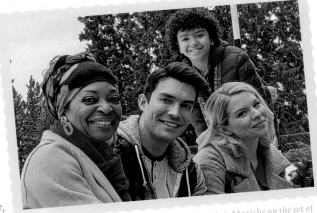

Tina Lifford, Peter Porte, Ali Liebert, and Dominic Mariche on the set of *Cherished Memories: A Gift to Remember 2*. (Photo courtesy Topher Payne)

Following the events of *A Gift to Remember* (page 106), Aiden (Porte) has moved to Philadelphia to be near Darcy (Liebert), who is now managing the bookstore. The two of them work together to save the rec center. Landlady Mrs. Monica Henley (Lifford) takes care of her young nephew, whose father is serving overseas in the military. (And yes, Mrs. Henley and restaurateur Luigi [Aurelio DiNunzio] are still an item.) Aiden sets out to complete the Christmas village that Darcy's father never finished, and also to propose to Darcy.

HOT TAKES

"AWESOME—THIS IS HOW YOU DO A SEQUEL, HALLMARK."—Bran

"LOVE THIS MOVIE, IT SUCKER-PUNCHED ME RIGHT IN THE FACE."—Panda

"ENJOYED MORE THAN MOST; I HAVE LEGITIMATE FEELS."—Dan

WHAT THE HALLMARK?

Panda: You know, they're getting real specific about the ounces of hot chocolate that Books! Books! Books! is ripping people off on, and I just want to know. I mean, they're very specific—nine ounces, right?

Dan: In a twelve-ounce cup.

Panda: I literally wrote down, "That's next-level evil" on my note.

A secret about how I write Hallmark movies. My helpful characters, the people who always help our leads along the way, are whenever possible named after significant people from my own life. One of my dearest friends and mentors was an actress in Atlanta named Jo Howarth, and I've been saving that name in my back pocket because I wanted her to be a complete deus ex machina when I brought her in. So when Aiden and Marcus [Dominic Mariche] go to Darcy's childhood home, and they encounter someone who is driven by kindness and realizes the secret before they do, I got to hear my friend who is no longer with me—I got to hear her name spoken again, in a context that I think she would appreciate.—Topher Payne

CHRISTMAS AT DOLLYWOOD

WITH GUEST JUSTIN KIRKLAND, ESQUIRE.COM, MY YEAR WITH DOLLY PODCAST

Niall Matter in Christmas at Dollywood

PREMIERED DECEMBER 8, 2019,
ON HALLMARK CHANNEL.

STARRING DANICA McKELLAR,
NIALL MATTER, AND DOLLY PARTON.

WRITTEN BY NINA WEINMAN.
DIRECTED BY MICHAEL ROBISON.

New York City party planner and single mom Rachel (McKellar) goes home to Pigeon Forge, Tennessee, for Christmas. She's rising in the ranks at her firm in New York, but she still harbors an ambition to become a children's-book author. Once she's back in Tennessee, she takes on a gig at Dollywood to plan the theme park's thirtieth-anniversary celebration, which puts her at odds with Luke (Matter), a twenty-year veteran of the park who hopes to become general manager. Leave it to Dolly Parton to arrive and solve everyone's problems—even if she doesn't sing.

Hot Takes

"NEEDED MORE DOLLY; THE LAST TWENTY MINUTES IS JUST A ROLLER COASTER OF FUN AND POOR DECISIONS."—Bran

"ONLY OK, AND I'M A LITTLE DISAPPOINTED."—Panda

"I WAS BORED INTO COMPLACENCY."—Dan

"HIGH ART—ALSO, NOT GOOD."—Justin

There's always heart in these movies, but a lot of the times, there's not much there for the male to really grab on to and define who he is. Hallmark has seen that in me—they can throw me in and think that, hopefully, he's going to do something interesting with this role. In Christmas at Dollywood, there wasn't much confrontation between the two characters, and in Hallmark, you don't want confrontation. But you want there to be two opposing things happening in a scene, so you maybe throw a sideways glance, or a look that indicates there's something else going on for this guy. There has to be some form of stakes there. Otherwise, why are you watching it?—Niall Matter

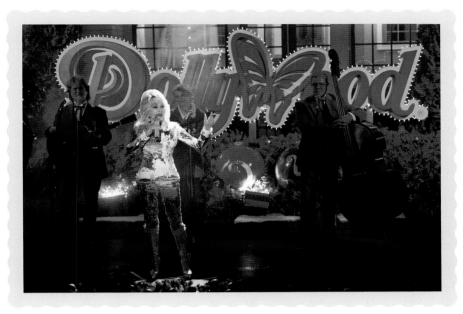

Dolly Parton in Christmas at Dollywood

Panda: You have the biggest party of the year, the biggest one. And guess what? You only have six days to plan it. Or eight or ten. We can't figure out a timeline. After just a few days, they're already saying, "Hey, we've been there for five days working together." And that would mean that the party's the very next day. Lo and behold, it's not the next day.

Justin: I have, as quite a rotund child, made that run from Show Street all the way up to Glacier Ridge, which is right next to Thunderhead. That is a solid fifteen-minute walk, ten-minute run, and unless Danica is doing double time on her Peloton, I don't think that she could have made that run in heels without being totally winded at the end. And if you're going to cater something at Dollywood, my Wait, What is, why are you sleeping on the cinnamon bread at the Grist Mill? That really strange onion-pepper-sausage combination that you can get as you're leaving Show Street? Aunt Granny's in its entirety? This is a park that's already overflowing with great food; you are leaving money on the table.

Dan: This is the worst board of directors of all time. None of them talk. Because I believe if they talk, then the Screen Actors Guild has to pay them. But I will say this: they are better as a board of directors than Danica McKellar is as a parent, because she's an absentee mother in this movie. She literally drops her orphan child off at her parents' house to plan a Dollywood party, and writes about her, but never sees her, doesn't bother to include her in anything.

CHRISTMAS AT GRACELAND

WITH GUEST JOHN JURGENSEN,
WALL STREET JOURNAL

PREMIERED NOVEMBER 17, 2018,
ON HALLMARK CHANNEL.

STARRING KELLIE PICKLER
AND WES BROWN.

WRITTEN BY GREGG ROSSEN AND BRIAN SAWYER.
DIRECTED BY ERIC CLOSE.

Financial analyst and single mom Laurel (Pickler) travels from Chicago back home to Memphis for work, but also to see friends at Christmastime. At Graceland, she runs into Clay (Brown), her ex-boyfriend and former singing partner, who's organizing the Christmas show at Elvis's mansion. He tries to talk Laurel into putting the band back together, in more ways than one.

Panda: The one that made me laugh out loud is when Kellie Pickler is playing piano at night, and her daughter comes out. First, she looks at her daughter and says, "Oh, you're up," even though she's literally playing just a few feet from her door, keeping her up all night. But then they sing like one line, and then she finishes the last "Sleep in heavenly peace," and goes, "That's you, sweetie. Go to bed." It ends bonding time! You're bonding with your daughter, and we just sing one line of "Silent Night," now go to bed right now. It's a terrible scene.

John: Also the fact that the hotel at Graceland is apparently a much more magical and lively place than Graceland itself. Which makes sense, because I'm sure they want to promote that pretty heavily.

Dan: The line, "I noticed a pattern—the more time you spend commuting, the less time you spend at home." Here's the thing: unless you're a time traveler, you're right. Another terrible bit of dialogue, and this is a classic end-of-the-movie line, an easy layup, and they throw it over the backboard: "It's like that saying: you don't really know what you've missed until it's gone." No, no, no. When you miss something, you don't know what you've got till it's gone.

Bran: One thing that really ground my gears: she comes into her friend's house at three p.m., and she says, "I'm going to make dinner. I'm going to roast a turkey." Kellie, you don't have time.

Dan: Either that turkey is going to be dry as a bone, or everybody's getting salmonella. Those are your only two options.

"EVEN AS SOMEBODY WHO LOVES THESE MOVIES,
I FOUND THIS ONE ROUGH."
—Bran

"DUMPSTER FIRE."
—Panda

"EVEN WITHOUT PICKLER'S FIRST TIME AROUND THE
ACTING CAROUSEL, THIS WAS A DISASTER."
—Dan

"SQUANDERED OPPORTUNITY; THEY HAVE THE RUN OF
GRACELAND AND DO NOTHING WITH IT."
—John

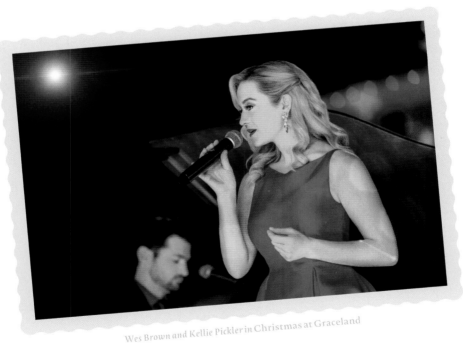

Wes Brown and Kellie Pickler in Christmas at Graceland

CHRISTMAS AT GRACELAND:
HOME FOR THE HOLIDAYS

PREMIERED NOVEMBER 23, 2019,
ON HALLMARK CHANNEL.

STARRING KAITLIN DOUBLEDAY
AND ADRIAN GRENIER.

WRITTEN BY NICOLE BAXTER.
DIRECTED BY ERIC CLOSE.

(L to R) Kaitlin Doubleday, Trace Masters, Laney Malone, and Nina Thurmond in Christmas at Graceland: Home for the Holidays

Globe-trotting curator Harper (Doubleday) comes home to Memphis for Christmas. While she's waiting to hear about a job in London, she crosses paths with widowed dad Owen (Grenier), who hires her to nanny his three adorable children over the Christmas season. And, as in 93 percent of all 2019 Hallmark movies, a party is planned.

HOT TAKES

"REALLY LIKED, THOUGHT IT WAS A LOT OF FUN."
—Bran

"OK; BETTER THAN THE FIRST *GRACELAND*, WHICH
IS NOT A DIFFICULT BAR TO CLEAR."
—Panda

"STANDARD-BAD; IT MAKES A YOUNG PROFESSIONAL
WHO'S STUDIED ABROAD AND WORKED HER WHOLE LIFE
DREAM OF BEING A NANNY OF THREE TWEENS."
—Dan

Panda: Are these kids homeschooled? Because they're very well-spoken and seem very mature for their ages. They also seem to not do things that normal children do. They're very excited to hang out with one another. They are very excited to sing songs around the piano, and they randomly break into "Up on the Housetop."

Dan: That's right. And they also were excited about getting an Advent calendar.

Panda: Yeah. And literally, as soon as they were like, "Advent calendar!" and they got excited, number one, I was like, Oh, they're homeschooled. And number two, I got excited. I remember when my parents brought home an Advent calendar, and I was like, Heck yeah!

Dan: Did you get it nine days before Christmas?

Panda: We got ours in advance, because we were always very prepared for the birth of our Lord.

Bran: You can't be too prepared for the birth of our Lord with chocolate, right?

Panda: No, no, I wasn't allowed to get the chocolates. It was just a Bible reading on a little flap. For Easter, we used to have these Easter eggs that you would open up, and you think there'd be candy in them, but they always had something to do with the resurrection or something like that. One time there was one with just cloves in it, because Jesus was buried with incense, and we didn't have incense. The more I'm talking, the more I realize I'm proving the point that I was homeschooled.

Dan: I want to know how long a tour of Graceland lasts. They start the tour in the morning. They finish the tour at night. Is that how long the tour of Graceland lasts? Is it a full day touring Graceland? I've been on a tour of the Biltmore Estate, and it takes three, four hours. I've never been on a tour that takes twelve hours.

Bran: You can make the Biltmore tour last as long as you want. There are a lot of things you can read. I don't read all the plaques. I imagine it's kind of similar, where you can go quicker or you can go slower, and they're homeschooled, so they're taking a long time.

Panda: Oh, they read every plaque.

CHRISTMAS AT GRAND VALLEY

PREMIERED DECEMBER 21, 2018,
ON HALLMARK MOVIES & MYSTERIES.

STARRING DANICA McKELLAR,
BRENNAN ELLIOTT, AND DAN LAURIA.

WRITTEN BY MARK AMATO, KAREN BERGER, AND
SUE TENNEY. DIRECTED BY DON MCCUTCHEON.

Brennan Elliott and Danica McKellar in Christmas at Grand Valley

Struggling artist Kelly (McKellar) can't get any of the art galleries in Chicago to give her a show, so she heads home to Grand Valley, where her dad, Frank (McKellar's *Wonder Years* costar Dan Lauria), runs a diner, and where her cousin manages the lodge. Kelly gets pressed into service to run an arts-and-crafts "Christmas Camp" at the lodge, while resort executive Leo (Elliott) comes to town with his kids to see if his company wants to buy the lodge.

"SUPER GREAT; IT'S WONDERFUL, IT'S CHRISTMASY."
—Bran

"REALLY LIKE; SOLID OUTING."
—Panda

"TON OF WAIT, WHATS, BUT IT REDEEMS ITSELF, SOMEHOW."
—Dan

Panda: At the very start of the movie, Kelly gets called down to the gallery, and she shows up and they tell her, "We got some bad news for you—your art's not going to make it to the gallery." Why would you call her down to tell her that? Couldn't you just tell her on the phone?

Dan: That is the next level of mean. That's a level of mean that only takes place in the big city.

Bran: I want to look you in the eyes when I tell you that your career is going downhill.

CHRISTMAS AT PEMBERLEY MANOR

PREMIERED OCTOBER 27, 2018,
ON HALLMARK CHANNEL.

STARRING JESSICA LOWNDES,
MICHAEL RADY, AND ELAINE HENDRIX.

WRITTEN BY RICK GARMAN.
DIRECTED BY COLIN THEYS.

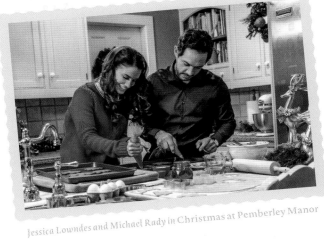

Jessica Lowndes and Michael Rady in Christmas at Pemberley Manor

Big-city party planner Elizabeth (Lowndes) agrees to organize a small-town Christmas festival as a favor to her old college chum George (Cole Gleason), the town's mayor. When a burst pipe wipes out the town square, Elizabeth convinces no-nonsense business magnate William Darcy (Rady) to host the festival at stately Pemberley Manor, which is in the process of being sold.

Wait... What?

Panda: Can we start off with just the reality that that's not a manor?

Dan: It's not a manor. Also, that front yard isn't big enough to host most Baptist church Christmas festivals, much less a town's Christmas. Like, this is the entire town, and you're telling me they're all going to be in the front yard?

Panda: The concert scene for me is one of the most unbelievably stupid things I've ever seen in a Hallmark film. When Kris (Steve Larkin) comes up to Elizabeth, and he's like, "Maybe this is your big night"—I don't understand how this was relevant to anything. They don't make a big deal about her singing really well.

Bran: Let's talk about Kris. Did anyone see it coming? This is not a "he may be Santa," which happens a few times. He almost comes right out and says that he is Santa Claus.

Dan: He is *the* Santa Claus. The reason I didn't see it coming is because he's kind of an off-putting Santa. I think he's what Dr. Phil imagines Santa would be. Like, he's got a Southern accent, and he wants to confront everybody about their problems.

"LOVE, REALLY FUN, VERY CHRISTMASY."
—Bran

"LIKED; GREAT WAY TO GET THE CHRISTMAS JUICES FLOWING."
—Panda

"BAD ON TOP OF BAD; THOUGHT THE MOVIE HAD FLOWN
BY AND THEN REALIZED WE WEREN'T HALFWAY DONE."
—Dan

Michael Rady in Christmas at Pemberley Manor

*Everywhere I go, there's a Hallmark fan. I'll be sleeping on the plane, and the server will be like [whispers], "Hey, I'm so sorry, but I love your movies on Hallmark." Even great casting directors—I'll walk out of an audition, and the casting director will say [whispers], "I just wanted to let you know—I love your Hallmark movies." You're not supposed to love them out loud; it's so funny. There are the people who know that rule, and then the unabashed fans. I'll be walking through Grand Central Station, and someone will shout, "I love you on Hallmark!" But then there's the [mutters], "Hey . . . bro . . . I love your Hallmark movies, bro." "Why are we whispering? Oh right, sorry, sorry."—**Michael Rady**

CHRISTMAS AT THE PALACE

WITH GUEST AMBER, HALLMARKIES PODCAST

PREMIERED NOVEMBER 22, 2018, ON HALLMARK CHANNEL.

STARRING MERRITT PATTERSON, ANDREW COOPER, AND BRITTANY BRISTOW.

WRITTEN BY JOIE BOTKIN.
DIRECTED BY PETER HEWITT.

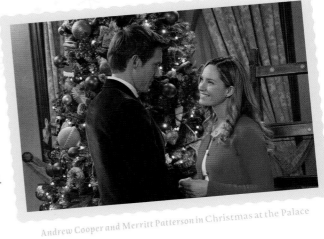

Andrew Cooper and Merritt Patterson in *Christmas at the Palace*

A traveling figure-skating show finishes its tour in the kingdom of San Senova, where King Alexander (Cooper) has a reputation as a Christmas hater. The widowed monarch's daughter, Princess Christina (India Fowler), loves ice skating and convinces her dad to host a Christmas Eve Founder's Day pageant on ice to boost his holiday image. They hire the skating troupe's lead performer, Jessica (Bristow), and former skater turned coach Katie (Patterson) to stick around and put the event together.

"LOVE THIS MOVIE; CHEESY, BUT IN THE BEST POSSIBLE WAY."—Bran

"LOVE—UNDERLINE, HYPHEN, ASTERISK—THIS MOVIE."—Panda

"LUDICROUS; FAKE ENGLAND MEETS ICE SKATING, AND I HATED EVERY SECOND OF IT."—Dan

"GOOD CHEMISTRY BETWEEN THE LEADS, SERVICEABLE STORY LINE."—Amber

HOT TAKES

WAIT... WHAT

Amber: I was super confused—what in the world is King Alexander going to contribute to the ice-skating show?

Dan: The pageant is about a queen, and then the king of San Senova says, "Guess who's playing the queen? This guy!" Can you imagine? "Attention, everyone here at the Peace Center: correction in your playbill—the part of Abraham Lincoln will be played by Meryl Streep." Actually, she would crush it. How about this: "The part of Joan of Arc will be played by Brendan Fraser."

Bran: Again, I'm in. I need a good example.

Dan: "The part of Queen Elizabeth I will be played by Prince Charles." You can't just say, "Guess what, daughter of mine, who I planned this whole pageant for—I know the queen bailed, but I'm the queen now."

CHRISTMAS AT THE PLAZA

Bruce Davison and Elizabeth Henstridge in Christmas at the Plaza

**PREMIERED NOVEMBER 28, 2019,
ON HALLMARK CHANNEL.**

**STARRING ELIZABETH HENSTRIDGE,
RYAN PAEVEY, BRUCE DAVISON,
JULIA DUFFY, AND NELSON WONG.**

WRITTEN AND DIRECTED BY RON OLIVER.

Scholar Jessica (Henstridge) is commissioned to create an exhibit about the history of Christmas at New York's legendary Plaza Hotel. Nick (Paevey), who has been hired to decorate the lobby, is pressed into service as her assistant. Despite the snotty condescension of her academic boyfriend, Jessica begins to research the *finial d'arbre* tree topper that has graced the hotel's tree every year since 1907. She discovers a mystery: why was there no *finial d'arbre* in 1969? Searching for the answer will reveal the hidden past of the hotel's chief bellman, Reginald (Davison). Keeping watch over the Plaza's front desk is, of course, Kenny (Wong; see "Across the Kennyverse," page 128).

"PHENOMENAL; INSTANT HALLMARK CLASSIC."—**Bran**

"HITS ALL THE BEATS."—**Panda**

"ONE OF THE BEST OF THESE; AN ACTUAL CHRISTMAS MOVIE."—**Dan**

I have gone to the Plaza for decades, and I've always loved that hotel. The people who work there are great. And I thought, "That's a great place for a Christmas movie." So my executive at Hallmark, Jennifer Phillips, and I were talking about places we want to make movies, and I said, "Well, the Plaza, of course." One day, I was standing at the bar at the Plaza Hotel with a drink in my hand. The bartender took a picture. I posted the picture on Facebook; I said, as a joke, "Here I am doing research for my next movie, Christmas at the Plaza." Monday morning, I get a call from Jennifer saying, "If you're serious, we'll make that movie."—Ron Oliver (Writer-Director)

Bran: Reginald's face, when he was looking at this woman who he hasn't seen since 1969. An hour and twenty minutes into the movie, we see a new character, and there's a scene where he's just looking at her like he is looking at a precious jewel. His face just sells it. When Jessica says the ornament is beautiful, and he looks at his old flame and says, "It most certainly is," in a whisper—it just works. And Nick putting up Christmas lights on Jessica's house. And a line that just made me laugh—she's listing all the degrees that she has, and Ryan says, "One more degree, and you'll have a fever."

Panda: You literally took every single one of my feels, including that line, which I think is hilarious. Listen, just the Plaza—each room is a treasure. There's so much beauty there, and whoever decorated the set, kudos.

Dan: The Plaza was one of my feels; the Bruce Davison scene, obviously. I actually googled, during the movie, the *finials d'arbre*, the tree toppers, and Ron Oliver used a lot of the real tree toppers. He used three or four actual ones. Those are the ones from the Plaza Hotel, and they do remake them and sell versions of them to the public.

Ron Oliver, Nelson Wong, and Elizabeth Henstridge on the set of Christmas at the Plaza (Photo courtesy of Nelson Wong)

CHRISTMAS BELLS ARE RINGING

PREMIERED DECEMBER 22, 2018,
ON HALLMARK MOVIES & MYSTERIES.

STARRING EMILIE ULLERUP, JOSH KELLY,
AND REBECCA STAAB.

WRITTEN BY NICOLE BAXTER.
DIRECTED BY PAT WILLIAMS.

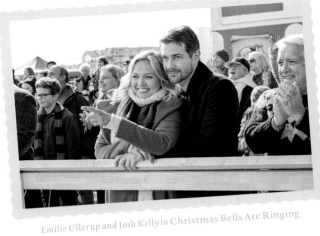

Emilie Ullerup and Josh Kelly in Christmas Bells Are Ringing

Photographer Samantha (Ullerup), who's up for a full-time position at a Boston newspaper, heads to Cape Cod for her widowed father's Christmas Eve wedding. She runs into childhood pal Mike (Kelly), a real estate agent and handyman. The candidates for the newspaper gig have to turn in one more photo, and Samantha sets out to capture the perfect image of Christmas on the Cape, with Mike's help.

Bran: The couple is getting married on Christmas Eve—how close would you need to be to somebody to go to a wedding on Christmas Eve?

Dan: You two are two of my dearest friends in the world. If you're getting married on Christmas Eve night, I'm not there. Speaking of that wedding, there's a dance scene, and I want you to take it to the tape, desperately. Because in this dance scene, it starts with a wide shot, and all these couples are slow-dancing, and there is one woman in a black dress near the fireplace who, by herself, is doing some sort of really weird Milli Vanilli Riverdance.

Panda: There's one at every wedding, though.

Dan: I'm very confused about this whole gift-wrapping ordeal, because they insinuate that she wrapped a hundred gifts in ten minutes. And also, it's a contest? And they're just throwing gifts over their shoulders, and one dude is catching the gifts? Who is counting? Who has everyone's tally of how many they're doing in ten minutes?

> **"I DID NOT FALL ASLEEP, BUT I WANTED TO."**
> —Bran
>
> **"NOT A LOT OF APPEAL."**
> —Panda
>
> **"FOR A MOVIE THAT HAS TWO POSSIBLE JOB CHANGES, A WEDDING, AND A DEAD FAMILY MEMBER, IT FELT LIKE NOTHING WAS HAPPENING."**
> —Dan

TOUGH QUESTIONS FOR EMILIE ULLERUP

Dan: There's a gift-wrapping scene in that movie, Emilie, and you may not know the answer to this, but they basically say that somebody wrapped an absurd amount of gifts in an hour. Like . . .

Emilie: I think I say a hundred?

Dan: Yeah. And we're talking . . . what is that? In sixty minutes?

Panda: Yeah, it's over a gift a minute.

Dan: You are wrapping more than one gift a minute. Now, in an hour, I could not successfully wrap *a* gift, I don't think, singular, unless I just had a bag and tissue paper. Was that really in the script that way? A hundred in an hour?

Emilie: Are you insinuating that I would have made up that line?

Dan: I'm insinuating that there's no way anyone could wrap a hundred in an hour, so either . . .

Bran: So, whose idea was it?

Dan: . . . you did it because the screenwriter put it in there, or you decided to ad-lib it, which, either way, I'm just interested.

Emilie: I did not ad-lib that line.

CHRISTMAS CAMP

PREMIERED JULY 11, 2019,
ON HALLMARK MOVIES & MYSTERIES.

STARRING LILY ANNE HARRISON,
BOBBY CAMPO, AND JOHN JAMES.

WRITTEN BY KAREN SCHALER.
DIRECTED BY JEFF FISHER.

Ad exec Haley (Harrison) wants to land a Christmas campaign for a big toy-company client, but her boss doesn't think she's a good fit, since she never celebrates Christmas. Boss sends Haley to Christmas Camp for a "holiday attitude adjustment." While learning to love Christmas, Haley helps Ben (James), who runs the camp, develop a franchise that would bring Christmas Camp to hotels everywhere, and she falls for Ben's architect son Jeff (Campo).

HOT TAKES

"LOVE THIS MOVIE; THE CAMP WAS SMALL AND DUMB, BUT IT WAS AWESOME."—**Bran**

"WANTED TO LIKE; THE CAMP IS CREEPY."—**Panda**

"BAD; CAN I INTEREST YOU IN A PLACE WHERE TWELVE STRANGERS ARE KIDNAPPED BY AN OLD MAN, AND HE TAKES ALL THEIR PHONES, AND THEN THEY DO TEAM-BUILDING ACTIVITIES?"—**Dan**

WHAT THE HALLMARK?

Panda: At the very beginning of the movie, Haley is chastised by her boss for taking three weeks to set up the Christmas tree, and then they slowly pan over to Tom [David Ten Hoeve], who's decorated the entire Christmas office. And Tom just kind of looks up from his decorating, and there's a little eyebrow-raise. I want to know more about him. I want to know what motivates Tom. What wakes that man up in the morning where he's like, "I'm going to decorate the entire office this year."

Bran: Why don't we just put Tom in charge of it every year? Why do we have to do this cycle?

THE CHRISTMAS CARD

PREMIERED DECEMBER 2, 2006,
ON HALLMARK CHANNEL.

STARRING ALICE EVANS, JOHN NEWTON,
LOIS NETTLETON, AND ED ASNER.

WRITTEN BY JOANY KANE.
DIRECTED BY STEPHEN BRIDGEWATER.

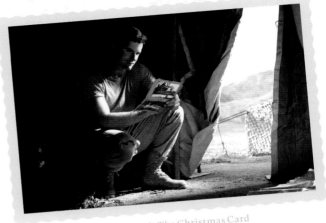

John Newton in The Christmas Card

During the Afghanistan War, a soldier shows a Christmas card to Master Sergeant Cody Cullen (Newton). The card had been sent by Faith (Evans), who lives in the soldier's hometown of Nevada City, California. Following the soldier's death in combat, a shaken Cody travels to Nevada City to visit the man's widow. In quick succession, Cody bumps into Faith at the local diner and then saves the life of Faith's father, Luke (Asner), who is almost hit by a car. Cody stays in town over the holidays, and he and Faith find themselves growing closer.

"LIKE. ED ASNER SAVED THIS MOVIE FOR ME."—Bran

"DIDN'T HATE, BUT I GET WHY THIS MOVIE IS NUMBER ONE WITH *DECK THE HALLMARK* FANS."—Panda

"AN ABOMINATION."—Dan

Dan: I would like to see a prequel on Faith's family, because I feel like they're a really weird family, and there are things that they do that would only make sense if they were raised in a world that was just devoid of anything outside of them. Like, for instance, they're all shag-dancing to "What Child Is This?" If you ever hear "What Child Is This?"—come on, don't you immediately go grab a partner, like this is beach music? And then also, because of how Faith was raised, I don't think she sticks with Cody. I mean, she's already cheating on Paul. She's in a relationship with this guy, and emotions just take over, and she kisses Cody anyway.

THE CHRISTMAS CLUB

PREMIERED NOVEMBER 27, 2019,
ON HALLMARK CHANNEL.

STARRING ELIZABETH MITCHELL,
CAMERON MATHISON,
AND SHEILA McCARTHY.

WRITTEN BY JULIE SHERMAN WOLFE,
BASED ON THE NOVEL BY BARBARA HINSKE.
DIRECTED BY JEFF BEESLEY.

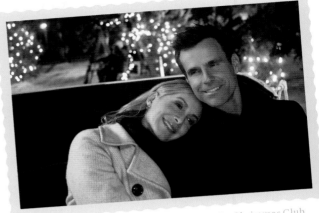

Elizabeth Mitchell and Cameron Mathison in The Christmas Club

Dance instructor and single mom Olivia (Mitchell) and business-boy Edward (Mathison) bump into each other outside a shop when a gust of wind blows away four twenty-dollar bills belonging to Gertrude (Gabrielle Rose). Olivia and Edward look for the bills but can't find them; they each give Gertrude two twenties of their own and soon find their generosity being paid forward through a number of surprising encounters. Meanwhile, Olivia's boss, Maggie (McCarthy), decides to sell the dance studio, so Edward convinces Olivia to get a loan and start her own dance school.

"SO GOOD; ROCKED MY FREAKING WORLD."—Bran

"LOVE; WITTY DIALOGUE, LEGITIMATELY LAUGHED OUT LOUD."
—Panda

"JUST A NO FOR ME; I LIKE A DASH OF CHRISTMAS MAGIC—
THEY DUMPED A WHOLE BARREL ON THIS."—Dan

I did a movie for ABC Family, and I worked with producers there that were doing a Hallmark movie. They had a hard time casting this smaller role in one of the Hallmark movies. The character is a bit of a jerk; he was the kind of boyfriend that the girl shouldn't have, and then she ends up with the Hallmark stud. And I was the jerk. The producer said, "Listen, man, I need you to do me a favor: this is not a lead role, but if you get in good with Hallmark, it could be awesome." I said, "Yeah, man, this sounds great"—a character I don't normally get to play, in a movie called Window Wonderland, *with Paul Campbell. I finished that, and I guess the Hallmark execs loved what I did, so they had me go in for* The Christmas Ornament. *I shot that with Kellie Martin, and things exploded after that.* **—Cameron Mathison**

Panda: The hand-holding scene at the Christmas tree is one of my favorite ones, because Olivia's daughter normally holds her hand at the Christmas tree lighting, and then the daughter goes away. As a dad of a little girl, I can imagine what that's like when my daughter will no longer want to hold my hand at those kinds of things. So that gave me feels, but then Edward comes along and, in a very romantic gesture, holds Olivia's hand as the tree lights up. That's a great scene.

Bran: I also just appreciate in general the progression of affection, from hand-holding to kiss on the cheek to kiss on the lips. And the progression of Edward throughout the movie—he starts out kind of like a Christmas hater, he doesn't believe in fate, he doesn't believe in the magic. And then he says this line towards the end of the movie, and it is a humdinger: "I kind of like living in a world where fate and magic exist." Yeah! Yeah, you do.

Dan: Early on, there's just a good old we-know-what-this-is feel from the writing, like when the mom says, "Hey, I got all the fixins here for my eggnog," and the daughter asks, "Why do you say 'fixins' like you're from the South?" And she's like, "I am. I'm from south Minnesota." And that last scene, where Edward says that he's going to stay here because he's found his home—that line really worked for me. It's hard to describe when you're in love, in a long-term relationship, and you're married and you've got kids and all this stuff—you can describe that love a lot of different ways, but "home" is really the best way to do it.

A CHRISTMAS DETOUR

PREMIERED NOVEMBER 28, 2015,
ON HALLMARK CHANNEL.

STARRING CANDACE CAMERON BURE,
PAUL GREENE, AND BARBARA NIVEN.

WRITTEN BY MARK AMATO.
DIRECTED BY RON OLIVER.

Magazine writer Paige (Cameron Bure) thinks she's found the perfect mate in her fiancé, Jack (Marcus Rosner), whom she's traveling to see at Christmas so they can begin planning their wedding. On the plane, she winds up seated next to Dylan (Greene), who thinks that she and her vision board—which she has brought with her on the plane—are ridiculous. A blizzard forces them to land in Buffalo, and the only way she's going to make it to Jack's by Christmas is to go on a road trip with Dylan and constantly squabbling married couple Maxine (Sarah Strange) and Frank (David Lewis).

Panda: Going back to her vision board, I have a couple of problems. It gave me feels, but I have some conflicting emotions. At one point, Dylan says, "I don't need a bulletin board to tell me what I want." And CCB responds with, "You need the Great Wall of China." I don't know what that means.

Dan: I guess she's saying he needed a bigger vision board? Which doesn't make any sense at all.

Bran: Kenny (see "Across the Kennyverse," page 128) is the one who checks people onto the flight, and so he asks Paige, "Window or aisle?" Paige says "Aisle," and Kenny says, "We only have window." I love that.

Dan: She's really worried about the flights not taking off, and then they put her up in the airport hotel, and she says, "Well, give me a room facing the airport, so I can see when the planes are taking off again." I know that Hallmark is not technologically savvy, but if she doesn't know the planes are taking off by the time they're taking off, she's Amish. She is 100 percent not even trying if she's gotta look out the window to go, "I'll be danged! The planes are taking off!"

Candace Cameron Bure and Paul Greene in A Christmas Detour

"INSANE IN ALL THE BEST WAYS; LOVE THIS MOVIE."
—Bran

"OK; FIRST HALF IS EXCRUCIATINGLY LONG,
THE SECOND HALF IS A REAL BANGER."
—Panda

"UNMITIGATED DISASTER; CANDACE CAMERON BURE'S
CHARACTER IS THE WORST PERSON."
—Dan

My mom is an extra in almost all the movies I've worked on. And if she's not there, then I have her picture somewhere. So I've managed to get my mom in every project, other than maybe one or two. It's like Where's Waldo?, finding my mom.—**Paul Greene**

A CHRISTMAS DUET

PREMIERED NOVEMBER 25, 2019,
ON HALLMARK CHANNEL.

STARRING CHALEY ROSE, ROME FLYNN,
AND TERYL ROTHERY.

WRITTEN BY JOEY ELKINS AND BLAKE SILVER.
DIRECTED BY CATHERINE CYRAN.

Rome Flynn and Chaley Rose in A Christmas Duet

Years ago, Avery (Rose) and Jesse (Flynn) scored a big hit with, what else, a Christmas duet. But things fell apart, and now Jesse is struggling to make it as a solo artist while Avery has left the music business to open an inn. Wouldn't you know it: just when Avery is up for the Top Winter Lodge award—and she should be tending to persnickety awards judge Miss Selig (Rothery) and her cavalcade of needs—Jesse blows into town on tour.

"BIG FAN, PLUS AN ORIGINAL SONG I ACTUALLY LOVED."—*Bran*

"REALLY ENJOYED THE PLOT; THEY CAN BOTH SING THE LIGHTS OUT."—*Panda*

"A LOT GOING FOR, A LOT GOING AGAINST."—*Dan*

Bran: His version of the song "This Christmas" was great. It was acoustic, which I haven't heard a lot; you kind of hear "This Christmas" as the same basic thing, big horns and all that stuff, which it should be, but he did a really great stripped-down version of the song. And then at some point this lady says, "I will donate hot chocolate for the festival," and so they go to try it. She brings out a flight of hot chocolate on this board, three small mugs, three different types of hot chocolate. I could not be more in on that being a thing. Breweries? Overrated. Bars. Get out of here. I want a place where I can go and just get all the different types of hot chocolate. I want a flight of hot chocolate. Let's do this. I think we should maybe stop the podcast and go into the hot chocolate business.

Dan: I'm concerned about the scene where Avery's talking with this girl who's super cute. And the girl says, "This boy left a ladybug on my desk at school, and then said I was his girlfriend." That's gross. And Avery replies, "Well, relationships are complicated." No, no, no. The correct response there—little girl, if you're listening—is no one can tell you at any time that you're their girlfriend. Relationships are not complicated. This is cut and dry. No one can tell you that. It's not cute. That's terrible advice. And that's a bad story, period. There's no other answer there. You can't just go, "That's how boys are. Boys are just mean to you because they like you." No.

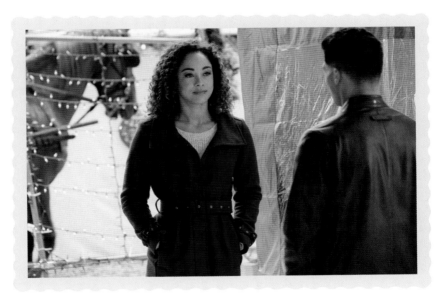

Chaley Rose and Rome Flynn in A Christmas Duet

*It was great to be a part of progress, and on the other hand, it was 2019. It was like, "We shouldn't really be having this conversation. We're talking about putting black people on the network." I did a viewing party with a drinking game, and my friend Cindy is Chinese, and she decided she was going to drink every time she saw an Asian person onscreen. I think it happened twice. I mean, she was completely stone sober. It's great to start adding diversity. I think it should have happened already.—**Chaley Rose***

CHRISTMAS EVERLASTING

WITH GUEST JONATHAN SHAPIRO,
WRITER-PRODUCER,
THE BLACKLIST, GOLIATH

**PREMIERED NOVEMBER 24, 2018,
ON HALLMARK CHANNEL.**

**STARRING
TATYANA ALI, DONDRÉ T. WHITFIELD,
DENNIS HAYSBERT, AND PATTI LaBELLE.**

WRITTEN BY MARCY HOLLAND, MARIA NATION,
AND RON OLIVER, BASED ON THE NOVEL
THE SECOND SISTER, BY MARIE BOSTWICK.
DIRECTED BY RON OLIVER.

Dennis Haysbert and Patti LaBelle in Christmas Everlasting

Soon after getting promoted at her big-city law firm, Lucy (Ali) learns of the death of her sister Alice, who years earlier had survived a car crash that left her with special needs. Lucy travels home to deal with inheriting their family home, and she learns from Peter (Whitfield)—Lucy's ex and Alice's attorney—that before ownership can be transferred to Lucy, she has to stay in the house for four weeks.

> **"LOVED IT."—Bran**
>
> **"IT'S LIKE AN ONION: THE MORE YOU PEEL IT,
> THE MORE YOU FEEL IT."—Panda**
>
> **"EASILY THE BEST HALLMARK MOVIE I'VE EVER SEEN."—Dan**
>
> **"ELEGIAC; IF INGMAR BERGMAN MADE A HALLMARK
> CHRISTMAS MOVIE, THIS WOULD BE IT."—Jonathan**

On Christmas Everlasting, *my mom had just passed away, and I lost my dog all at the same time. It was like a bam-bam punch. It was hard. I thought, "Well, let me bring that emotion to this," in the script itself and with the actors, the performances. The trick is to make sure it doesn't become this grim march to the graveyard. I put into that movie the Nat King Cole music that the network bought for me to use, because my mom loved Nat King Cole. I used that in the movie for inspiration. It kept it fresh for me, and I think it keeps it fresh for the audience.—**Ron Oliver (Cowriter and Director)***

Dan: The flashbacks when she and her sister are little—both of them work incredibly well. Those scenes gave me the feels, and also clearly when Maeve and her adoptive parents come and join the family for dinner. That's a great scene, no doubt about it.

Jonathan: Well, that dinner scene was very moving, but I have to say—and it would have been a Wait, What, but I just went with it—the Andy Williams "Most Wonderful Time of the Year" montage, quilting with the three-weird-sisters coven of evil, I found very moving.

Panda: The death of the sister early on gets me on several levels. First of all, because it's emotional in and of itself, but also, that was the closest I came to crying this entire film. We've had those moments where you get that phone call you don't like. They build up that you've already been introduced to the sister, there's some background to it, and then that scene hits, and for once, Hallmark lands the feels for me.

Jonathan: I want to know what Lucy's going to do for a living when she's disbarred. We know she can't practice law in Wisconsin, but we also know that she abandoned her client in New York. Her first line to that client is, "I got some great news for you—the city has approved zoning for your property, and you can have a mixed use of this property." And then midway through, the head partner of the firm who makes her the junior partner, says, "Hey, we gotta check the contracts, we got to make sure that it was a for-use." That's a little bit like a doctor saying, "You know that blood transfusion? Was it type A or B?" And then, rather than give that client in New York the answer, she hangs up and uses that information to kill the bakery deal. So what is she going to do next? She can't quilt. She can't fish. I'm concerned about her future.

A CHRISTMAS FOR THE BOOKS

PREMIERED DECEMBER 20, 2018,
ON HALLMARK MOVIES & MYSTERIES.

STARRING CHELSEA KANE AND DREW SEELEY.

WRITTEN BY THOMMY HUSTON.
DIRECTED BY LETIA CLOUSTON.

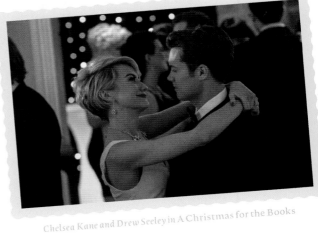

Chelsea Kane and Drew Seeley in A Christmas for the Books

Joanna (Kane) is a TV personality who's also a Christmas expert and a crafter and a blogger and the author of a best-selling relationship guide. She's been keeping her personal life secret because this expert on love is—gasp!—single. In the hopes of landing a big TV gig, she plans the network's Christmas party, but she is expected to arrive with her boyfriend. Enter Ted (Seeley), who just got dumped by his girlfriend for not living up to Joanna's published standards. He agrees to be her fake boyfriend in exchange for getting first-hand lessons from Joanna on how to do relationships better. Complications arise in both the form of a hunky TV exec with an eye for Joanna and the surprise arrival of Ted's ex.

"NONE OF IT WORKS."—Bran

"EVEN THOUGH THIS WAS ACQUIRED FROM AN OUTSIDE PRODUCER, IT'S LIKE THE WORST VERSION OF EVERYTHING HALLMARK ACTUALLY STANDS FOR."—Panda

"LIKE NOBODY IN THE MOVIE EVER EXPERIENCED CHRISTMAS, BUT HEARD ABOUT IT THROUGH A GAME OF TELEPHONE."—Dan

Panda: We gotta talk about Valerie (Alanna LeVierge), the ex, because she's frightening. And it's almost like the movie just skirts past the fact that she's as crazy as she is. She shows up after breaking up with her boyfriend, throwing a rock at this stranger's house to get them to come outside. And there's a scene at the end that caught me off guard. Joanna walks into her closet, and Valerie's just there stroking her dress, staring at it, holding it up to her, petting the dress. And she stares out, and she's like, "Oh … hey." She's a Wait, What for me; she's really strange.

Bran: I think the big What the Hallmark is Joanna's point system. She writes a book about how to find love and keep it, and in it is a point system. And with the information that we've been given, I can't make heads or tails of it.

Dan: The worst part is that it seems like the only people that need to score points are the men. The women are just keeping score, and the men have to get a certain number of points, from what I can tell. That actually led me to believe that Valerie isn't the worst. Joanna's the worst, because Valerie is just following the advice she read in Joanna's books. Also, TV exec guy is shipping Ted and Joanna hard. He has a son who's an eligible bachelor, and he's about to hire this woman.

Bran: How much do you have to either (a) hate your son, or (b) love the guy you just met?

Dan: I mean, he *loves* Ted. He's a big fan. He's like, "You gotta get together with Ted. It would be the last wish of my dead wife for you to get together with Not My Son."

CHRISTMAS IN ANGEL FALLS

PREMIERED DECEMBER 2, 2017,
ON HALLMARK MOVIES & MYSTERIES.

STARRING RACHEL BOSTON, PAUL GREENE,
AND BEAU BRIDGES.

WRITTEN BY MELISSA DE LA CRUZ.
DIRECTED BY BRADLEY WALSH.

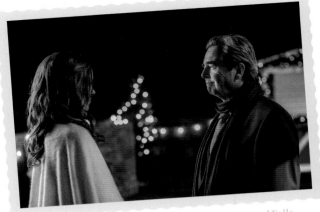

Rachel Boston and Beau Bridges in Christmas in Angel Falls

Gabby (Boston) is a cheerful angel sent by her boss Michael (Bridges) to restore the Christmas spirit to the town of Angel Falls, by bringing back its traditions and mending relationships among its citizens. Gabby gets lots of help from hunky firefighter Jack (Greene), and as she finds herself falling in love with him, it becomes clear that Michael's assignment isn't just about fixing Angel Falls; it's about Gabby deciding whether or not she wants to be human.

WAIT... WHAT?

Panda: Any choir scene in this movie gave me feels; when I was a kid in church, one of my favorite times of year as part of the children's choir was Christmas. We would always do what they called a Christmas cantata, and I would have some speaking roles. It was a lot of fun, if for no other reason than we would have extra practices in there. I actually enjoyed them, because we would always go outside and play afterward, and that was the main reason I wanted to be in the choir.

Dan: This is an adult choir, five people that just sing the melody.... It's just the worst choir I've seen on Hallmark ever.

Panda: OK, it might be really terrible, but maybe that's one of the reasons why I enjoyed it, because I'm not very good. And I realized that I could probably be a part of this choir.

Paul Greene and Rachel Boston in Christmas in Angel Falls

A producer that works for Hallmark talked to me and said, "I'd like to make a film with you." And he sent me a few ideas, and I wrote him back and said, "I've always wanted to make a movie about angels. Here are some ideas I have." And then we got Melissa de la Cruz involved and started developing a Christmas movie that changed quite a bit in the development process, but it turned into Angel Falls.*—Rachel Boston (Actress and Executive Producer)*

CHRISTMAS IN EVERGREEN

PREMIERED DECEMBER 2, 2017,
ON HALLMARK CHANNEL.

STARRING ASHLEY WILLIAMS,
TEDDY SEARS, HOLLY ROBINSON PEETE,
AND BARBARA NIVEN.

WRITTEN BY RICK GARMAN.
DIRECTED BY ALEX ZAMM.

Veterinarian Allie Shaw (Williams) is about to move from Evergreen, Vermont, to Washington, DC, where she has a new job and an old boyfriend, Spencer (Marcus Rosner). Her parents (Niven, Malcolm Stewart), who run the local diner—where the snow globe is said to grant wishes—are sad to see her go; so is Michelle (Robinson Peete), who has taken over Allie's duties running the annual Christmas festival and who is being driven crazy by the detail-oriented new mayor, Ezra (Chris Cope). Bad weather keeps Allie from flying out; it has also stranded Florida-bound Dr. Ryan Bellamy (Sears) and his young daughter, Zoe (Jaeda Lily Miller).

Panda: When Allie comes home, flips on the light switch, and there's a tree there waiting for her that Ryan put up because she hadn't gotten one yet. Impeccably decorated. That's some Balsam Hill stuff for you right there. I love that scene, because that was a very thoughtful move.

Dan: When did Hallmark switch? Because somewhere along the way, they switch from having really nice Christmas trees to . . . I feel like every movie we watched the season after this had a terrible Christmas tree in it. Not symmetrical, not full.

Bran: It depends on whether it's a Balsam Hill movie or not. If it's a Balsam Hill movie, they're going to have really nice trees. They're getting trees in August; it's tricky. The thing I love is that it's as if you're in a snow globe. The town of Evergreen takes place within the snow globe in Evergreen, if that makes sense. And I love the bit they do with the story and the narrator; that voice is great, and it gives you those feels.

Dan: The one thing I will say about the movie is that I feel like Allie's relationship with her mom is really genuine. Barbara Niven is great, Ashley Williams is great—I bought their relationship. I bought how close they were. That relationship works and screams more authenticity than the rest of the movie did to me.

Ashley Williams in Christmas in Evergreen

"LOVE THIS MOVIE; FUN AND WHIMSICAL."—Bran

"THE BEST OF WHAT HALLMARK DOES."—Panda

"ASHLEY WILLIAMS IS PLENTY CHARMING;
I COULD NOT STAND THIS MOVIE."—Dan

I really loved working with Barbara Niven and Holly Robinson Peete. Those women are awesome. I've been following Barbara Niven's career for years, and Holly Robinson Peete—oh my gosh, I mean, a hero of mine since the nineties. So getting to work with these, like, legends was really, really cool and different. And it became this girl mob—this group of girls who were also making this movie on top of hanging out. And I had a three-month-old. I was just starting a real family with a bunch of kids and a whole schedule, and I was an actress, and they gave the greatest advice. They were so kind to me. The memories I have from that experience were really awesome.—Ashley Williams

CHRISTMAS IN EVERGREEN:
BELLS ARE RINGING

PREMIERED DECEMBER 5, 2020,
ON HALLMARK CHANNEL.

STARRING RUKIYA BERNARD,
ANTONIO CAYONNE, HOLLY ROBINSON
PEETE, BARBARA NIVEN, ASHLEY WILLIAMS.

WRITTEN BY ZAC HUG AND SHARI SHARPE.
BASED ON CHARACTERS CREATED BY RICK GARMAN.
DIRECTED BY LINDA-LISA HAYTER.

Rukiya Bernard and Antonio Cayonne in
Christmas in Evergreen: Bells Are Ringing

It's another busy Christmas in the town of Evergreen, Vermont. Mayor Michelle (Robinson Peete) is getting ready for her upcoming wedding to Thomas (Colin Lawrence), even though a snowstorm has him trapped in Maine, and Hannah (Bernard) and Elliot (Cayonne) question the next step in their relationship, particularly after he gets the opportunity to expand his business to Boston. The town plans to open a Christmas museum in the old hat factory, but the factory's former manager is being a real Grinch about it. Some old friends return, and some new ones visit for the first time—including Bea (Colleen Winton), who's dating Michelle's dad, and who we're pretty sure is the same Bea who used to own the bookstore in *Hope at Christmas* (page 126), but no one knows for certain.

HOT TAKES

"WE'RE AT THE POINT WHERE EVERGREEN SHOULD GET ITS OWN TV SHOW, BECAUSE THEY TRY TO DO A LOT, AND WE DON'T GET ENOUGH TIME WITH ANYTHING."—*Bran*

"THE TOWN IS CHARMING, AND WE'VE GOTTEN TO KNOW THESE CHARACTERS, BUT THIS MOVIE FEELS ALL OVER THE PLACE, AND IT DIDN'T GEL FOR ME."—*Panda*

"SO, SO BAD, AND HAS THE MOST RIDICULOUS PLOTLINE I'VE EVER SEEN IN A HALLMARK MOVIE."—*Dan*

Bran: The hat guy is upset that he's the reason the business failed and not that—oh, I don't know—people don't buy top hats like they used to. He is under the impression that it is all his fault.

Dan: He says this line, I wrote it down: "If I really did the best I could, the hat factory would still be open." I think you did the best you could. There was no world where the Evergreen hat factory was going to make it.

Panda: I feel dumb. I have down as my What the Hallmark, "Why did the hat factory fail?"

Dan: Are you serious? You don't think it has anything to do with the fact that it's 2020 and not the Roaring Twenties?

Bran: Evergreen is a small town and, I don't know, people just didn't need hats anymore.

Panda: You don't think . . . I mean, you could create, like, ironically—

Dan: Oh, you think it could have been an ironic hat factory?

Bran: I do think there is some blame on him for not at least trying to evolve. You can argue that he did try to evolve, because when they open up the closet, there are some weird hats in there.

Dan: Is there room in Evergreen for a boutique, as in, "we make custom hats"? Yes. Not a hat factory.

Panda: So you're saying for mass production of hats, there's not room in Evergreen for a huge factory.

Dan: I don't know if it's a huge factory, because the museum is only one hallway.

CHRISTMAS IN EVERGREEN: LETTERS TO SANTA

PREMIERED NOVEMBER 18, 2018, ON HALLMARK CHANNEL.

STARRING JILL WAGNER, MARK DEKLIN, HOLLY ROBINSON PEETE, BARBARA NIVEN, AND RUKIYA BERNARD.

WRITTEN BY ZAC HUG, BASED ON CHARACTERS CREATED BY RICK GARMAN. DIRECTED BY SEAN MCNAMARA.

After putting it off for years, Lisa (Wagner) decides to spend Christmas in Evergreen, the small town where she lived until she was seven years old. On her way into town, she sees a familiar red truck and gets to know Kevin (Deklin), who's in town for a while and borrowing the truck from Allie. (See *Christmas in Evergreen*, page 52.) The general store where Lisa used to send her letters to Santa has closed; she decides to use her expertise to spruce up the space and attract a prospective buyer, with the help of Kevin.

WAIT... WHAT?

Panda: Listen, the project-management skills of these people? Troublesome. First of all, he's the only contractor in town, which ... I have questions. When they begin working on the general store, there's a pipe that burst, and they're asking, "Can we get this done by Saturday?" But then later on he goes, "We're not going to have time to set up two Christmas trees!"

Dan: But there's time to put garland in the gutters. And Kevin is only in town for a week, right? He's not the town contractor. You know what, Kev? Maybe less garland in the gutters and more fixing the HVAC vent hanging in the middle of Daisy's store. I don't understand why that's so hard for you to understand as a contractor.

Bran: They go out to visit Dad's farm, and the typewriter is sitting there. Just sitting out and about. What's that typewriter doing there, guys? It's outside!

Panda: The secretary uses it; she carries it around.

"SUPER FUN AND SUPER CHRISTMASY."
—*Bran*

"LOVED THIS MOVIE, ALTHOUGH THERE ARE SOME CLASSICALLY STUPID LINES."
—*Panda*

"NOT GOOD, BUT GREAT CHEMISTRY BETWEEN JILL WAGNER AND MARK DEKLIN."
—*Dan*

Barbara Niven and Holly Robinson Peete in *Christmas in Evergreen*

I mean, it's not just Hallmark that needs more diversity. It's pretty much every single network out there, including BET—they should diversify, too, in other ways, right? My whole attitude is, You're not changing the game unless you're playing the game, so that's been my M.O. The fact of the matter is, I love romantic comedies, so it's kind of an ideal network for me to work with, especially since they shoot here in my hometown, Vancouver. (It's not really my hometown—I'm from Toronto—but it's where I live.) It's a nice merging, and the more my face is out there, the more it's representing people that look like me.
—*Rukiya Bernard*

CHRISTMAS IN EVERGREEN:
TIDINGS OF JOY

PREMIERED NOVEMBER 29, 2019,
ON HALLMARK CHANNEL.

STARRING MAGGIE LAWSON, PAUL GREENE,
HOLLY ROBINSON PEETE, BARBARA NIVEN,
RUKIYA BERNARD, JILL WAGNER,
ASHLEY WILLIAMS, AND PATTY McCORMACK.

WRITTEN BY ZAC HUG, BASED ON CHARACTERS
CREATED BY RICK GARMAN.
DIRECTED BY SEAN McNAMARA.

Rukiya Bernard in Christmas at Evergreen: Tidings of Joy

In this follow-up to *Christmas in Evergreen* (page 52) and *Christmas in Evergreen: Letters to Santa* (page 56), New York writer Katie (Lawson) meets hometown boy Ben (Greene) on the Evergreen Express. The legendary Evergreen snow globe unlocks a mystery five decades in the making. Things are getting serious between mayor Michelle (Robinson Peete) and David (Marlon Kazadi), while David's sister Hannah (Bernard) is falling for her lifelong friend Elliot (Antonio Cayonne).

"MY LEAST FAVORITE OF THE EVERGREEN TRILOGY,
BUT IT STILL WORKS."—Bran

"GETS A PASS FROM ME SIMPLY BECAUSE IT'S PART OF A TRILOGY
THAT FORCES YOU TO GIVE A PASS IN GENERAL."—Panda

"DIMINISHING RETURNS; THIS MOVIE
IS AN ABOMINATION."—Dan

Dan: When does tourist season start in Evergreen? Because it's clearly December 1 when she shows up, Jill Wagner's talking about how nobody's coming to buy anything in the store, and they say, "Don't worry, tourist season will be here before you know it." And in a town like Evergreen, which is a snow globe—wouldn't you think that would start after Halloween?

Bran: The Hannah-Elliot love story was just straight fire. I have not seen that much chemistry. There were legit sparks. I was like, What is going to happen in this movie with them? We didn't get a ton, and I'm saddened by that. All the scenes of them putting the snow globe together, blowing the glass, playing the piano together. They need their own movie. Anytime they were on screen together, I had feels.

Panda: Early on, you get Ashley, Jill, and Maggie Lawson, all of whom I'm a big fan of. I was really hoping that all three would be in the movie more. And then that one scene was it, and it kind of left me sad.

Dan: I don't really have any feels. I mean, I guess the Hannah-Elliot stuff was not bad. I wanted them to get together, but I knew they were going to get undersold, and they did. It would have been cool had everybody been able to show up at the same time for Evergreen, but they couldn't make it happen. They couldn't get Mark Deklin in there with everybody else.

Bran: I am fairly certain they took a scene of Mark Deklin...

Dan: From the second one!

Panda: And then Jill runs to him, and then they cut, so there's no hug.

Holly Robinson Peete, Maggie Lawson, Paul Greene, and Marlon Kazadi (back to camera) in Christmas in Evergreen: Tidings of Joy

Staying in BFF-land is daunting, I'll be honest. And on a personal level, you want to grow your career. I've been so grateful that Hallmark has recognized my passion—I like rom-coms, so it's been nice to be moving into story-arc world, where your character has an arc, and there's a journey that she goes on. I'd like to do more of that, and I'm curious to see what the future is going to bring.—Rukiya Bernard

CHRISTMAS IN LOVE

WITH GUEST ROBYN ROSS,
ENTERTAINMENT WEEKLY

PREMIERED NOVEMBER 11, 2018,
ON HALLMARK CHANNEL.

STARRING BROOKE D'ORSAY
AND DANIEL LISSING.

WRITTEN BY STEPHEN A. STEWART AND
BOB SÁENZ. DIRECTED BY DON MCBREARTY.

Ellie (D'Orsay) lives in the small town of White Deer and works at the local Carlingson's bakery, famous for its holiday kringles pastries and as the employer of most of the town. The CEO of Carlingson's, in the main office in San Francisco, sends his son Nick (Lissing) to work at the factory undercover so he can get to know the employees of the company that will one day be his to run.

Panda: There's one bakery. And they have corporate offices in San Francisco. I have questions.

Dan: This is the Wait, What of the film, and I'm glad you brought it up. Mr. Carlingson does not live in the city where all of his baked goods are made. But he believes that he's a small-town guy, I guess? And also, could they say "corporate" a few more times in this movie? It's the equivalent of *Glee* and "regionals"; every time we turn around, they're saying "corporate." We get it.

Panda: If they're trying to save money, it feels like not having your corporate offices on the other side of the country would make sense. The other Wait, What to me is actually probably one of the more corporate things you could do: they have the charity dinner, but it's at the craft fair, surrounded by high-end crafts that no one can afford. It's like, "Hey guys, here's your free dinner, but you can't afford the crafts because you're poor."

Robyn: I have a follow-up question to the part about the bakery: does every single person in the town work for the bakery? When Nick gave the big speech at the Christmas tree lighting, everyone was like, "Yay," as if they're all part of it. And if you didn't work at the bakery, are you like, "What is happening; I don't care"?

Dan: "What's going on over there?" "Some bakery, their jobs are saved."

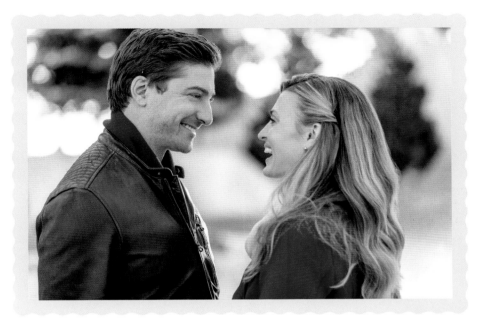

Daniel Lissing and Brooke D'Orsay in Christmas in Love

"LIKED, DID NOT LOVE; SOMETIMES I THINK THEY PUT BAKING IN WHEN THEY CAN'T THINK OF ANYTHING ELSE."—Bran

"LIKED; THERE WAS SOME GOOD CHARACTER DEVELOPMENT."—Panda

"GENERIC, DOWN TO THE TITLE."—Dan

"THE LEAD ACTRESS WAS CHARMING AND DELIGHTFUL; LISSING WAS THE TYPICAL MALE LEAD WHERE YOU'RE LIKE, HAVE I SEEN THAT GUY IN ANYTHING ELSE? MAYBE IN OTHER HALLMARK THINGS?"—Robyn

CHRISTMAS IN MONTANA

PREMIERED DECEMBER 14, 2019,
ON HALLMARK MOVIES & MYSTERIES.

STARRING KELLIE MARTIN,
COLIN FERGUSON, AND ART HINDLE.

WRITTEN BY JULIE SHERMAN WOLFE.
DIRECTED BY T. W. PEACOCKE.

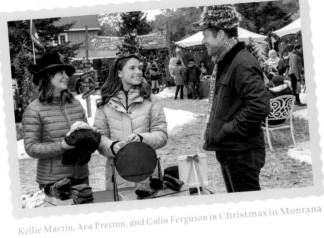

Kellie Martin, Ava Preston, and Colin Ferguson in Christmas in Montana

Single mom Sara (Martin) is sent to Montana by her L.A.-based bank to evaluate a second-mortgage application filed by rancher Travis (Ferguson). Can she convince him that turning his property into a Christmas ranch is the best way to stay afloat?

"SNOOZER."—Bran "SNOOZER."—Panda

"TOO BORING TO BE THE WORST."—Dan

"THIS MOVIE COULD HAVE USED A CRYSTAL-DANCE SCENE." (SEE "BIRTH OF A BIT," PAGE 21.)—Bran

"YOU STIR IT ONCE, YOU SHAKE IT TWICE, YOU SIGN RIGHT HERE, *IT'S A CHRISTMAS RANCH!*"—Dan

Panda: I want to know who folded the napkins at Steven's, the fancy restaurant. It's this kind of movie—that was the question that came to mind. I was looking at the napkins and thought, "Ooh, that's a fun fold."

Dan: If you've not seen this movie, and you're thinking that Pandolph's napkin-fold What the Hallmark sucks—it's not his fault. It's that kind of movie.

CHRISTMAS IN ROME

PREMIERED NOVEMBER 30, 2019, ON HALLMARK CHANNEL.

STARRING LACEY CHABERT, SAM PAGE, AND FRANCO NERO.

WRITTEN BY GREGG ROSSEN, BRIAN SAWYER, AND ALEX WRIGHT. DIRECTED BY ERNIE BARBARASH.

Angela (Chabert) is an American working as a tour guide in Rome. She's just been fired by a tourist agency, but her dream is to strike out on her own, taking people on individually crafted excursions through the Eternal City. Business guy Oliver (Page) is in town, hoping to acquire a centuries-old family business from Luigi (Nero) on behalf of his corporate employers. Luigi says he won't sell until Oliver has fallen in love with Rome, so Oliver hires Angela to take him around and show him the sights.

ALL THE FEELS

Bran: No Christmas feels for Bran. I did get Vespa feels. I really, really want a scoot.

Panda: This might be the first time I haven't gotten a feel in a movie. I got one bread feel—they pan past some bread, and it looked good. I haven't had a lot of bread lately. I would like to eat that bread.

Dan: I got some angry feels in this movie, which I'd love to share with you. Look, Hallmark has done a great job of mimicking this podcast and being completely areligious. We don't talk about religion on the pod. Hallmark doesn't talk about religion in their movies; it seems to be a formula that works for everyone involved. Having said that, if Candace Cameron Bure in all her movies can talk about angels and God and faith and hope, then a movie set in Rome, where the Vatican is, might at least mention Catholicism and Christianity. If you google "Christmas in Rome," you know what you're going to find? A bunch of nativity scenes. The inflatable-Santa-to-nativity-scene ratio was off the charts in this movie.

Lacey Chabert in Christmas in Rome

"NO AMOUNT OF NOT-GREAT STORY CAN BE MADE UP WITH JUST BEING IN ROME."
—*Bran*

"I ACTIVELY HATE THIS MOVIE."
—*Panda*

"TERRIBLE; HALLMARK ISN'T EQUIPPED TO MAKE A $2 MILLION PICTURE AFTER HAVING TO FLY LACEY CHABERT'S FAMILY AND LODGE THEM IN ROME FOR A WEEK."
—*Dan*

CHRISTMAS JOY

PREMIERED NOVEMBER 3, 2018,
ON HALLMARK CHANNEL.

STARRING DANIELLE PANABAKER,
MATT LONG, AND SUSAN HOGAN.

WRITTEN BY JENNIFER MAISEL AND TRACY ANDREEN,
BASED ON THE NOVEL BY NANCY NAIGLE.
DIRECTED BY MONIKA MITCHELL.

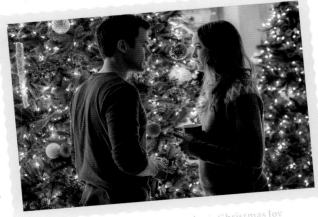

Matt Long and Danielle Panabaker in Christmas Joy

Joy (Panabaker) works in Washington, DC, but she comes home to North Carolina for Christmas when her aunt falls off a ladder. And with her aunt bedridden through the Christmas season, it's up to Joy—with the help of her high school chum Ben (Long)—to take her place in the cookie crawl, an annual open-house event that the aunt has won for the last several years.

"BAD, BORING, DIDN'T UNDERSTAND THE PREMISE."—*Bran*

"FINE BUT NOT GOOD; THE STAKES REALLY COULDN'T BE LOWER."—*Panda*

"LAUGHABLE, HILARIOUS, MEMORABLE—AND ONE
OF THE WORST I'VE EVER SEEN."—*Dan*

Panda: They spend a lot of energy on trying to figure out a theme for the cookie crawl. And I want to point out it's six days before the cookie crawl. Aunt Ruby is clearly organized. Ruby's not dead, guys, she has broken her ankle—and they could have legitimately just asked, "Hey, Ruby, what was the theme you had planned?"

Dan: Let's just camp out on Ruby for a second. Yeah, first of all, six days out. She's not planned a theme yet. You suck at this Ruby, sorry. I can't believe you're the five-time Golden Wreath award winner, whatever it is; you're bad. Second of all, it's a broken ankle, not typhoid fever. Can we just establish that unless there are other serious health concerns, with a broken ankle, you go home the same day from the hospital? And if you spend the night—which you might—you definitely don't go to an overnight inpatient rehab facility for six more days and then leave walking like you've never had the injury.

Bran: But she did have a cane afterward, for one scene, and then she's like, "I don't need this cane!"

A CHRISTMAS LOVE STORY

WITH GUEST WILLIAM "BIBBS" BIBBIANI,
CRITICALLY ACCLAIMED PODCAST

PREMIERED DECEMBER 7, 2019,
ON HALLMARK CHANNEL.

STARRING KRISTIN CHENOWETH
AND SCOTT WOLF.

WRITTEN BY NICOLE BAXTER.
DIRECTED BY ERIC CLOSE.

Katherine (Chenoweth) once wrote and starred in a hit Broadway musical; now she conducts a youth choir and is preparing for their annual Christmas concert. She has to write a new Christmas song, and one of her male singers has gotten sick. Danny (Kevin Quinn) shows up to volunteer for the day; when it turns out he has a great singing voice, Katherine invites him to join the choir. That doesn't play well with Danny's widowed father, Greg (Wolf), who wants Danny to concentrate on getting into college.

Bibbs: This is a very sweet movie. I like it. But this is one of those Hallmark movies where if you tilt your head ever so slightly, it becomes a horror film. Movie starts, they zoom in, and she's conducting the choir, and then the camera awkwardly cuts to one guy coughing, and I remember thinking, "Oh, he's going to die." Like, that's the plot of this movie. But it turns out, he gets sick, and that's why Danny is able to sort of fill in; they need a tenor really, really fast. And then you realize that Danny isn't there by chance—Danny came on purpose to insinuate himself into his biological mother's life. Danny infected that boy with some sort of virus. That's my theory. And then Scott Wolf has a couple of moments where he also makes it really weird. They light up their terrible Christmas tree, and Kristin Chenoweth goes, "Oh, it's beautiful!" And then he looks at her with the intensity of a serial killer and says, "*Yes. It is.*" She's an "it" to Scott Wolf right now. That's very disturbing. I know it's unintentional, because of course, it's Hallmark. But there's an alternate take on this which is maybe going on at the exact same time, where this is actually very sinister, and a part of me wants to see that version, I'm not gonna lie.

Bran: That puts to shame mine, which is, just what's going on with the famous eggnog martini? What makes it famous? But after that, who cares about the martini?

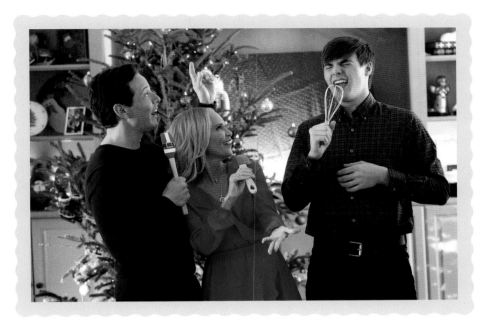

Scott Wolf, Kristin Chenoweth, and Kevin Quinn in A Christmas Love Story

"LOVE THIS MOVIE, I CRIED."—Bran

"I DON'T KNOW WHAT MORE YOU COULD WANT."—Panda

"BETTER-MADE THAN YOUR AVERAGE
HALLMARK MOVIE."—Dan

"TWO HALLMARK MOVIES TRYING
TO FIGHT EACH OTHER."—Bibbs

CHRISTMAS MADE TO ORDER

WITH GUEST DOUG JONES,
ACTOR, THE SHAPE OF WATER

PREMIERED DECEMBER 23, 2018,
ON HALLMARK CHANNEL.

STARRING ALEXA PENAVEGA
AND JONATHAN BENNETT.

WRITTEN BY MATT MARX AND ANNA WHITE.
DIRECTED BY SAM IRVIN.

Steven (Bennett) is on the partner track at his architecture firm. (His boss is played by Jo Marie Payton of *Family Matters*.) A water pipe bursts in Steven's sister's house, so the entire family is coming to spend Christmas with him in Salt Lake City. Since he's focused on work and not the holidays, he hires Christmas decorator Gretchen (PenaVega) to hang the holly; before long, Gretchen has become the family's Christmas coach, making cookies and cider and taking everyone out to eat holiday treats and to see the lights.

Panda: The very first one I have to point out was one of the scariest scenes in a movie we've watched this Hallmark year: she's on a ladder in high-heeled shoes. That is terrifying. And that's a terrible idea. Also, she's a terrible decorator.

Dan: It's almost like Hallmark makes sure that whatever their protagonist's profession is, they're actually really bad at it. It doesn't make any sense. It's like, "I'm Winnie Cooper, and I'm an artist!" (See *Christmas at Grand Valley*, page 30.) No, you're not. You're real bad.

Doug: He's on his way to a partnership in an architecture firm, right? Gretchen is on her way to two job offers, then she gets the interview for Steven's company to decorate as her own company. And then at the end, both of them have trashed their former lives to follow their dreams. Ain't nobody got a job!

"HALFWAY LOVE; DIDN'T FULFILL ITS POTENTIAL."
—Bran

"REALLY FUN, BUT AS A WHOLE, PRETTY DUMB."
—Panda

**"FACEPLANT; IT REALLY SHOULD HAVE
BEEN A HORROR MOVIE."**
—Dan

**"I LOVED IT FOR ALL THE FAMILY FEELS, THREE
GENERATIONS IN ONE ROOM."**
—Doug

Doug: The two conversations that Steven had with his mom. I love the late-night scenes when it's like, "Oh you're up? What are you doing up, Mom?" "Oh, I'm making you some cocoa." If I could walk downstairs in my kitchen right now and see my mom again making me cocoa, I would just melt.

Bran: This is going to sound really dumb—it's only because it's Harriette Winslow, and I loved *Family Matters* growing up. But the scene where he gets declined on his modern architect thing, and I was expecting her to be like, "You gotta get better if you want to be part of the firm," but she was very encouraging, and I love a good, encouraging boss. If you're a boss out there, as somebody who's not a boss, the times that I get encouragement, it goes so far.

A CHRISTMAS MELODY

PREMIERED DECEMBER 19, 2015,
ON HALLMARK CHANNEL.

STARRING LACEY CHABERT,
BRENNAN ELLIOTT, KATHY NAJIMY,
KEVIN CHAMBERLIN, AND MARIAH CAREY.

WRITTEN BY JENNIFER NOTAS SHAPIRO.
DIRECTED BY MARIAH CAREY.

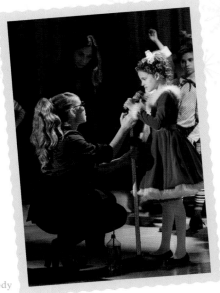

Mariah Carey directs Fina Strazza in A Christmas Melody

Single-mom fashion designer Kristin (Chabert) returns to her Ohio hometown after her boutique goes out of business. Her musically inclined daughter preps for the big Snowflake Pageant with music teacher Danny (Elliott), who's always carried a torch for Kristin. A classmate she's less thrilled about running into is Melissa (Carey), still a snotty mean girl after all these years.

**"LOVE EVERYTHING ABOUT THIS MOVIE
EXCEPT THE MOVIE ITSELF."**
—Bran

"KIND OF BORING."
—Panda

"ACTIVELY BAD, AND MARIAH CAREY IS TERRIBLE."
—Dan

Mariah is adorable and sweet and amazing. But when you're the biggest musical icon on Earth, still living—she's a huge star, and she's been doing that for thirty years, so I think she's in her world. And there are so many things going on that, you know, taking three weeks out of your schedule to go direct a movie might be a little tough. I think that maybe at the time, she was like, "Wow, I gotta be here all day?" But see, then she was there. And she'd never directed before—she did some videos, but this was her first time directing. She was wonderful. She was engaged in the scene. She would give us notes; she would try things. I have nothing negative to say about her directing.—Brennan Elliott

Dan: Santa says, "I hear this year's Snowflake Pageant is going to be one of the best ones ever."

Bran: "Last year, oof!"

Panda: I have questions about how the program is funded and why everyone is so concerned about raising money for this. I understand why they want to raise money. But Mariah goes, "If it's not good, keep in mind, the whole pageant funds the entire music program for the entire year." Here's my thing: does anyone go to a school pageant, paying money for the ticket, and expect it to be anything other than trash that your kid's in? And you sit there, and you're like, Yaaaaay, my kid. The expectations are immediately lower.

Dan: How do you have Mariah Carey in a movie, and she doesn't sing? For crying out loud, Kellie Pickler sang in *Christmas at Graceland* (page 26), and she can't sing! How is Mariah Carey not at least belting out a few bars? She literally sings probably the most-played Christmas song on the radio every season. Nah, let's just have her do bad acting on a green screen and kind of interpose it into the movie.

Brennan Elliott in *A Christmas Melody*

A CHRISTMAS MIRACLE

PREMIERED NOVEMBER 14, 2019,
ON HALLMARK MOVIES & MYSTERIES.

STARRING TAMERA MOWRY-HOUSLEY,
BROOKS DARNELL, AND BARRY BOSTWICK.

WRITTEN BY MARK AMATO.
DIRECTED BY TIBOR TAKÁCS.

Single mom Emma (Mowry-Housley) works as an assistant at a magazine and pitches her boss a story about real-life Christmas miracles; the boss rejects it, but later, Emma hears her boss pitch the idea as her own to a higher-up. Deciding to tackle the story herself, Emma begins researching Santa Dean (Bostwick), a popular local busker. She realizes that he once had a jazz career as part of a trio, and with the help of Marcus (Darnell), a photographer at the magazine, she sets out to reunite Dean with his former bandmates and his estranged daughter in time for Christmas.

WHAT THE HALLMARK?

Panda: I want to know more about the Wanamaker Trio. They have an album called *Everything Goes*. I mean, that sounds like a bonkers album if *everything* is able to go.

Bran: What's crazy is they're a jazz band, and things are pretty loosey-goosey. But imagine an album where *everything* goes. We take even the few rules we have in jazz, throw them out the window.

Dan: Once again, we had a tree decoration scene which starts with nothing on the tree. Let's put a ribbon in the middle of it, and start from there. What are we doing: no lights, no ornaments, ribbon center, start wrapping. I'm not OCD at all, and that drives me crazy.

Bran: Regardless of if you start with the lights at the top or the bottom, you do not start with a ribbon in the middle before the lights. You can't!

Panda: You wouldn't.

Bran: You shouldn't.

Dan: That is the *Everything Goes* of decorating.

Tamera Mowry-Housley, Brooks Darnell, and Barry Bostwick in A Christmas Miracle

"MIDDLE OF THE PACK; THE MUSIC WASN'T UP TO SNUFF."
—Bran

"TURNED AROUND IN THE SECOND HALF WITH A REALLY NEAT PLOT POINT."—Panda

"DUH-DUH-DUMPSTER FIRE; THE GUY WHO PLAYS MARCUS IS SUPER CHARMING, BUT HE TALKS LIKE HE'S JUST ALWAYS ABOUT TO TELL YOU A BORING SECRET."
—Dan

CHRISTMAS NEXT DOOR

WITH GUEST JONATHAN SHAPIRO, WRITER-PRODUCER, THE BLACKLIST, GOLIATH

PREMIERED DECEMBER 16, 2017,
ON HALLMARK CHANNEL.

STARRING FIONA GUBELMANN
AND JESSE METCALFE.

WRITTEN BY JUDITH BERG AND SANDRA BERG.
DIRECTED BY JONATHAN WRIGHT.

(Center, L to R) Brittany Bristow, Jesse Metcalfe, and Fiona Gubelmann in Christmas Next Door

April (Gubelmann) is a violin teacher whose stage fright over auditions has hampered her philharmonic dreams. Her neighbor Eric (Metcalfe) writes best-selling books about the glories of bachelor living, but when his mother feigns having the flu and foists a young niece and nephew on him, Eric has to get a crash course in celebrating Christmas.

"HAS STUCK WITH ME, MAYBE BECAUSE OF THE ABSURDITY."
—Bran

"FUN PLOT, GUY WHO'S A BACHELOR HAVING TO WATCH KIDS."
—Panda

"NORMALLY A FISH-OUT-OF-WATER PLOT LENDS
SOME NUANCE, BUT NO."
—Dan

"NOT THE MOST PAINFUL THING I'VE EVER EXPERIENCED,
BUT TO BE FAIR, I WAS STUNG IN THE CROTCH BY
A PORTUGUESE MAN-OF-WAR."
—Jonathan

Panda: At one point, the kids come out, and Jesse pulls up in a sports car. They *do not* want to ride in the cool sports car and opt instead to ride in their mom's minivan. There is not a child on Earth that would say, "You know what, I'm out. I'm out on the sports car, in for the minivan." And if there is a child like that, I don't want to be around them. Is that a terrible thing to say? I don't want to be around the kids if they want to be in the minivan.

Jonathan: Somebody is leaving Christmas ornaments on the guy's lawn, which looks like a Superfund toxic site that nobody should be near, by the way. They're ninety-nine-cent reject Christmas ornaments. Are they insulting him? Is this some kind of a hate crime? Secondly, if somebody coughs down the street, they hear it in their bedroom. I don't think this is a neighborhood; I think this is a work camp of some kind.

Bran: This movie was clearly written for an apartment, but they couldn't figure out, "Why is this bachelor who's a best-selling author living in an apartment?"

Dan: Maybe if it was in an apartment, we would have questioned Jesse Metcalfe's salary, but now we're stuck questioning the salary of an evening restaurant violinist with a three-thousand-square-foot house. She plays violin to unsuspecting guests trying to eat and makes enough money to afford that house. There's just no way. And is his new book on how to not be a bachelor really just a pamphlet? The guy is holding the pages, and unless he single-spaced . . .

Bran: All it says is, "Fall in love." That's it.

CHRISTMAS ON HONEYSUCKLE LANE

WITH GUEST BRIAN EARL,
CHRISTMAS PAST PODCAST

PREMIERED NOVEMBER 24, 2018,
ON HALLMARK MOVIES & MYSTERIES.

STARRING ALICIA WITT, COLIN FERGUSON,
AND LAURA LEIGHTON.

WRITTEN BY CAITLIN D. FRYERS,
BASED ON THE NOVEL
THE HOUSE ON HONEYSUCKLE LANE,
BY MARY MCDONOUGH.
DIRECTED BY MAGGIE GREENWALD.

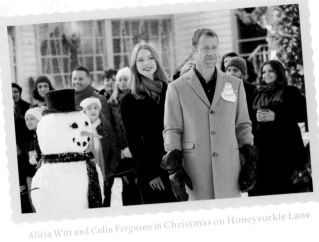

Alicia Witt and Colin Ferguson in Christmas on Honeysuckle Lane

Lawyer Emma (Witt) hasn't been home in a long time, but since her brother and sister are planning to sell the family house, they are all gathering there for one last Christmas. Emma meets Morgan (Ferguson), a historian and appraiser who comes over to help sell the antique furniture. In a desk that belonged to her mother, Emma finds a cache of love letters—written by a man who was not her father.

"LOVE IT; I'M NOT A HUGE ALICIA WITT FAN, BUT IN
THIS MOVIE, SHE WORKS FOR ME."
—Bran

"ENTIRELY CARRIED BY ALICIA WITT AND THE MAYTAG GUY."
—Panda

"NOT A FAN; THIS MOVIE NEVER REALLY MESHED FOR ME."
—Dan

"MY FIRST HALLMARK MOVIE—I WAS PLEASANTLY SURPRISED."
—Brian

Brian: I'm from New England, and the house that they lived in is not unlike a house that was in the town I grew up in. Every year, it was the house everyone went to look at around Christmastime. Around this time of year, living out in California, I start to feel homesick for the New England winters and the New England Christmas, so right when I saw that, it was very triggering to me.

Panda: It's not a good feel, but when the boyfriend Ian (John Palladino) comes in and cooks gluten-free pancakes for everybody, and everyone's like, "Wow, these pancakes are terrible." And he goes, "Oh, but Emma likes them." And then Emma in front of everyone just throws him under the bus and says, "Actually, I've always hated these pancakes."

Dan: To be fair, Ian does not ever read the room correctly. He just has no ability to do that at all. "Hey, don't show up." "I'm showing up." "Here's your favorite pancake." "Not my favorite." "Here's a ring." "I don't want to marry you." "Shovin' it on your finger anyway." He is just striking out like you would not believe.

Bran: She goes into the attic and smells garland—which shouldn't really have a smell but it does, I guess—and she has a memory of something, and that reminded me of the smells that I smelled during Christmastime. That reminded me of the joy that I had as a kid.

Dan: When Emma finds the letters written to her mother, she initially believes that they are from her father, and it turns out they are not. My grandfather was a twenty-three-year veteran in the army. He passed away in 2015. And I remember the day of his funeral, my grandmother said, "Anything in his closet you want, you gotta take it." So I'm digging through his closet, and I find this shoebox. And it's letters. They look just like the letters in the movie, and they were all letters that he wrote to my grandmother when he was in Vietnam. They were married for sixty-five years. And I just remember sitting on the bed and reading these letters and just bawling my eyes out, to think of my grandfather in that light. When the letters came out, and she started reading them, I just was like, This is so cool, and it reminded me of that moment.

CHRISTMAS ON MY MIND

PREMIERED DECEMBER 21, 2019,
ON HALLMARK MOVIES & MYSTERIES.

STARRING ASHLEY GREENE,
ANDREW WALKER, AND JACKÉE HARRY.

WRITTEN BY KIRSTEN HANSEN, BASED ON THE
NOVEL *THE GOODBYE BRIDE*, BY DENISE HUNTER.
DIRECTED BY MACLAIN NELSON.

Andrew Walker and Ashley Greene in Christmas on My Mind

Lucy (Greene) is running down the street, wedding dress in hand, when she slips on the ice and hits her head. She heads back to her hometown to be with Zach (Walker), her fiancé; she is shocked to learn that they broke up two years ago. Zach takes her to Dr. Albright (Harry), who diagnoses retrograde amnesia. Lucy stays in town in an attempt to reconstruct what made her leave her home, and Zach, behind; following her out there from the city is her assistant, Anna (Donna Benedicto), and Lucy's current fiancé, Brad (Clayton Chitty).

"FUN, BUT THE WHOLE THING—THE BREAKUP AND HER BEING MAD ABOUT IT—IS REALLY DUMB."—Bran

"BETTER THAN *MERRY & BRIGHT* (PAGE 153), BUT REALLY BORING."—Panda

"GOOD IDEA FOR A MOVIE, AND A GOOD CAST, BUT THE MYSTERY AMOUNTS TO NOTHING—TERRIBLE."—Dan

Panda: We're talking a major head injury, enough to cause retrograde amnesia. Even though it is something that can be recovered from, that's a jarring blow. She ends up going to the hospital, and Zach is the one who takes her there. But when she's being delivered the medical news, Zach's just chilling out in the room with her. That's not how hospitals work.

Dan: I just want to say a phrase for you: Dr. Jackée Harry. I could not take a single line she said seriously. And lastly, the tree is all ball ornaments, and they put their one dove on there, and it drove me absolutely bonkers. I'm a fan of all ornaments, but if you have an all-ball ornament tree, don't put one other ornament on there.

CHRISTMAS SCAVENGER HUNT

PREMIERED NOVEMBER 3, 2019,
ON HALLMARK CHANNEL.

STARRING KIM SHAW, KEVIN McGARRY,
AND TOM ARNOLD.

WRITTEN BY TAMMY KLEMBITH AND
GEORGE KLEMBITH AND BARBARA KYMLICKA.
DIRECTED BY MJ GRABIAK.

Tom Arnold, Kim Shaw, and Kevin McGarry in Christmas Scavenger Hunt

Real estate agent Belinda (Shaw) returns to her hometown for Christmas, partially to spend time with her father, Carl (Arnold), but also because her firm wants to buy the old museum in her town so they can turn it into condominiums. She bumps into ex-boyfriend Dustin (McGarry) and winds up being his teammate in the town's annual Christmas scavenger hunt.

"FUN PREMISE, COULD HAVE BEEN FANTASTIC, NOT QUITE THERE."—*Bran*

"NOT HORRIBLE, BUT IT'S GOING TO BE REMEMBERED SIMPLY BECAUSE TOM ARNOLD'S IN IT."—*Panda*

"GOOD IDEA, TERRIBLE MOVIE, AND THE SCAVENGER HUNT IS AN AFTERTHOUGHT."—*Dan*

Bran: How do you win the scavenger hunt? It appears as if Tom Arnold looked at all the pictures that were sent in and judged the gingerbread houses and the Christmas tree and the cookies and the random act of kindness and the snowman and chose who he thought did it the best. But again, a scavenger hunt is you have the list of things, you do them, and whoever gets it done first wins.

Panda: There seems to be a lot of angst around this museum. I don't know any museum in the entire US that creates as much anxiety about potentially closing. And that's the term they use, actually: "We can't announce that the museum might be closing down, or it might really ruin everyone's holidays." If you told me the Louvre was closing down, I'd be like, "Aaaaw, that stinks," but it wouldn't ruin my Christmas!

CHRISTMAS TOWN

PREMIERED DECEMBER 1, 2019,
ON HALLMARK CHANNEL.

STARRING CANDACE CAMERON BURE,
TIM ROZON, AND BETH BRODERICK.

WRITTEN BY DONALD MARTIN AND WESLEY BISHOP,
BASED ON THE NOVEL *THE CHRISTMAS TOWN*, BY
DONNA VANLIERE. DIRECTED BY DAVID WEAVER.

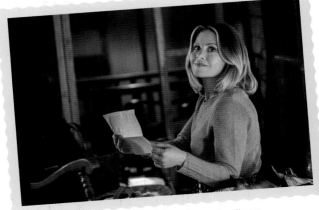

Candace Cameron Bure in Christmas Town

On her way from Boston to Springfield for her first teaching gig, Lauren (Cameron Bure) winds up in the town of Grandin Falls. There's a lot in the town that takes her back to her own childhood, from the locally produced Christmas angel that her father put on their tree to young foster child Dylan (Jesse Filkow), who reminds Lauren of her own experience in foster care after the death of her parents. As Lauren grows close to Dylan's foster father, Travis (Rozon), she begins to contemplate staying in Grandin Falls.

Dan: I hate that this is a Wait, What, because it's about adoption. Look, I highly encourage you to open up your home to foster kids. And if you feel so led, and you feel like you can provide the care to adopt kids out of the Department of Social Services, that is a calling, and I think you should look into it. Having said that, they do not just give any rando on the street living in the roof of somebody's antique store a kid. There's a lot of red tape. There are several applications; you have to show up for no less than sixteen hours of parenting classes. There is a fire marshal who comes to your house and does a full check. You have to show your bank account to show you have money to provide for this child. You have to show your lodging.

Bran: That attic above the antique store is not passing.

Bran: Grandin Falls gave me feels. It is second in the list of awesome Christmas towns. Obviously, Evergreen (*Christmas in Evergreen*, page 52) is number one. It'll never be beat. Anytime those types of towns happen, I have feels. I want to live in it.

Panda: Let me tell you something that gave me some feels: the letters that her dad wrote to her before he passed. I am a sucker for the *P.S. I Love You* genre. I like that movie.

Dan: It's amazing how in tune her dead father is with her emotions, considering how much of an absentee father he was. Because every letter she reads is written for that specific circumstance.

Bran: We joked about it, but I wouldn't have been surprised if she got a letter that said, "Hi. I know that you're about to adopt a child that you just met, and I want you to know that I am for that, and for you, and it's great. And I love you. Merry Christmas."

THE CHRISTMAS TRAIN

PREMIERED NOVEMBER 25, 2017,
ON HALLMARK CHANNEL AND HALLMARK
MOVIES & MYSTERIES.

STARRING DERMOT MULRONEY,
KIMBERLY WILLIAMS-PAISLEY,
DANNY GLOVER, JOAN CUSACK,
AND NELSON WONG.

WRITTEN BY NEAL DOBROFSKY
AND TIPPI DOBROFSKY, BASED ON THE NOVEL
BY DAVID BALDUCCI. DIRECTED BY RON OLIVER.

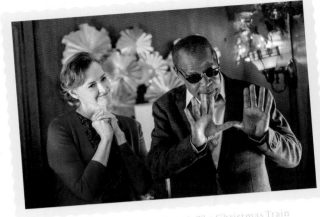

Joan Cusack and Danny Glover in The Christmas Train

Writer Tom (Mulroney) takes the DC-to-L.A. Christmas train to see his actress girlfriend in Los Angeles. Who should be on board the train but his ex, Eleanor (Williams-Paisley), who is collaborating on a screenplay with A-list Hollywood director-producer Max Power (Glover). Also, a bartender named Kenny (Wong; see "Across the Kennyverse," page 128).

HOT TAKES

"FUN, BUT THE SECOND TIME, YOU CATCH MORE OF THE GAPS."—Bran

"FINE, BUT KIND OF A TOUGH SLOG—THE M. NIGHT SHYAMALAN OF CHRISTMAS MOVIES."—Panda

"THE CAST DOES ELEVATE THE MATERIAL, AND THE MATERIAL, MAKE NO MISTAKE, IS TERRIBLE."—Dan

ALL THE FEELS

Panda: For me, it was the Christmas dance that they get off the train for. I love the shopping in the little holiday town there. I felt Christmasy all throughout this film; it gave me a lot of the feels. I love the train—the train's great! I would want to ride on that train.

Dan: I'm not a train enthusiast per se. DC to L.A. in four days, on a train, not happening.

Bran: I don't know what it was; this movie didn't do much for me on the feels.

Dan: I don't even know you anymore.

 Wait... What?

Panda: The bartender says at the very beginning that he's going to make a drink called the Grinch, and if you hear of a drink called the Grinch, what color is that drink?

Bran and Dan: It's green.

Panda: That drink was clear! It's a clear Grinch! That was the most preposterous drink I've ever seen in my life.

Dan: I'm going to piggyback on that: I don't think the bartender knows what alcohol is or what it does. The first time he goes, "I'm going to make you a Grinch. Have one, and you're going to think it's Christmas every day," which implies he thinks it's going to make you wasted for life.

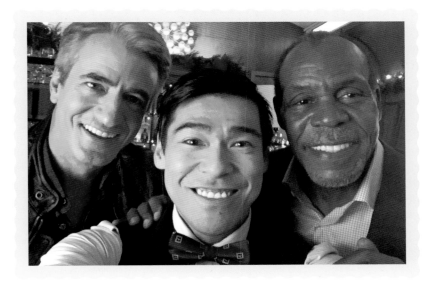

Dermot Mulroney, Nelson Wong, and Danny Glover on the set of
The Christmas Train (Photo courtesy of Nelson Wong)

It's great; I just soak it up. When Ron's in town making a movie, it's always exciting to get to visit my friend and to see him work, but to then be a part of it is extremely exciting. It's the best film school I can imagine. I've got all these greats working around me. Christmas Train *was a hoot, getting to work with Dermot Mulroney and Joan Cusack and Danny Glover. But every single set is like that, with all the different talent that comes on board.—Nelson Wong (On Working with Director Ron Oliver)*

CHRISTMAS UNDER THE STARS

PREMIERED NOVEMBER 16, 2019,
ON HALLMARK CHANNEL.

STARRING AUTUMN REESER,
JESSE METCALFE, AND CLARKE PETERS.

WRITTEN BY JAMIE PACHINO,
BASED ON THE NOVEL *THE CHRISTMAS TREE LOT*,
BY RIKK DUNLAP. DIRECTED BY ALLAN HARMON.

Schoolteacher and single mom Julie (Reeser) is preparing for her first Christmas since the death of her father; his medical bills have left her with debt and bureaucratic red tape. Slick finance guy Nick (Metcalfe) gets fired from his job and winds up working at a Christmas tree lot run by Clem (Peters), an old friend of Julie's father. Julie and her son are frequent visitors to the lot, and she grows close to Nick—until she learns that his former firm is the company managing her father's medical debt and making her life difficult.

ALL THE FEELS

Bran: For me, it's this line that Clem says to Nick: "If you think you love a woman, don't waste time. Even forty-one years wasn't enough." We're all married to wonderful women. I've been married for almost six years now, the best six years of my life. It's gone like [snap]. And so I can imagine that after forty-one years, I would say the same thing.

Panda: I think that scene was my number one, but another scene that gave me feels is when Nick comes back to the Christmas shop after Clem's either been taken to the hospital or is back, and he sees his dad there. And even though it's a little out of character for his dad, I love the scene where he sits there and basically says, "Son, I'm proud of you no matter what."

Dan: It's really an acting moment more than anything else. Clarke Peters gets mad at Nick and then starts to equate the fact that, "If I screw up your future because of me and my past, it's going to eat me alive," and he almost breaks down in tears. He starts a sentence about his wife, Gracie, and he can't finish the sentence; he goes all the way to the edge, it looks like it's about to be a flood of tears, and then he backs off and goes, "Your future's important."

Anthony Bolognese and Clarke Peters in Christmas Under the Stars

Christmas Under the Stars. *And Autumn Reeser plays a foster parent, thank you very much.*
—Jen Lilley (On Her Favorite Hallmark Movie That She's Not In) Lilley is a foster parent in real life, and the host of the Bramble Jam podcast Fostering Hope with Jen Lilley.

CHRISTMAS UNDER WRAPS

PREMIERED NOVEMBER 29, 2014,
ON HALLMARK CHANNEL.

STARRING CANDACE CAMERON BURE,
DAVID O'DONNELL, ROBERT PINE,
AND BRIAN DOYLE-MURRAY.

WRITTEN BY JENNIFER NOTAS SHAPIRO.
DIRECTED BY PETER SULLIVAN.

Brian Doyle-Murray, Candace Cameron Bure, and David O'Donnell
in Christmas Under Wraps

Big-city medical student Lauren (Cameron Bure) gets turned down for an important fellowship she expected to land, and her boyfriend dumps her. She accepts the only residency available, in the remote town of Garland, Alaska. Everyone in town seems happy, particularly Andy (O'Donnell), who drives her around and helps her get settled in, and Andy's dad, Frank (Doyle-Murray), who seems . . . familiar.

> "I LOVE THIS MOVIE—IT'S SO INSANE, IT'S SO CHRIST-MASY, IT'S SO FUN."—Bran
>
> "I LIKE THIS MOVIE A LOT; IT IS ABSOLUTELY CRAZY." —Panda
>
> "LUDICROUS; I WAS LAUGHING A LOT, BUT NOT WHEN I WAS SUPPOSED TO."—Dan

Panda: All of Garland, Alaska . . .

Dan: That's Garland for ya.

Bran: *That's Garland for ya!*

Dan: I mean, they say that a hundred times.

Panda: Yes, they do. I loved it.

Bran: Because . . . that is Garland for ya.

Panda: There's a scene where Frank almost dies.

Dan: Nope, nope. And I want to be clear, we're supposed to think he almost dies. And then Candace Cameron Bure, who's a doctor in this film, tells us very clearly it was not a heart attack. Now, she doesn't tell us what it *was*.

Panda: But she does clearly say it's *not* a heart attack.

Bran: This is what she does. She walks in and she says, "Where was the pain?" And he says, "Here, and my arm." So she says, "Not a heart attack."

Dan: She listens and she goes, "Your blood pressure's high; you're some-thing something. This wasn't a heart attack." Now, I'm worried, because if you look up heart-attack symptoms on the Goog, you just type it in there, it will say, chest pains and shooting pains down your arm. And I'm no doctor.

Panda: Then Candace tells him, "I'm going to discharge you as a gift." Now, doctors—traditionally, in my experience—when I ask for the gift of early discharge, especially when I've had a near-fatal something, they say no.

Dan: It's called the Hippocratic Oath, that's what you're looking for. And what ol' D. J. Tanner says is, "Look, I know you had a not–heart attack, and I know you need to have some bed rest, and I've told you to sit still and not eat any cookies, but since it's Christmas, why don't you go ahead and leave?" Either he's medically cleared to leave, or he's not; there should be no gift exchanging hands in this entire procedure.

Panda: "My gift to you is you can go die."

Dan: "My gift to you is I'm going to be a bad doctor."

Bran: Hey, that's Garland for ya.

CHRISTMAS WISHES & MISTLETOE KISSES

PREMIERED OCTOBER 26, 2019,
ON HALLMARK CHANNEL.

STARRING JILL WAGNER, MATTHEW DAVIS,
DONNA MILLS, AND DARBY HINTON.

WRITTEN BY LIZ SCZUDLO, BASED ON THE NOVEL
BY JENNY HALE. DIRECTED BY D. J. VIOLA.

Wyatt Hunt and Jill Wagner in Christmas Wishes & Mistletoe Kisses

Single mom Abbey (Wagner) works at a retirement home but really wants to be an interior decorator. Her boss Caroline (Mills) recommends her for a gig decorating the enormous home of her son, business-boy Nick (Davis).

> "SO GREAT—SHOT DIFFERENT THAN A NORMAL HALL-MARK; IT FEELS LIKE A WINTER MOVIE."—**Bran**
>
> "LOVE THIS MOVIE, JILL WAGNER CRUSHES IT; GAVE ME LOTS OF CHRISTMAS FEELS."—**Panda**
>
> "LOVE JILL WAGNER, HATED THIS MOVIE."—**Dan**

It was my grandmother who got me into this. I was talking to her one day, and she's like a mom to me. I said, "Grandma, what have I not done in my career that you want to see me do?" And she's like, "Well, you know, I love those Hallmark movies." I said, "Is that what you want me to do? You want me to do a Hallmark movie?" And she's like, "I would love it. It would just make my year." So I called my manager and said, "Get me a Hallmark movie." He's like, "Wait a minute—we're doing Stargate: Atlantis, *and then you want a Hallmark film?" I'm like, "Grandma wants a Hallmark film. What Grandma wants, Grandma gets." And so singlehandedly, she didn't know it, but she changed the whole trajectory of my career. I'm so thankful that she did. Because of Hallmark, I don't have to live in Los Angeles. I can live on my farm. I can spend a lot of time with my husband, which is super, super important to me. It's just a really good company to work for, because they care about their people, and they're just nice people.* —**Jill Wagner**

Bran: Most of my Wait, Whats end with "He's a billionaire."

Dan: There are six scenes where Nick could cup his hands together and go, "I'm a billionaire!" And it fixes it.

Bran: I'm sure there's more that I'm missing, but first, they go furniture shopping, and she points out a table that is the most boring table I've ever seen. There is no billionaire that owns that table. I could afford that table. It's Christmas Eve, and he wants to do this big thing for her to show that he loves her. And he says he can't find a snow machine on Christmas. *You're a billionaire!*

Dan: *"I'm a billionaire!"*

Bran: His big thing on Christmas Eve is finding two violin players. *You're a billionaire!* Get an orchestra! Kate brags about how she got him box seats for a Cavs game—not a big gift, because *he's a billionaire!*

Dan: I got another one: They're at the antique store. Jill Wagner looks at him and goes, "It's on sale! High five!" *"I'm a billionaire! It's full price for me!"*

Bran: OK, end of the movie, based on personality and looks . . . who are you picking?

Dan: This is not a contest right now. Dr. Mike (Brandon Quinn) is made for Abbey.

Panda: Here's why I disagree.

Bran: Really? You're going with Nick? Is it because *he's a billionaire?*

Panda: I'd like to think that I'm above that working on me, but it would work on me. The other thing is Dr. Mike's an uncouth swine, and here's why. When they're at dinner, he sits there, and she's like, "Oh, I love violins." And he goes, "Yeah." No! That's your only contribution to the violins that were playing at the dinner, is "Yeah"? It shows that he's just not on the same wavelength as Abbey.

Bran: You've brought up the violin players—did Nick actually not spend any money on the big thing? Did he just steal the violin players from the restaurant?

CHRISTMAS WITH HOLLY

WITH GUEST ALONSO DURALDE,
THE WRAP

PREMIERED DECEMBER 9, 2012,
ON ABC (*HALLMARK HALL OF FAME*).

STARRING ELOISE MUMFORD
AND SEAN FARIS.

WRITTEN BY P'NENAH GOLDSTEIN,
BASED ON THE NOVEL *CHRISTMAS EVE
AT FRIDAY HARBOR*, BY LISA KLEYPAS.
DIRECTED BY ALLAN ARKUSH.

After being abandoned at the altar, Maggie (Mumford) starts her life over by opening a toy store in Friday Harbor, a small island off the coast of Washington State. Mark (Faris) has been raising his niece Holly (Josie and Lucy Gallina) since the death of his sister. Holly has been so shaken by the death of her mother that she hasn't spoken for months. When Holly's school tells Mark that she'll have to repeat the first grade, he uproots her from her home in Seattle and takes her back to Friday Harbor, where he owns a coffeehouse. Also living there are Mark's brothers, contractor Scott (Dana Watkins) and marine biologist and grad student Alex (Daniel Eric Gold). Maggie and Mark start to hit it off, and by the time Christmas rolls around, Holly will find her voice as well as a new family.

Panda: I'm concerned about the educational system as it exists within the world of *Christmas with Holly*. At one point, Alex is writing a thesis; at one point, he's writing a dissertation. He's going for a grant. Without getting into the minutiae here, those are all pretty different steps in the education system, and I'm still confused. What's he doing?

Bran: "Ooh, the water is the same temperature today as it was yesterday. *Give me a grant!*"

Alonso: Why is this child not in therapy? Her school wants to make her repeat kindergarten or whatever. Is she seeing a therapist? Is she talking to a counselor? Is she drawing pictures for a medical professional? It seems so strange that her uncles think, "Well, we'll just hang out, and we'll love her enough."

Bran: The security system at Holly's school consists of a child checking passes of adults and saying thumbs up or thumbs down. That's the security check. You want to have lunch with your kid? That's fine. You're going to have to go through Jimmy. And he's strict!

Dan: He's eight-and-a-half. He's got his second-degree yellow belt. So back off.

Eloise Mumford costars with Josie and Lucy Gallina in Christmas with Holly

"FANTASTIC; HAS SOME OF THE BEST MOMENTS
FROM THESE MOVIES."—Bran

"ADORE THIS MOVIE; BEST SET OF B-CHARACTERS
IN A HALLMARK CHRISTMAS MOVIE."—Panda

"NOT A FAN, BUT HAVING OTHER PLOTLINES TO HANG
MEAT ON WAS NICE."—Dan

"BETTER THAN A LOT OF THE CURRENT CROP;
IF YOU LIKE IT, I SEE WHY."—Alonso

CHRISTMAS WONDERLAND

PREMIERED DECEMBER 1, 2018,
ON HALLMARK MOVIES & MYSTERIES.

STARRING EMILY OSMENT,
RYAN ROTTMAN, AND KELLY HU.

WRITTEN BY JAY CIPRIANI AND ANNA WHITE.
DIRECTED BY SEAN OLSON.

Emily Osment and Ryan Rottman in Christmas Wonderland

Heidi (Osment) has back-burnered her dreams of being an artist by taking a job assisting at a New York City art gallery. Her sister asks her to come home to babysit her niece and nephew for a few days, which she agrees to do, even though she also has to plan the gallery's Christmas party. Heidi attends a PTA meeting on her sister's behalf and is surprised that the teacher in charge is her ex, Chris (Rottman). Chris is coordinating the annual Snow Ball, and Heidi is the only one who showed up for the meeting, so she gets pressed into service.

HOT TAKES

"WASN'T SUPER INTO IT; I DON'T THINK EMILY WAS SUPER INTO IT."—Bran

"WANTED TO LIKE THIS MOVIE; I JUST DIDN'T—PRETTY RUN OF THE MILL."—Panda

"I WAS OFFENDED AS A MOVIEGOER AND AS AN EDUCATOR."—Dan

WHAT THE HALLMARK?

Dan: I think it was a very bold choice for Hallmark to literally have them not communicate anything to the Heidi character. These parents walk out the door and just basically don't say everything that's important like, "Hey, you gotta participate in the Christmas decorating. Your ex-boyfriend is the guy in charge of it. You're the only other member of that particular planning committee. The dishwasher is broken. You drop off the daughter." It is just one after another.

Bran: I leave a longer note when I'm leaving my dogs for a day.

CROWN FOR CHRISTMAS

WITH GUEST MARK GRAY, TV FOR PRESIDENT PODCAST (AND ALSO BRAN'S BROTHER)

PREMIERED NOVEMBER 27, 2015, ON HALLMARK CHANNEL.

STARRING DANICA McKELLAR AND RUPERT PENRY-JONES.

WRITTEN BY NEAL DOBROFSKY AND TIPPI DOBROFSKY. DIRECTED BY ALEX ZAMM.

Allie (McKellar) works as a maid at a fancy Manhattan hotel; when she is fired for not making up a room fast enough, she is hired by one of the guests—King Maximillian of Winshire (Penry-Jones)—to travel to his kingdom and become governess to his feisty young daughter.

"LOVED THIS MOVIE, IT MADE ME REALLY HAPPY."
—Bran

"*MAID IN MANHATTAN* MEETS *PRINCESS DIARIES* MEETS *FIRST KID*, AND YOU GET A REAL TURD OF A FILM."
—Dan

"MY HOT TAKE IS: BRANDON, YOU REALLY LIKE THESE MOVIES? I FOUND IT MISERABLE AND BORING."—Mark

(THIS IS THE ONE EPISODE PANDA MISSED, BUT HE TEXTED TO DAN, "LOVED THIS MOVIE. IT WAS GREAT. TONS OF WHIMSY.")

Bran: The snow in this movie, every time they're outside, I was like, This is so good. Listen, I don't know if it was real snow, but however they got it, whatever they did, this is what they should do all the time.

Mark: So this is a real problem? The snow?

Bran: Oh, Mark . . . you don't even . . .

Dan: You just don't know.

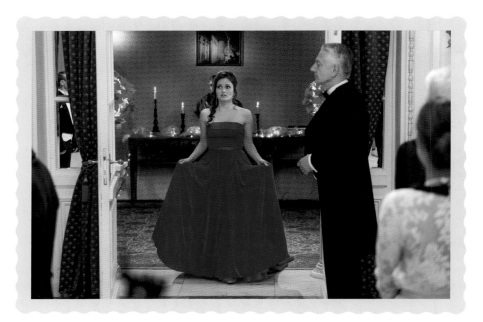

Danica McKellar in Crown for Christmas

Bran: There was a scene where Allie and Theodora (Ellie Botter-ill) were making cookies, and they were singing "O Christmas Tree." Who knows the lyrics to "O Christmas Tree," second verse?

Dan: Nobody.

Bran: They go into the second verse of "O Christmas Tree," and I'm like, That is unrealistic.

Mark: One thing about Theodora: it's hyped up what a terrible child she is. I'm thinking the kid's got a drug problem, or at the very least she's violent or setting things on fire. She's a little bratty. And for someone who's complete-ly entitled, I was a little disappointed with that. This is the conflict of the movie? Winning over this kid who seems easily won over?

Bran: And who knows the second verse to "O Christmas Tree"?

A DECEMBER BRIDE

WITH GUEST ALONSO DURALDE,
THE WRAP

PREMIERED NOVEMBER 20, 2016,
ON HALLMARK CHANNEL.

STARRING JESSICA LOWNDES
AND DANIEL LISSING.

WRITTEN BY KAREN BERGER, BASED ON THE NOVEL
BY DENISE HUNTER. DIRECTED BY DAVID WINNING.

Layla (Lowndes) is unsure if she wants to attend her cousin's wedding—since her cousin is marrying Layla's ex-fiancé, who left Layla for her cousin. Layla's old friend Seth (Lissing) takes her to the wedding, and for a series of complicated reasons, Layla and Seth pretend to be engaged.

HOT TAKES

"LOVE IT, SEEN IT MULTIPLE TIMES."—Bran

"TRANSCENDENTLY GOOD."—Panda

"TERRIBLE, AWFUL—MS. LOWNDES, IT'S A GOOD THING SHE'S ATTRACTIVE."—Dan

"I CAN'T DEFEND THIS MOVIE, BUT IT'S FIRMLY OK, ON A HALLMARK SCALE."—Alonso

WAIT... WHAT?

Alonso: This movie doesn't understand how December works. Thanksgiving has happened, they're talking about "December bride" this and that, and the Holiday Tour of Homes still hasn't happened. When, exactly, does it happen? Is it Christmas Eve? How much time is left? And finally, at the end, when she's a December bride, I was wondering, "Is it still *this* December?"

Dan: That's my ultimate Wait, What. I think this movie thinks this is the last December, ever. There's not another one. If you don't get married this December, there will be hell to pay. You have to plan it in six days.

Panda: Darcy [April Telek], the mean boss, loses the Holiday Tour of Homes, walks into Seth's house that's beautifully decorated and has won the award, and she just stands there. And she's like, "Guys, I guess I missed my chance." And no one acknowledges her existence the entire time. They're popping champagne, and they're like, "Hey, that Darcy lady just lost everything!"

Dan: There is a weird bit where she's a ghost. She's standing there, like, "Someone say something nice to me," and no one even looks at her.

Bran: If she is a ghost, this movie is *so good*.

DELIVER BY CHRISTMAS

PREMIERED OCTOBER 25, 2020,
ON HALLMARK MOVIES & MYSTERIES.

STARRING ALVINA AUGUST
AND EION BAILEY.

WRITTEN BY MIKE MARIANO.
DIRECTED BY TERRY INGRAM.

Single baker Molly (August) keeps flirting with a handsome guy during her Christmas errands, and she's also falling for Josh (Bailey) over a series of phone conversations. Eventually, she realizes that Josh and the handsome guy are one and the same, although a series of misunderstandings leads her to believe that he's married, even though Josh is a widowed dad. Can these two graduate from phone friends to an IRL love match?

Panda: Their first meet-cute is really good; love that scene. Any scene where he's tucking his boy into bed at night? Dad-feels all day long, so great. And then the ending might be my favorite ending of a Hallmark Christmas movie I've ever seen.

Bran: As a dad, I have to talk about how fantastic Eion Bailey's performance was as a guy who is just trying to figure it out without his wife there. I don't feel like we get a lot of these movies where it is the guy who lost his wife and has to deal with the kid. That relationship was such an important part of this movie, in such an organic and authentic way. As a dad, I just loved it; it brought me to tears multiple times.

Dan: The reason that it works so well, in my opinion, is not just the male lead's performance. It's because the kid [Kesler Talbot] does a great job at not being burdened by his mom's death, because he doesn't remember her. Like, is he sad that he doesn't remember his mom? Absolutely. Does he miss his mom? Yes. But he doesn't live a life full of memories of his mom; he doesn't have those memories. And so Dad is carrying that weight for the kid. The kid has moments where he says, "I miss Mom"; it breaks your heart more, but it also is kind of a relief that this kid doesn't have this burden that his dad is carrying. It's both the performance—the kid was great—and also the writing that really does that.

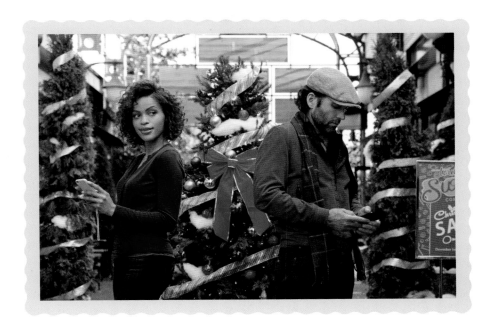

Alvina August and Eion Bailey in Deliver by Christmas

"WHEN I SIT DOWN TO WATCH A HALLMARK MOVIE, THIS IS WHAT I'M HOPING FOR."—Bran

"IT WORE ME DOWN WITH ITS ADORABLENESS; IT'S GREAT."—Panda

"IT'S BEEN DONE A HUNDRED TIMES. ON THE BIG SCREEN, THOSE TREADS ARE WORN BALD, BUT BY HALLMARK STANDARDS, THIS IS A REALLY GREAT MOVIE."—Dan

DOUBLE HOLIDAY

PREMIERED DECEMBER 21, 2019,
ON HALLMARK CHANNEL.

STARRING CARLY POPE AND
KRISTOFFER POLAHA.

WRITTEN BY NINA WEINMAN.
DIRECTED BY DON MCBREARTY.

Rebecca (Pope) and Chris (Polaha) are competing for the same position at a property-development company. They've also been tasked with throwing the company holiday party. Chris goes to Rebecca's house to talk party plans and winds up celebrating the first night of Hanukkah with Rebecca's family. She learns about Christmas, he learns about Hanukkah, and they incorporate both into the party.

Panda: There are a couple of exchanges of dialogue I really enjoyed. One of them was when she uses the dinosaur cookie cutter to make Christmas cookies, and then Kris makes just an offhand joke about Santa riding on his velociraptor. I lost it at that joke. I thought that was funny.

Bran: They spoke over each other a little bit more, which I appreciated. I believe we get to see three candle-lighting scenes in this movie. The first one, Kris has a book in front of him, so that he can follow along with the prayer. Then I believe it's day five, and it's just Carly and Kris lighting the candle together, and he and she say the prayer together, and he doesn't use the book. It was a great scene. And it was him showing interest in something that is clearly very important to her and saying, "Hey, this matters to you. It matters to me."

Dan: The dinosaur cookie-cutter Christmas cookies were my favorite part of this movie. This movie mostly shies away from dumb people, which I appreciate. Early in the movie, Kris goes, "Yeah, I know Hanukkah has got a menorah and a dreidel." In *Holiday Date* (page 117), this guy shows up, and he doesn't know how to spell "Christmas." It's the dumbest thing in the world.

Ceyon Crossfield, Kristoffer Polaha, and Carly Pope in Double Holiday

Nina Weinman, the amazing woman who wrote the script—she's one of the queens of script writing for Hallmark. She does an amazing job, and all her movies are fan favorites. The origin of it was that they were kind of at odds, in that Carly's character didn't like my character, and my character didn't like hers. But I asked Nina early on, "Wouldn't it be more interesting if Mike always was interested in her, so I can play [being in] love from the beginning? And what if it's a different view she has of me which allows her to see that, all along, there's been this guy that kind of likes her?" And she agreed. So instead of being at odds and butting heads, it was my character being sort of annoying and too funny and not serious enough for her, and Carly's character being ambitious.—Kristoffer Polaha

A DREAM OF CHRISTMAS

PREMIERED DECEMBER 3, 2016,
ON HALLMARK CHANNEL.

STARRING NIKKI DeLOACH,
ANDREW WALKER, AND CINDY WILLIAMS.

WRITTEN BY MIKE BELL AND GARY YATES.
DIRECTED BY GARY YATES.

Nikki DeLoach and Christopher Russell in A Dream of Christmas

Penny (DeLoach) is frazzled—her sister's family is living with her; her husband, Stuart (Walker), is a photographer who's constantly going out of town for shoots; and she's up for a promotion at work that she doesn't think she's going to get. While standing in line with her nieces to see Santa Claus, Penny mutters a wish that she had never gotten married, which is overheard by the mysterious Jayne (Williams). When Penny wakes up, she's got a snazzy car, a fancy apartment, a high-powered job—and no husband.

HOT TAKES

"SO MUCH ABOUT THIS MOVIE IS DIFFERENT AND WONDERFUL."
—Bran

"GIVES ME *IT'S A WONDERFUL LIFE* VIBES, WHICH IT'S GOING FOR."
—Panda

"WALKER AND DELOACH TOGETHER? ONE HUNDRED PERCENT GREAT. THE REST OF THIS MOVIE IS VERY DIFFICULT, BORDERLINE OFFENSIVE."
—Dan

Panda: Someone says this to Nikki DeLoach: "You look white as a sheet. And not in a good way." Has there ever been a time when someone has said, "You look white as a sheet. Great look!" And then the Christmas miniature thing that Andrew Walker is photographing. He says, "I'm on a tight deadline for this." For what? Everything that would need this, that deadline's past. You're a week from Christmas. You're shooting next year's catalog, Andrew.

Bran: At the party, there is a girl walking around—you know how you do at parties where you have food, walking around and stuff? Like cookies? She's got a full lobster.

Dan: We're eating lobster off paper plates with our hands. The best part about that is if somebody goes, "Oh, there's lobster over there? I'm going to go over to the hors d'oeuvres table and grab some lobster. It's right next to the crab legs." Either sit down and serve lobster, or stand up and don't.

Panda: I would do a stand-up lobster.

Bran: Yes, you would. I would love to see it.

Dan: Nikki gets very sad when she sees her husband is engaged to someone else, and rightly so. She goes to have a good cry, and she goes where any of us would go to have a good cry: the steps leading into the kitchen, where servers have to walk in and out. Could she go to the bathroom? Sure. Could she go to her car? Absolutely. No, let me go to the highest-foot-traffic spot in the entire building, where people are going to walk nonstop, and let me sit down and bawl my eyes out.

ENTERTAINING CHRISTMAS

PREMIERED DECEMBER 15, 2018, ON HALLMARK CHANNEL.

STARRING JODIE SWEETIN AND BRENDAN FEHR.

WRITTEN BY MARCY HOLLAND. DIRECTED BY ROBIN DUNNE.

Candace (Sweetin), the daughter of a legendary cookbook author, is poised to inherit her mother's home-cooking-and-crafts multimedia empire. There's just one problem: Candace is a terrible cook, a worse baker, and hopeless at crafts. A young girl whose father is serving overseas in the military records a video that goes viral, inviting Candace's mother to come to the girl's small town to help make her dad's homecoming more special. Candace goes in her mother's place, hoping to generate good PR and to prove that she's worthy to take the reins from her mom. The girl's uncle, John (Fehr), is a reporter for the local paper, and he follows Candace around to do a story. Will his growing affection for her keep him from revealing the truth about her domestic ineptitude?

Bran: I just really couldn't get past the fact—and maybe I couldn't comprehend—that she is not able to do a single thing that her mother does.

Dan: She can't do one thing.

Bran: I can make an omelet. So when you have a mom who's a chef, I find it hard to believe that she never taught her daughter anything. And even if she never taught her anything, Candace would still be able to do *something*. She belongs in the infomercials where people are just falling all over the place.

Dan: The fact that she can't do anything is absurd, but the fact that she just doesn't tell them "no" bothers me too. You're a celebrity, if we're going to call the daughter of a famous person a celebrity. You're supposed to stay a day; you've agreed to stay four days for the return of this guy. Just say no! Do you want to knit with us? "No. I'm here for four days." Do you want to judge the gingerbread house competition now? "Sure." Do you want to make one? "No, I don't."

Bran: My second thing is John writes stories, and while he's writing stories, he takes notes, and some of the notes include things like just the word "fraud." You couldn't remember that you think she's a fraud? You needed to write it down?

Dan: Every journalist in the country has a book, and they write stuff down in it. This guy just has a stack of loose-leaf Post-Its. He has taken a Post-It note, gotten a Sharpie, written "FRAUD?," and stuck it down.

"FINE; IT WASN'T GREAT."—Bran

"I LIKED IT; ONE OF MY FAVORITES OF THE YEAR."—Panda

"POORLY EXECUTED, LAZY, REALLY BAD."—Dan

Jodie Sweetin and Brendan Fehr in Entertaining Christmas

A FAMILY CHRISTMAS GIFT

PREMIERED DECEMBER 22, 2019,
ON HALLMARK MOVIES & MYSTERIES.

STARRING HOLLY ROBINSON PEETE,
DION JOHNSTONE,
AND PATTI LaBELLE.

WRITTEN BY ALEX WRIGHT.
DIRECTED BY KEVIN FAIR.

After getting passed over for a promotion at the magazine where she works, Amber (Robinson Peete) decides to go home to Colorado for Christmas to spend the holidays with her Aunt Dora (LaBelle), a retired music legend who now runs an inn. Amber has an awkward meeting with Alan (Johnstone), whom she assumes is a driver but who turns out to be a close friend of Dora. Alan is running a fundraiser, and he's a bit of a disaster, so Amber comes in and takes over.

Holly Robinson Peete and Patti LaBelle in A Family Christmas Gift

Bran: Let's just slide into All the Feels, because obviously "O Holy Night" is everybody's feel. It was amazing. For my money, I think it's one of the best songs ever written. Not just one of the best Christmas songs, but one of the best songs ever written. It's absolutely beautiful. Patti LaBelle crushes it. I'm crying. It's amazing. But anytime Holly Robinson Peete is talking to Patti LaBelle, you can tell she is just soaking it in, especially the scenes in which HRP is interviewing her for her piece. They are so believable. I just felt like she was interviewing her about her life; I didn't feel like I was watching a movie.

Panda: One specific conversation, when Patti LaBelle is talking about the christening, that she was on tour and she missed the christening, and hear me out, it has nothing to do necessarily with the content per se, but they just ooze believability in that conversation. As I said before, the church gave me feels and then obviously that final scene—again, I just want to emphasize, when she sings that, we were dead silent. And I got tears.

Dan: I do have one other one, aside from Patti LaBelle singing. If you have watched all these movies with us, then you know what I'm talking about, because "Silent Night" and "Deck the Halls" are at the top of that public-domain list. They're in, like, every movie; somewhere along the way, you're going to hear "Deck the Halls" or "Silent Night," and you hear "Silent Night" in this movie. It does happen. But there's a rendition of "It Came upon a Midnight Clear" playing while they're decorating the tree, and it really worked for me. The tree looked great; I believed they were actually decorating it.

A GIFT TO REMEMBER

PREMIERED NOVEMBER 19, 2017,
ON HALLMARK CHANNEL.

STARRING ALI LIEBERT,
PETER PORTE, AND TINA LIFFORD.

WRITTEN BY DEAN ORION AND TOPHER PAYNE,
BASED ON THE NOVEL BY MELISSA HILL.
DIRECTED BY KEVIN FAIR.

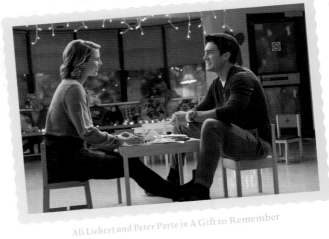

Ali Liebert and Peter Porte in *A Gift to Remember*

While riding her bike, Darcy (Liebert) swerves to miss a car and knocks down a guy (Porte), so she accompanies him to the hospital. He wakes up with retrograde amnesia, so Darcy—with the help of her landlady, Mrs. Henley (Lifford)—tries to help him piece together clues to his identity.

"I LIKE THE PACE, LOTS OF CHRISTMAS FEELS."—Bran

"MORE PLOT, BETTER ESTABLISHED CHARACTERS; IT DIDN'T GIVE ME THE CHRISTMAS FEELS AS MUCH."—Panda

"MIDDLE OF THE HALLMARK PACK, SO FOR ME, A STANDARD HATE."—Dan

The thing that stresses me out—I think, to an appropriate degree—when I'm adapting those books is knowing I'm going to toss out 70 percent of the material. And I sometimes have the opportunity to have conversations with the author of the original work. They have no control over it, because they sell the rights to Hallmark, but it's important to me that I try to honor whatever their intention was with it. And so if I can have those conversations with the author directly, that's great—like I did with Melissa Hill—or if I'm just trying to extract [those intentions] from reading the book. It's a matter of trying to streamline the dang thing. Figure out what we can squeeze in, in maybe five minutes.—Topher Payne (Screenwriter)

Bran: Mrs. Henley loves Christmas and loves decorations, and she says, "Darcy, I have the most beautiful star for the top of your Christmas tree." Mrs. Henley, I have news for you: that star is not beautiful. There is a rival bookstore. It's called Books! Books! Books!, and they are doing a Christmas Eve party as well. But there is this line: "Books! Books! Books! is going to have a Santa bounce-house. How are we supposed to compete with that?" Well, I don't know. Get a Santa bounce-house?

Panda: They do not know what retrograde amnesia is in this movie. Retrograde amnesia is where you have no memory of all events prior to an accident, right? So you can form new memories after the accident. The scene then pans to him trying to do a card match, and he cannot match the cards. Just because he forgot everything before the accident, they treat him like he can't remember anything.

Dan: Later in the movie, they've got this John Doe in the hospital, and Darcy's at her wits' end wondering how they figure out who this is. And she goes, "All I have are his dog, his mail, and his keys." Wait a minute. You're telling me with those three clues you can't crack the case? Good thing you're not on Movies & Mysteries; people are just dying. "All I have is a sign with his social security number on it." Are you serious, you can't figure it out from that?

Bran: "All I have is a photo album of every event in his life."

A GINGERBREAD ROMANCE

PREMIERED DECEMBER 16, 2018,
ON HALLMARK CHANNEL.

STARRING TIA MOWRY-HARDRICT,
DUANE HENRY, MILO SHANDEL,
AND MELISSA PETERMAN.

WRITTEN BY BARBARA KYMLICKA,
GREGG ROSSEN, AND BRIAN SAWYER.
DIRECTED BY RICHARD GABAI.

Architect Taylor (Mowry-Hardrict) has never been particularly interested in Christmas, since her family traveled a lot during her childhood. She hopes to get a promotion that will take her from Philadelphia to the Paris office, but her boss (Peterman) informs her that she must represent the firm in a city-wide gingerbread house–building contest. When her original collaborator backs out to work with a rival firm, Taylor must turn to single-dad baker Adam (Henry). His cozy aesthetic clashes with her sleek-and-modern sensibilities, but he ultimately convinces her that traditional is the way to go when it comes to Christmas. She gets the Paris gig, but will her growing feelings for Adam keep her in the City of Brotherly Love?

WAIT... WHAT?

Bran: Between density-of-gingerbread conversation and not compromising taste or texture, if you took those conversations out, we'd have a vignette. We'd have an eight-minute movie in the city of Philadelphia. There was one scene where they're talking about not compromising taste and texture that went, I don't know, eighty minutes too long. And how does a guy who just works at a bakery afford the house that he has?

Dan: Well, he's working at a bakery that gives him time off, which was really nice.

Panda: I got into the wrong industry. Here's my issue with his culinary school. He makes this quote—and this is terrifying about what they're teaching at culinary school these days—he said that one thing they don't teach in culinary school is that butter makes things taste better.

Dan: That's actually in my notes, too. They don't teach that to you because they teach it to you in everything. You shouldn't need to know that.

Bran: If they have to teach that to you, maybe you shouldn't be in culinary school.

Tia Mowry-Hardrict in A Gingerbread Romance

"OK; LOVE THE GIANT GINGERBREAD HOUSES."
—Bran

"RIDICULOUS PREMISE, ALTHOUGH IT'S COOL TO
WATCH THEM CONSTRUCT THE GINGERBREAD HOUSE;
NO CHEMISTRY BETWEEN THE LEADS, THOUGH."
—Panda

"IT'S NOT ABOUT SMALL TOWNS BEING BETTER
THAN CITIES; IT'S GOT THE GIANT GINGERBREAD HOUSES;
STILL A DISASTER."
—Dan

A GODWINK CHRISTMAS

WITH GUEST BILL SIMMONS,
AMERICAN LEPROSY MISSIONS

PREMIERED NOVEMBER 18, 2018,
ON HALLMARK MOVIES & MYSTERIES.

STARRING KIMBERLEY SUSTAD,
PAUL CAMPBELL, AND KATHIE LEE GIFFORD.

WRITTEN BY JOHN TINKER AND DAVID GOLDEN,
INSPIRED BY THE SERIES OF BOOKS BY
SQUIRE RUSHNELL AND LOUISE DUART.
DIRECTED BY MICHAEL ROBISON.

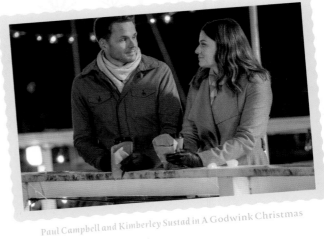

Paul Campbell and Kimberley Sustad in A Godwink Christmas

Antiques appraiser Paula (Sustad) has a workaholic fiancé she doesn't want to marry. She visits her aunt Jane (Gifford) in Nantucket for Christmas. Paula gets fogged in at Martha's Vineyard and strikes up a friendship with innkeeper Gery (Campbell). Aunt Jane is convinced that a confluence of events is actually a series of "godwinks" indicating that divine forces are conspiring to bring Paula and Gery together.

"SO MUCH FELT SO UNNECESSARY."—Bran

"FINE UNTIL IT DERAILS IN THE FINAL SCENE."—Panda

"IT GOT IN ITS OWN WAY A NUMBER OF TIMES,
SPECIFICALLY WITH THE GOD-WINKING GAMBIT, WHICH
IS ONE OF THE WORST IDEAS FOR A MOVIE."—Dan

"DIDN'T HATE IT, BUT I MOSTLY REMEMBER
THE DECORATIONS."—Bill

We shot Godwink *in August, and it was, like, mid-eighties for most of the shoot. But that movie actually had a big budget for effects, so they had sixty tons of real snow brought in. In a lot of those scenes where we are standing out in the snow, we were standing in real snow, so it actually cools the temperature down around you. It's funny, because you get sucked into it—when you're looking at the set, when you're facing the building or the Christmas trees or whatever, and you're in the snow in your scarf and jacket, you forget about the heat for a minute. And then you do a 180, and there's a bunch of dudes in T-shirts and shorts shoveling snow into a wheelbarrow, just sweating their beans off. —Paul Campbell*

WAIT... WHAT?

Dan: So here's the deal: the whole movie, it's like maybe God's winking at you, wink wink. You know, maybe this is his way of telling you to move. No, no, no. Kathie Lee Gifford, apparently with her friend in Martha's Vineyard, has determined that Paula is right for this dude who left his wife because he wanted to live in a Currier and Ives painting. And so they have decided to create a series of events, all to look like God is winking, but really, they're pulling all the strings to get these two kids together. And that is a really weird thing to have happen at the end of this movie.

Bran: At the end of the movie, they go to this carousel, and the carousel only runs in summertime, right? Carousel turns on, and "O Come All Ye Faithful" is the carousel tune. I'm interested in why that is a summertime tune. I cannot believe there's a movie about God winking, and the cab driver wasn't an angel. Somebody had to be an angel. There are angels in the outfield, but there isn't a single angel in this movie. It was shocking.

Bill: Well, there was a devil, and that was the fiancé. Because he's the only one that used three words that I think you don't say in a Hallmark Christmas movie. He said, "summer," "beach," and "Florida." And so I'm pretty sure that's when I knew he was the enemy.

Dan: And he also told Paula, if you marry me, you don't have to work anymore. And that goes over well in 2000 Hallmark, but it's 2018; you do not tell a woman she does or does not have to work to make herself happy. Come on, man, be better. And also "summer" and "beach"? What are you doing?

A GODWINK CHRISTMAS: MEANT FOR LOVE

PREMIERED NOVEMBER 17, 2019,
ON HALLMARK MOVIES & MYSTERIES.

STARRING CINDY BUSBY,
BENJAMIN HOLLINGSWORTH,
AND KATHIE LEE GIFFORD.

WRITTEN BY JAMIE PACHINO,
INSPIRED BY THE SERIES OF BOOKS BY
SQUIRE RUSHNELL AND LOUISE DUART.
DIRECTED BY PAUL ZILLER.

Benjamin Hollingsworth and Cindy Busby in A Godwink Christmas: Meant for Love

Alice (Busby) meets Jack (Hollingsworth) at a Christmas party organized by her mother, Olga (Gifford). Turns out he wandered into the wrong party by mistake, but it also turns out they're both attending the same wedding the following day, so they decide to carpool. Jack encourages Alice to leave her retail job to become a counselor, which she really wants to do, but she worries about what her family will think. Alice is diagnosed with MS, and she tries to keep Jack at a distance, since he's already lost both parents and a brother. But one "godwink" after another keeps bringing this couple together.

"DIDN'T DISLIKE, BUT THE 'GODWINK' THING IS ANNOYING."—Bran

"NOT AS BAD AS THE FIRST ONE."—Panda

"WORSE THAN THE FIRST ONE, ALTHOUGH THE TRUE STORY IS BETTER."—Dan

Panda: It's low-hanging fruit on this one, but the very last scene where he's got the cue cards and he's dropping them, that's great.

Bran: This was taken straight from *Love Actually*. Is it an homage? Or do they not think we'll recognize it?

Dan: The big *Love Actually* scene is across a street in public. So one window's here, one here, but literally anyone on that street in Minneapolis can see those signs. May I submit to you that "I KNOW ABOUT YOUR MS" should never be written in broad strokes on a card for all to see? I'm not telling you how to do your job, or how to make a great romantic gesture, but what I am telling you is that should never be included. "I KNOW ABOUT YOUR MS." Not great. Not great. There are so many ways you could do that and be like, "It doesn't matter—I know about your condition." Is that a little bit better? Maybe? I don't know.

Bran: "Your brother told me about you-know-what behind your back"?

A GODWINK CHRISTMAS: SECOND CHANCE, FIRST LOVE

WITH GUEST PAUL CAMPBELL, HALLMARK STAR

PREMIERED NOVEMBER 22, 2020, ON HALLMARK MOVIES & MYSTERIES.

STARRING BROOKE D'ORSAY AND SAM PAGE.

WRITTEN BY JOHN TINKER AND JAMIE PACHINO, INSPIRED BY THE SERIES OF BOOKS BY SQUIRE RUSHNELL AND LOUISE DUART. DIRECTED BY HEATHER HAWTHORN DOYLE.

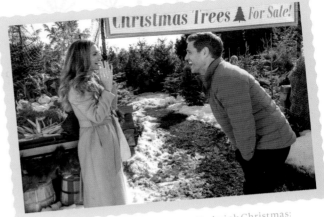

Brooke D'Orsay and Sam Page in A Godwink Christmas: Second Chance, First Love

Former high school sweethearts Margie (D'Orsay) and Pat (Page) run into each other in Boise after fifteen years apart. Pat was living in Hawaii; Margie had stayed in Idaho, where she's been climbing the corporate ladder. He's a widower with two sons, and she has a long-distance boyfriend, but when they keep running into each other, they begin to wonder if powers beyond their control are bringing them together. When Pat gets an offer to move to Seattle, are they destined once again to go their separate ways?

"THIS PLOT IS BUILT ON THE THINGS THAT HAPPEN IN THESE MOVIES EVERY WEEK, BUT WITH A GOD STAMP ON IT."—Bran

"IT DOESN'T DO IT FOR ME, FOR A VARIETY OF REASONS."—Panda

"THE GODWINK MOVIES ARE THE EPITOME OF EVERYTHING WRONG WITH HALLMARK MOVIES; THEY ARE EQUAL-OPPORTUNITY OFFENDERS OF ATHEISTS AND BELIEVERS, SOMEHOW."—Dan

"THE STAKES WEREN'T PARTICULARLY HIGH; I THINK IT WAS JUST VERY SWEET."—Paul

HOT TAKES

Panda: The two boys go into the store to buy their grandma a gift. And I get that there's gonna be product placement in these movies, but there is probably one of the most egregious product placements of all time, for Hallmark greeting cards. Margie picks it up, and they cut to the card—it's dead silent, by the way, there's no music—she closes the card, then flips it over, so you can see "Hallmark Signature" on the back of it. That's a real scene in a real movie!

Dan: Paul, if you're asked to do that in a movie, what are you saying?

Paul: I have done it in a movie, but this one stood out to me. Like, oh no. I find that I probably do them in every other movie. In *Holiday Hearts* (page 121), we were featuring this Christmas tree where the lights go on and off. Essentially, we had a little ad for the tree and how it works.

Bran: We looked it up afterward!

Paul: It was woven into the energy of the scene, and it was flawless. I mean, a lot of these movies rely on product placement just to subsidize costs and stuff like that. The one in this movie, even I was like, Aw, man. As an actor, you just go, Alright, we're doing this.

HEARTS OF CHRISTMAS

WITH GUEST HEIDI GARDNER,
PERFORMER, SATURDAY NIGHT LIVE

PREMIERED DECEMBER 4, 2016,
ON HALLMARK MOVIES & MYSTERIES.

STARRING EMILIE ULLERUP,
KRISTOFFER POLAHA, KIMBERLEY SUSTAD,
AND SHARON LAWRENCE.

WRITTEN BY J. B. WHITE.
DIRECTED BY MONIKA MITCHELL

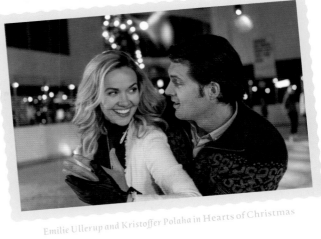

Emilie Ullerup and Kristoffer Polaha in Hearts of Christmas

Neonatal intensive care unit (NICU) nurse Jenny (Ullerup) clashes with Matt (Polaha), the new budget-minded hospital CFO. They fall in love after planning a Christmas party. Sharon Lawrence costars as Alice, Jenny's boss and a veteran NICU nurse, who is being forced into early retirement by Matt's budget cuts; the big, moving finale features Alice's former patients, many of them now adults, coming to the party to tell her that they owe their lives to her hard work.

> "FULLY ENJOYED, BUT JUST KINDA THERE."—Bran
>
> "REALLY LIKED THE FILM—AND I USE THE WORD 'FILM' LIBERALLY."—Panda
>
> "BAD MOVIE; THEY WERE LIKE, 'WHAT IF WE DO SOMETHING FOR AN HOUR AND TEN MINUTES UNTIL THE GOOD PART IS GOING TO HAPPEN?'"—Dan
>
> "FOR HALLMARK, YOU WANT ALL THE FEELS OR CHEESY-BAD OR CHEESY-FUNNY BUT STILL ENJOYING IT; THIS WAS JUST BLAND."—Heidi

Hot Takes

EMILIE ULLERUP

Bran: We just watched *Hearts of Christmas*, and Kris's character didn't know what a NICU was.

Emilie: I know.

Panda: I'm concerned.

Emilie: And I'll tell you this. In real life, Kris Polaha didn't know how to pronounce it.

Bran: No!

Panda: No!

Dan: Did he say "nigh-coo" or something?

Emilie: Yep.

Dan: Aww, he's never going to hear the end of it.

Emilie: And it wasn't just Kris; it was several people that we just needed to make sure knew how to pronounce that.

Panda: The tradition of the NICU, where they all hold hands, and she starts reciting this very long poem? My question is, what's with the hand-holding part? It felt creepy to me.

Bran: Is it a prayer?

Heidi: I think it was for sure a prayer; it's like they took a verse from the Bible but took out all the things that would seem overly religious and just changed those words to "glorious" and "blessing."

Dan: So, you've seen a lot of Hallmark movies, then?

Panda: I'm concerned that Matt, the guy who's taking over as CFO, doesn't know what the term "NICU" means. And I'm confused about whatever that party location, Forever Young at Heart, actually is. They walk in, and they're like, "There's nothing like it!" And all it is, is a gigantic bouncy house and a kids' table.

Heidi: When the mom and Jenny are having a conversation while they're making cookies, and the mom's like, "Hey, I just wanna let you know, Bob and I are coming up on our thirtieth Christmas together." People don't celebrate their thirtieth Christmas; they celebrate their anniversary. And I get it, it's a Christmas movie, but that just revealed to me that these are psychopaths. And when Jenny says to her mom, "It's a wonder to me how you guys are together, you're *so* different. You like tennis, he likes golf." Those are both rich-white-people sports, and they can be played at the same club.

Dan: They're explaining this heart procedure they're going to do on this little baby, and it's a very serious scene, and Jenny reassures the parents by saying this: "The doctor has done this procedure hundreds of times. Successfully." Now, there's a lot there. First of all, I want my doctor to have performed the procedure *thousands* of times, not hundreds, and that's a minimum. That's a new doctor, brand new. Leave that part out. Second of all, I would *hope* it was "successfully." Basically, what you're saying is there's some twenty-eight-year-old with a medical degree who's been successful occasionally.

HOLIDAY DATE

WITH GUEST JONATHAN SHAPIRO, WRITER-PRODUCER, THE BLACKLIST, GOLIATH

PREMIERED DECEMBER 14, 2019, ON HALLMARK CHANNEL.

STARRING BRITTANY BRISTOW, MATT COHEN, TERYL ROTHERY, AND BRUCE BOXLEITNER.

WRITTEN BY KAREN BERGER.
DIRECTED BY JEFF BEESLEY.

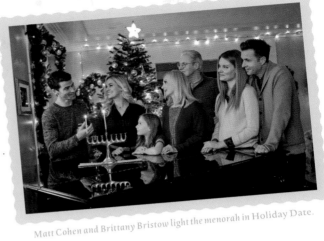

Matt Cohen and Brittany Bristow light the menorah in Holiday Date.

Aspiring designer Brooke (Bristow) gets dumped by boyfriend Ethan right before Christmas. At a friend's party, she meets aspiring actor Joel (Cohen), who is up for a role as a small-town guy. He needs the research, and she needs a boyfriend to take home for the holidays, so Joel pretends to be Ethan, despite the fact that Joel is Jewish and has no knowledge of Christmas traditions. (He also knows nothing about being an architect, which the real Ethan is.)

"LOVED; THIS WAS FUNNY BECAUSE THEY WERE TRYING TO BE FUNNY."—Bran

"REALLY LIKED, BUT IT HITS ALL THE TRADITIONAL HALLMARK VIBES IN THE DUMBEST WAY POSSIBLE."—Panda

"IF YOU'RE GOING TO BE A SCREWBALL COMEDY, YOU HAVE TO BE SMART AT THE SAME TIME; IT'S NEXT-LEVEL DUMB, ALL WHILE POLITELY EDUCATING US ON THE BASICS OF HANUKKAH."—Dan

"BROUGHT BACK THE TRAUMA OF BEING THE ONLY JEW AT COVENANT PRESBYTERIAN PRESCHOOL."—Jonathan

Jonathan: I don't think the problem is that Joel is Jewish; I think the problem is Joel's an actor and is so self-involved that he never noticed there was a thing called Christmas. And he grew up in New York, so I don't understand. Irving Berlin is born in a shtetl in Poland and manages to write "White Christmas." By the way, Jews wrote the New Testament, so it's not like we're not familiar with this story. Every young Jew is told "Christmas is beautiful—they're celebrating the birth of a Jewish boy." And somehow this actor never noticed.

Dan: It would have worked better as a spoof of Hallmark movies. Hallmark Christmas movies never address Hanukkah. This does, and does it so poorly that this movie works better as a spoof.

Jonathan: I want to see them do an Easter movie, where the stakes get a little higher. You know what I mean? He will have had ham at that point. And I also want to see the bris, and the scene where he explains to the dad what that's all about.

Dan: I do want to know where the mom purchased the "Oy Vey!" apron, because she got that thing overnight. She did not get it from Amazon, right? There was a store in that small town, and the only way that that is sold is patronizing, right? The only way that small town is selling "Oy Vey!" aprons is in a funny, winking, "Ha ha Jews" way. Not in a serious way.

Bran: That's actually the name of the store, just Ha Ha Jews.

HOLIDAY FOR HEROES

PREMIERED NOVEMBER 8, 2019,
ON HALLMARK MOVIES & MYSTERIES.

STARRING MELISSA CLAIRE EGAN
AND MARC BLUCAS.

WRITTEN BY TODD MESSEGEE,
LISA NANNI-MESSEGEE, AND
ANDREA GYERTSON NASFELL.
DIRECTED BY CLARE NEIDERPRUEM.

Café owner Audrey (Egan) sends coffee to her brother serving overseas, and he shares it with Matt (Blucas), who soon becomes pen pals with Audrey. Matt shows up in Audrey's town during a tough year for the community—the local National Guard troops are told they won't be coming home for Christmas, and the mayor cancels the annual Holiday for Heroes event. Audrey decides to spearhead the event herself, with Matt's help.

Bran: The opening sequence of this movie that, for three to four minutes, shows them writing letters back and forth throughout the period of a year. You can see him finding some sort of peace while he's reading her letters, writing his letters. It's the best opening sequence of a Hallmark movie I've ever seen.

Panda: There are so many in this movie, but when he decorates the ice rink and then he has her open her eyes, and then the music hits—right at that moment, I got feels.

Dan: They write back and forth about how she thinks Christmas should be all year long, and she also has a bit about angels on the tree. He brings her a box of homemade angels. Twelve. All of them are labeled different months. So, Christmas all year long, and they've been writing for a year, and then he says, "When I was overseas, you were my angel." That scene is an all-time good scene.

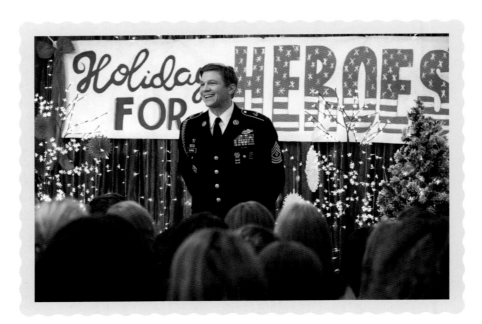

Marc Blucas in Holiday for Heroes

"LOVE; CLEARLY A WAY SUPERIOR VERSION OF
THE CHRISTMAS CARD (PAGE 39)."—Bran

"QUINTESSENTIAL; A THROWBACK TO HALLMARK MOVIES
THAT I USED TO WATCH GROWING UP."—Panda

"OVER THE TOP; THEY FIND THAT SWEET SPOT THAT
EVERY HALLMARK MOVIE HOPES TO HAVE ONE OR TWO
OF, AND THEN THEY ARE JUST HAMMERING IT LIKE
THERE'S NO TOMORROW."—Dan

HOLIDAY HEARTS

PREMIERED NOVEMBER 23, 2019,
ON HALLMARK MOVIES & MYSTERIES.

STARRING ASHLEY WILLIAMS
AND PAUL CAMPBELL.

WRITTEN BY SUSAN BRIGHTBILL,
BASED ON THE NOVEL *THE CHRISTMAS WISH*,
BY BARBARA ANKRUM.
DIRECTED BY ALLAN HARMON.

Ashley Williams in Holiday Hearts

Peyton (Williams) is planning her family inn's annual holiday party. Her ex, Ben (Campbell), is in town, but planning to head to Honduras to interview for a position with Doctors Care International. When their friend Ford (Matt Hamilton) is hospitalized with a knee injury, Ford asks Ben to take care of Ford's daughter, Lily (Payton Lepinski), and Ben begs Peyton to help out.

HOT TAKES

"BORING, BUT I LOVE PAUL AND ASHLEY."
—Bran

"LOVE ASHLEY AND PAUL; DID NOT LIKE THIS MOVIE."
—Panda

"UTTERLY TERRIBLE; IT'S LIKE *CHRISTMAS JOY* (PAGE 65)
WITHOUT THE COOKIE CRAWL."
—Dan

ALL THE FEELS

Panda: There's the Christmas tree scene where they're trying to sell me on Balsam Hill. It's only colored lights or white lights, but now you can get them both together? That sold me. I got "buy this now" feels.

Dan: So, my man hurt his knee. He's in the hospital bay; there are curtains drawn. In his hospital bay, there is a fully decorated Christmas tree. There is a wreath. It looks more festive than my home. Does this hospital decorate every bay like that? And if you can afford to buy your daughter a horse, you can afford to pay someone to watch your child while you're in the hospital four days for an outpatient procedure. That's all I'm saying.

Paul Campbell in Holiday Hearts

Ashley Williams is super nice. She's so down to earth, and she's hilarious. She did a lot of How I Met Your Mother; *she's a real comedian. We just laughed nonstop on set. There's no time to really mess around when they're doing the takes, but both of us just blow the rehearsals constantly because all we do is crack all the jokes that we would normally do if we had time to blow a few takes here and there. You know, some of this stuff, a lot of it is very serious, but there are a lot of times you can have some pretty serious fun with some of the stuff we do. If you can't laugh at some of the work you're doing, then what are we doing here?—**Paul Campbell***

A HOMECOMING FOR THE HOLIDAYS

PREMIERED DECEMBER 7, 2019,
ON HALLMARK MOVIES & MYSTERIES.

STARRING LAURA OSNES
AND STEPHEN HUSZAR.

WRITTEN BY ZAC HUG.
DIRECTED BY CATHERINE CYRAN.

Stephen Huszar and Laura Osnes in Homecoming for the Holidays

Charlotte (Osnes) plays guitar at an event for departing troops—including her brother Eric (Jesse Irving)—and she has a nice chat with another solider, Matt (Huszar). Cut to a few years later: Charlotte's country-music career is taking off, she dates and eventually dumps fellow music star Taylor Robb (Markian Tarasiuk), and it's time for Eric to come home. She heads home for Christmas, and there she once again encounters Matt, who is helping build housing for veterans.

> "A LOT OF WACKY THINGS GOING ON, BUT I ENDED UP ENJOYING IT."—Bran
>
> "ONLY OK; NOTHING GLARINGLY WRONG, BUT IT DOES EVERY SINGLE TROPE YOU EXPECT FROM HALLMARK WITHOUT A SINGLE SPIN ON IT."—Panda
>
> "WHAT'S ACTUALLY GREAT ABOUT THIS MOVIE IS NOTHING."—Dan

HOT TAKES

WAIT... WHAT?

Panda: She comes home from being on tour, takes a red-eye flight, enters her house. She says, "Merry Christmas, house!" And then she begins cooking a full meal—cookies, the whole nine yards. Her parents come downstairs, and they're like, "Oh, we thought it could have been a robber." You didn't communicate at any point? "Hey, Mom, Dad, I'm coming home early in the morning." And then second of all, who thinks, "Oh, the robber's baking downstairs"?

Dan: First of all, Taylor Robb is a great guy, and the fact that she doesn't want to be with him is weird to me. That's not a Wait, What as much as it just needs to be said. The problem is that our lead, Charlotte, is a chronic hand-holder. You cannot keep going, "I don't want to get back together with you" as you hold this guy's hand; that is not OK. At the end of the day, you get what you get with the paparazzi, because you've decided that this guy who clearly is into you—you're going to hold his hand every time you see him. Read the room just a little bit.

HOMEGROWN CHRISTMAS

WITH GUEST MIKE DiCENZO, THE TONIGHT SHOW

PREMIERED DECEMBER 8, 2018, ON HALLMARK CHANNEL.

STARRING LORI LOUGHLIN AND VICTOR WEBSTER.

WRITTEN BY NINA WEINMAN. DIRECTED BY MEL DAMSKI.

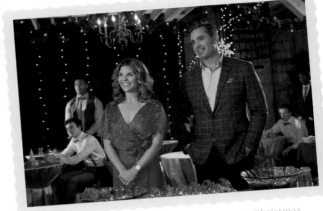

Lori Loughlin and Victor Webster in *Homegrown Christmas*

Maddie (Loughlin) sells off her shoe company and isn't quite sure what her next move will be. She comes home for Christmas, immediately encounters her ex, Carter (Webster), and has to help him prepare for the winter formal.

Panda: Next time we release the Bingo cards, I'm going to have to put "water damage" on one of the squares. The amount of water damage that ruins all the Christmas ornaments.

Dan: It's all the time.

Bran: Every gym in America has a leak, apparently, that ruins the whole production.

Dan: Are there any insurance companies that advertise on Hallmark?

Bran: I will say my favorite water break of the season was the one in *Christmas at Pemberley Manor* (page 31), when the entire city is just destroyed. The gazebo is now in hell.

Dan: *Christmas Wonderland* (page 92), where it's like, "Did you see that one drop?" and then suddenly it's glops of water.

Panda: I kinda like the one in *A Majestic Christmas* (page 146), where Christmas is ruined . . .

Dan: And then they go back, and it's fine. That water is a tricky, tricky mistress.

"FUN, BUT I GOT BORED."—Bran

"LAUGHED OUT LOUD AT THE COOKIE-SWAP SCENE; OTHERWISE KIND OF BORING."—Panda

"A CONTINUAL ROSTER OF DECISIONS THAT MAKE NO SENSE, AND THERE ARE LINES OF DIALOGUE TO MATCH THOSE DECISIONS."—Dan

"GREAT; I'M A *GILMORE GIRLS* FAN, AND I GOT *GILMORE GIRLS* FEELS."—Mike

Mike: The thing I was confused about, and I don't know if this is an actual saying, the line "There are no mistakes, only decisions." I really have trouble wrapping my head around it. I feel like mistakes and decisions can both exist independently of each other.

Dan: This movie was a decision if I've ever seen one.

HOPE AT CHRISTMAS

WITH GUEST ALONSO DURALDE, THE WRAP

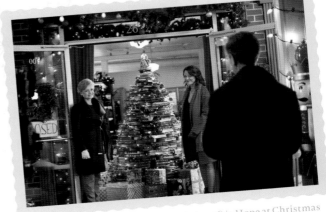

PREMIERED NOVEMBER 20, 2018,
ON HALLMARK MOVIES & MYSTERIES.

STARRING SCOTTIE THOMPSON
AND RYAN PAEVEY.

WRITTEN BY ROBERT TATE MILLER AND
RON OLIVER, BASED ON THE NOVEL BY NANCY
NAIGLE. DIRECTED BY ALEX WRIGHT.

Colleen Winton and Scottie Thompson (red scarf) in Hope at Christmas

Divorced mom Sydney (Thompson) and her daughter, RayAnne (Erica Tremblay), head to Sydney's hometown so that she can sell her grandmother's house, which she recently inherited. While shopping at a local bookstore run by Bea (Colleen Winton), Sydney sees Mac (Paevey) try to walk out with books. She thinks he's a shoplifter, but he actually teaches fourth grade. When his friend Kenny (Nelson Wong; see "Across the Kennyverse," page 128) has to drop out of being Santa, Mac takes his place, and when RayAnne tells "Santa" what her mom wants for Christmas, he uses that information to woo Sydney.

"FINE; I WASN'T DYING FOR IT TO BE OVER, BUT I ALSO WASN'T DYING FOR IT TO CONTINUE."—*Bran*

"LAZY WRITING; THIS MOVIE'S TRASH."—*Panda*

"STANDARD, RUN-OF-THE-MILL BAD."—*Dan*

"COOKIE-CUTTER HALLMARK MOVIE, DOWN TO THE ACTUAL COOKIE CUTTING."—*Alonso*

Dan: The Christmas tree made out of books. It was a dumb bit, but the reason that worked a little bit for me was there was one precalculus book in there. It's like all red books and someone thought, "This looks too perfect, we'll put it in there just to imperfect it," and that was dumb but OK, whatever.

Alonso: I did not have a ton of feels on this one, but I will say as tree-decorating scenes go, this one was pretty OK because the two of them had a certain chemistry. For me, that book tree is a Wait, What.

Bran: They have to make the book tree because the Christmas tree is falling down. And that gave me feels, because it was either my first Christmas with my wife or my second, we came out and our Christmas tree had fallen down.

Panda: My All the Feels actually has to do with the Hawaii thing. I've never been so angry at a Hallmark film. I get negative feelings on this one. I've never been so angry as when the mom is like, "Yeah, just tell your dad you don't want to go to Hawaii. He bought the ticket. You're about to go the next day. It's totally fine. Don't worry about that at all."

Dan: What kid is not going to Hawaii? What kid is going, "You know, Hawaii is wonderful and all, but what about reading past my bedtime? Can I do more of that, please?"

Dan: I'm excited about this—Mac's best friend in the film, who gets hurt playing Santa Claus, I think? Is he Kenny the bartender from *The Christmas Train* (page 82)? Yes, he is. Now, wait for it. Is his name also Kenny in *Hope at Christmas*? Yes. He's the same guy. And now I want a Kenny movie.

Alonso: He's the Rosencrantz and Guildenstern of the Hallmark universe, traveling to small towns to watch white people fall in love.

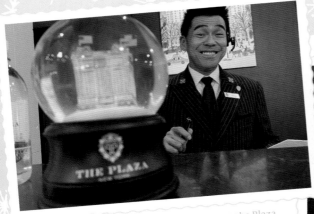

Kenny minds the front desk in Christmas at the Plaza.

Ryan Paevey steps in as Santa after Kenny gets injured in Hope at Christmas.

ACROSS THE KENNYVERSE

While watching *Hope at Christmas* (page 126), Dan made an observation that would forever change our experience of watching Hallmark movies. Realizing that the same actor, Nelson Wong, had played Kenny the injured Santa in *Hope at Christmas* and Kenny the bartender in *The Christmas Train* (page 82), Dan understood that the character was tampering with the very fabric of space-time itself. Dan had unlocked . . . the Kennyverse.

And after Kenny popped up again behind the front desk in *Christmas at the Plaza* (page 34) and in an airport gate in *A Christmas Detour* (page 42), we knew we needed answers. So we went to frequent Hallmark director Ron Oliver for enlightenment.

"Kenny was a three- or four-line part in a movie I did years ago called *Third Man Out* [2005]," Ron told us. "It was this Donald Strachey mystery series based on a book series, and the idea was *The Thin Man*, except husbands, two gay guys who were married, and they solved mysteries. So there Nelson played this scene; I had never met him before, and he comes in, and he is so funny, I thought, 'Okay, this guy is going to be in every movie I do.'

"He became Kenny Kwan. Now he's been in all four of those [Strachey] movies, and I just kept it going. Every movie that I do, there's the character, and you go, 'That's the guy; that's the Kenny Kwan part.' The script will come in, and I'll go, 'Oh there it is,' change the name to Kenny Kwan, cast Nelson, put him in. Now it's become a thing that it's not just my movies—this is across the board.

"There are other Hallmark directors who will do it. I cowrote a movie in 2018 called *Hope at Christmas*, and I was going to direct it, and then I did another one instead. The script still had Kenny's name in it, so I go up there, I know the director, and I said, 'Look, I did that, I was going to do a thing with Kenny, but you don't have to do that, don't worry.' He goes, 'Oh, are you kidding? This is gospel.'

"It's a line item now on the budget. It's very funny. One of our big executives, Randy Pope, who's a big muckety-muck at Hallmark and a dear friend, will ask, 'So what's the Nelson part? Where's Kenny showing up in this one?'

"We just finished a movie called *Exit, Stage Death*, which is one of the *Picture Perfect Mystery* mysteries," Ron continues. "These films are very stylized, so they kind of let me get away with stuff that most people don't get away with on a Hallmark. It's all very stylish and very sort of sixties and a bit tongue in cheek. I thought it was the perfect place for Kenny. We brought him in on the first one, and then on the second one he wasn't in it, and everybody complained. All the stars asked, 'Where's Kenny?' I actually had notes from the network saying, 'Isn't Kenny in this one?' I said, 'Well, I couldn't find a place to put him.' We brought him in on this third one. Now he's returned."

Even with this explanation, the mystery still seemed outside our grasp, so we talked to Kenny himself, Nelson Wong. "Nelson," we asked, "you've played Kenny twenty-seven times. What's your theory on Kenny? Is each Kenny its own Kenny, or is Kenny the same Kenny who just gets around? Who is Kenny? What is Kenny?"

"I think it's beyond me to say," Nelson replied, maintaining the enigma that is Kenny. "I'm just Nelson Wong, I'm just a human outside of movies who gets to visit, but Kenny lives beyond these. I gotta thank you guys at the podcast for naming the Kennyverse, putting your finger on that. I have my theories: he started off being a sidekick to a private investigator, so I still think he's just undercover on jobs. That's my theory."

All aboard for cocktails! Kenny works the bar car in The Christmas Train.

Nelson Wong and Candace Cameron Bure snag a backstage selfie on the set of A Christmas Detour. (Photos courtesy of Nelson Wong)

IF I ONLY HAD CHRISTMAS

PREMIERED NOVEMBER 29, 2020,
ON HALLMARK CHANNEL.

STARRING CANDACE CAMERON BURE
AND WARREN CHRISTIE.

WRITTEN BY SARAH MONTANA.
DIRECTED BY DAVID WEAVER.

Kansas City publicist Darcy Gale (Cameron Bure) spends her holiday doing pro bono work for an educational initiative run by a big corporation. Glenn (Christie), a vice president at the corporation, is what Darcy calls a "no guy," constantly second-guessing her big ideas for the Christmas fundraising gala. With the help of three new friends—and a seemingly endless cavalcade of references to The *Wizard of Oz*—Darcy might manage to help the nonprofit, charm Glenn, and maybe even get a glimpse behind the curtain at the corporation's famously reclusive CEO.

WAIT... WHAT?

Panda: We just need to establish that she's a terrible PR person. She clearly has no clue. She claims she's done research for the demographic, but she goes in and is completely like, "Hey, why don't we include kids in the promotional material?" You can't do that. I know that; I'm not in PR, and we all know that you shouldn't do that. That's a terrible idea.

Bran: The only serious Wait, What I had was that scene where she's dancing in front of the kids. The kids are onstage, they're supposed to be singing. They are not opening their mouths even a little bit. The director said, "Just sway, and it'll be fine." Come on, mouth something! It was unsettling.

Dan: They create a maze at this Christmas tree farm, and it's made of lights. It looks great. And then they say that they're lost. Bro, you can see through the walls of that maze. You can't possibly be lost.

Candace Cameron Bure and Warren Christie in If I Only Had Christmas

"MY LEAST FAVORITE OF THE SEASON; I'M BUMMED."—Bran

"THE PLOT IS BORDERLINE INCOMPREHENSIBLE."—Panda

"IF ONLY I HAD MY TWO HOURS BACK. *SHOE ADDICT'S CHRISTMAS* (PAGE 198) IS *CASABLANCA* NEXT TO THIS."—Dan

IT'S BEGINNING TO LOOK A LOT LIKE CHRISTMAS

WITH GUEST DOUG JONES,
ACTOR, THE SHAPE OF WATER

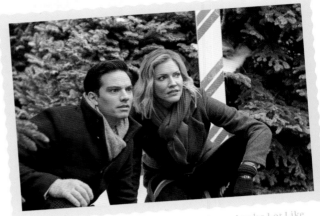

Raf Rogers and Tricia Helfer in It's Beginning to Look a Lot Like Christmas

PREMIERED DECEMBER 22, 2019, ON HALLMARK CHANNEL.

STARRING TRICIA HELFER AND ERIC MABIUS.

WRITTEN BY RICK GARMAN.
DIRECTED BY DAVID WEAVER.

Rival mayors—Liam (Mabius) of West Riverton and Sarah (Helfer) of East Riverton—compete with each other, and with mayors of other towns in New Hampshire, to see who can get a big candle company to build a distribution center in their town. They ultimately realize they have a better shot of winning if they work together, which might also apply romantically—and might, perhaps, restore the two halves of Riverton back into one town.

"THINGS GET MUSHED UP TOWARD THE END, BUT IT'S OUT-OF-THE-HALLMARK-BOX ENOUGH TO STAND OUT."
—Bran

"A WILD CONCEPT THAT THEY DON'T QUITE PULL OFF, BUT I HAD FUN."—Panda

"HATED IT; DON'T TELL ME THESE PEOPLE ARE COMPETITIVE WHEN THEY ALWAYS CHOOSE THE NICEST RESPONSE."—Dan

"IT'S ALL THE BUZZWORDS THAT DAN PROBABLY HATES—IT WAS CUTE, IT WAS CHARMING, IT WAS CHRISTMASY."—Doug

Doug: Remember, my dream role is to play a dad of a grown person in one of these movies, or more than one. Mayor Liam's parents in this, I adored both of them. They were delicious. And again, the chemistry between these two leads, romantically? By the end, when he said, "I need this," comma, "I need you." Come on now, that's a good quote.

Dan: If anybody out there thinks that TV-movie-star/actor Doug Jones is just phoning it in, it's cleared up now. He really does love these movies.

Panda: I like the Christmas barn. That barn was something special to me, and here's why: they have the potluck, right? And coming from church culture, the Christmas potlucks were always something special to me. They would have it decorated in the hall and everything, and you'd go and you pick the potluck food that was kind of lukewarm, but it was still fun.

Bran: I thought the coffee shop was hysterical. That first scene when they walk in and you see that split down the middle, I just thought it was a riot. And I want to find a town where that's the way it is; I think it's so much fun. I loved the decorations, the house battles, and I chuckled large when he pulled out his big mega-snowmen that were just a knockoff of what she had, but bigger.

Doug: I want to know how a town the size of Riverton as a whole could afford a full-time mayor, let alone split into two, and to be able to afford two full-time mayors. I've lived in a small town before, and we had a town council, but they all had other jobs.

IT'S CHRISTMAS, EVE

WITH GUEST JUSTIN KIRKLAND, ESQUIRE.COM, MY YEAR WITH DOLLY PODCAST

PREMIERED NOVEMBER 10, 2018,
ON HALLMARK CHANNEL.

STARRING LEANN RIMES
AND TYLER HYNES.

WRITTEN BY TRACY ANDREEN.
DIRECTED BY TIBOR TAKÁCS.

LeAnn Rimes and Eden Summer Gilmore in It's Christmas, Eve

Eve (Rimes) returns to her hometown for three weeks at Christmastime to be interim school superintendent and slash the budget. Living across the street from Eve's late father's house are music teacher Liam (Hynes)—whose department will suffer from Eve's cuts—and his young daughter.

WAIT... WHAT?

Panda: Hallmark loves to talk tech, and it's one of my favorite things. The two times where they do it the best are, first, Eve and Liam start talking about Brad, who has invented the Christmas wish list, and the way they describe it is, it's a place where people can put the items they want and connect links to them. That's a Word document.

Dan: He invented the Amazon wish list. I think he invented a word-processing-compatible Amazon.

Panda: He also mentions later on, "Boy, the website's really surging right now; there are twenty-five hundred people who have visited. I'm going to have to stay up all night so it doesn't crash." And this hurts me as a teacher, but they raised $162,000 for this. In order to save the jobs of multiple schools, the art and music, so that's two teachers per school, ten schools, that's twenty teachers. Guys, they're paying $8,000 a teacher.

Dan: I'm a principal, and I can tell you $8,000 is barely going to cut it. They will work for that, but just barely.

Justin: This is a good moment to remind people that teachers are grossly underpaid. The other thing that really bothered me is that Eve travels home with one bag, but I counted no less than nine elaborate coat-and-scarf combinations. I mean, great peacoats, wonderful peacoats.

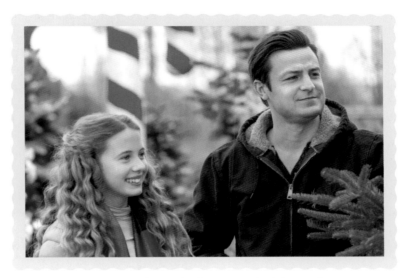

Eden Summer Gilmore and Tyler Hynes in *It's Christmas, Eve*

One of my biggest fears is somebody singing while looking into my eyes. It's like my worst nightmare. I don't know what to do with myself. Do I smile and acknowledge you while you're singing? And how long do I have to wait while you sing before I can clap and be done with this awkward experience? It's one of my biggest fears, somebody staring into my eyes while they sing. And Leanne absolutely loved that when she heard it. She took every opportunity that she had to stare into my eyes while singing. She was just, like, eye contact, the entire movie.—*Tyler Hynes*

JINGLE AROUND THE CLOCK

PREMIERED DECEMBER 22, 2018,
ON HALLMARK CHANNEL.

STARRING BROOKE NEVIN
AND MICHAEL CASSIDY.

WRITTEN BY JOIE BOTKIN AND ZAC HUG.
DIRECTED BY PAUL ZILLER.

Elle (Nevin) is so consumed with chasing after a promotion at her marketing firm and reconfiguring a cookware campaign that she's barely had time to hang out with her friends and organize their annual misfit Christmas party. The man she's been checking out at her coffee place turns out to be Max (Cassidy), a no-nonsense guy from the New York office who is also pursuing the same promotion.

Bran: They get into the elevator together, and they're going up, and they kind of hold hands. Now this gave me feels for many reasons, but the main one is, when my wife and I were dating, we worked at a summer camp together. And one night, she and I and some other people had to go in the back of a truck and pick up trash. We had just started kind of liking each other and stuff, and we're sitting on the bed of the truck on the edge, and I kind of put my hand over hers, and we touched pinkies. It was just a really sweet moment.

Panda: The same scene really got me.

Dan: My All the Feels is this, and props to everyone involved with this movie. This is the first time and the only time all season long that the romantic guy lead or girl lead sees the other in a compromising position with another person that could easily be misunderstood, and it's handled 100 percent correctly. He sees her in the car with Jay [Jeremy Guilbaut], and they're getting warm. He goes back inside. I think there's a commercial break, and then the next scene, he calls her on the phone and goes, "Hey, I saw you in the car with Jay." And she goes, "Oh, that's my friend. I'm not interested in him at all." And it's done! I was like, Wow, everyone acted like adults.

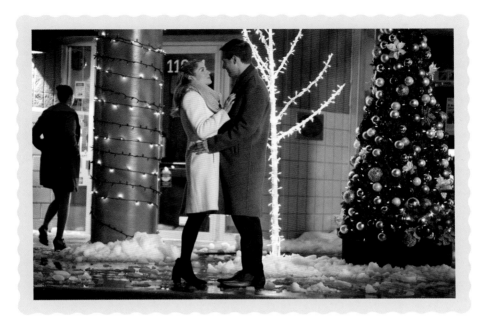

Brooke Nevin and Michael Cassidy in Jingle Around the Clock

"LOVED; THE FRIEND-GROUP B-CHARACTERS REALLY WORKED FOR ME."—Bran

"REALLY LIKED; THE LEAD ACTOR REMINDS ME OF DOLLAR-STORE PAUL RUDD, AND I'M A HUGE PAUL RUDD FAN."—Panda

"NOT TERRIBLE, NOT GREAT; DOESN'T DO NEARLY AS MUCH WRONG AS OTHER HALLMARK MOVIES."—Dan

HOT TAKES

JOURNEY BACK TO CHRISTMAS

PREMIERED NOVEMBER 27, 2016,
ON HALLMARK CHANNEL.

STARRING CANDACE CAMERON BURE,
OLIVER HUDSON, BROOKE NEVIN,
AND TOM SKERRITT.

WRITTEN BY MARIA NATION.
DIRECTED BY MEL DAMSKI.

A passing comet allows nurse Hannah (Cameron Bure) to travel from 1945—just as she learns her husband may have died in World War II—to 2016. Policeman Jake (Hudson) tries to solve the mystery of this strange newcomer while she attempts to return home with the help of an elderly man (Skerritt) she knew as a child.

Panda: At one point, the detective says, "I had the lab test it"—referring to her perfume—"it hasn't oxidized yet." Now I want to point out that, yes it had. Because as soon as you open a bottle of perfume, it oxidizes immediately, because oxidation, kids, is just exposure to oxygen.

Dan: I just want to go to the Crystal Falls forensic lab, where they've got beakers and Bunsen burners out and are going, "It hasn't oxidized yet!" What in the world? That's the worst forensic lab in the country. And that's his big clue.

Bran: Hannah's not good at gingerbread advice. They're building a gingerbread house, and they're doing this loop-de-loop thing for shingles, but barely any icing is going to go on. They're like, "Is it going to stay?" And she's like, "Trust me." CCB, it's not going to stay.

Dan: Hallmark tries to establish 2016 with buzzwords like "eBay" and "Uggs." It also has the worst piece of advice of any Hallmark movie we've ever watched, which is "Maybe everything's a miracle."

"LOVE; IT WAS ONE OF THE FIRST HALLMARK CHRISTMAS MOVIES THAT REALLY TURNED IT ON FOR ME."—Bran

"REALLY LIKE, ALTHOUGH A LOT OF THE DIALOGUE IS ABSOLUTELY RIDICULOUS."—Panda

"NOT GOOD, BUT BETTER THAN ANY OTHER CANDACE CAMERON BURE MOVIE—BUT NOT BECAUSE OF CANDACE CAMERON BURE."—Dan

Candace Cameron Bure and Eamon Hanson in Journey Back to Christmas

LAST VERMONT CHRISTMAS

PREMIERED NOVEMBER 19, 2018,
ON HALLMARK MOVIES & MYSTERIES.

STARRING ERIN CAHILL
AND JUSTIN BRUENING.

WRITTEN BY BLAINE CHIAPPETTA.
DIRECTED BY DAVID JACKSON.

Widowed mom Megan (Cahill) and her daughter return to Vermont to spend Christmas with Megan's parents, who are—to the surprise of their children—planning to sell the house. Complicating matters is the fact that one of the buyers is Nash (Bruening), Megan's high school beau.

WAIT... WHAT

Bran: They create ornaments every year.

Dan: I like the idea of creating ornaments, but simultaneously, if they have to wait to put every ornament up from the previous year, at some point, that's just all day, right? Where are they keeping all those ornaments? And we never saw any ornaments from previous years. I guess in principle, I like the idea of "We make ornaments every year," but in practice, there weren't any ornaments on the tree, and they're like, "Wait, wait, wait, we've got to get thirty-plus years of ornaments"?

Bran: You get the gang together, and you make the same kind of ornaments.

Dan: And then they throw them away at the end of the year? That seems like a waste of time.

Bran: I don't know if you know this, but we're wasting our time *here*.

Panda: It's not technically a Hallmark film, but they bought it, so we'll call it Hallmark. And Hallmark, again, talking tech and internet, I don't think Hallmark understands what the internet is. The sister is singing a song, and her other sister walks in and goes, "That was great. Do you think you'll end up online one day?" The sister responds, "It would be a miracle if it did." No. It's called YouTube. I've got Spotify. And guess what? It's *free*.

Bran: You can be a SoundCloud rapper.

Justin Bruening and Erin Cahill in Last Vermont Christmas

"HALLMARK BOUGHT IT AT THE LAST MINUTE; WASN'T WORTH IT."—Bran

"AWFUL, DUMB, BORING."—Panda

"ONE OF THE WORST; IF HALLMARK IS USUALLY HALF BAKED, THEN THIS IS QUARTER BAKED."—Dan

LET IT SNOW

WITH GUEST PATRICK SERRANO,
LIFETIME UNCORKED PODCAST

PREMIERED NOVEMBER 30, 2013,
ON HALLMARK CHANNEL.

STARRING CANDACE CAMERON BURE,
JESSE HUTCH, AND ALAN THICKE.

WRITTEN BY HARVEY FROST AND JIM HEAD.
DIRECTED BY HARVEY FROST.

Jesse Hutch and Candace Cameron Bure in Let It Snow

Developer Stephanie (Cameron Bure) travels to Snow Valley Lodge to look into tearing it down and building a sleek new resort on behalf of her boss, Ted (Thicke), who is also her father. Brady (Hutch), the son of the owners, shows her around, and she begins to fall for him and for the many Christmas traditions celebrated at Snow Valley, because she and her father have mostly ignored the holiday since the death of her mother.

"SO OVER-THE-TOP CHRISTMASY, SO GOOD."—Bran

"I'M NOT WHOLLY IN, BUT I LIKED IT OK."—Panda

"IT'S TERRIBLE; WHITEST MOVIE OF ALL TIME."—Dan

"CCB'S BEST ACTING; THAT'S ALL I'M GOING TO SAY."—Patrick

The core of my fan base is still very much Hallmark. I mean, if I'm looking at stats behind all my social media accounts, it's mostly women between the ages of eighteen and fifty-five. And yes, absolutely— definitely in the airports, especially—it's always Hallmark. Every time I get stopped, it's because of Hallmark. They say, "I love Let It Snow,*" or "I saw* Harvest Moon,*" or "I saw you when you were on* Cedar Cove,*" and it's just such a wonderful fan base. I haven't met a single Hallmark fan who's one of those fans where you're like, Okay, cool, I'm going to just book it now. Everybody's always sweet, they're kind. They have manners. Hallmark's definitely a culture: they know what they're looking for; they know what kind of projects they want to make and what they don't want to make. And I think that shows in the fan base as well. And all the fans are hard-core, man.—**Jesse Hutch***

Bran: The opening credits, where Brady is skiing down the slopes: it was shaky, it was weird, it was like they got the guys from MTV in '97 and said, "Hey, bring all your shaky-cam angles into the skiing." It was a disaster; it gave me a headache, and I almost fast-forwarded but I couldn't.

Panda: Both the dad and Candace's character are always complaining about how many Christmas decorations there are, at a ski resort, the week of Christmas. He's in real estate! What do you do with that?

Dan: That dad is so terrible, he's the baddest of the bad dads. He also says this: "Our demographic doesn't care about Christmas." Stop. Stop. You're telling me there's an entire demographic rich enough to buy real estate but doesn't care about Christmas? That's not a thing.

Patrick: My thing was the parents only speaking in clichés. It was out of control. "You never get a second chance to make a first impression." "A son is a son until he finds a wife / A daughter is a daughter for the rest of your life." Like, oh, God, no, please stop. Every conversation with the parents, I was just like, Can we be done with the parents?

Dan: I legitimately just thought of something: at one point, he or his daughter says, "We're going to bulldoze the place to the ground." Why are they visiting the lodge? Why does it matter? If they're going to bulldoze it, and he's already bought it, what are we doing right now?

Panda: That just blew my mind.

MAGICAL CHRISTMAS ORNAMENTS

WITH GUEST NIKKI DeLOACH,
HALLMARK STAR

PREMIERED DECEMBER 3, 2017,
ON HALLMARK MOVIES & MYSTERIES.

STARRING JESSICA LOWNDES,
BRENDAN PENNY, AND TIM MATHESON.

WRITTEN BY RICKIE CASTANEDA.
DIRECTED BY DON McBREARTY.

Marie (Lowndes) is a nonfiction editor who dreams of getting back into fiction. Marie used to love Christmas, but a breakup with Clark (Stephen Huszar) four years ago during the holidays has dampened her enthusiasm. Her mom sends her Christmas ornaments from home in an effort to rekindle the holiday magic. The ornaments—and neighbor Nate (Penny), who works at a pediatric hospital—improve her spirits.

Nikki: When the best friend gives a speech in the kitchen after they're playing games: we're deep into the movie at this point, and they're talking about Nate, and Marie is like, "I just need a sign," and I'm thinking, "Girl, you got forty signs! What are you even talking about? You got a barrage of Christmas ornaments. Magical things happening all around you, and you're asking for more signs." It just seems very selfish.

Bran: That dog, that poor dog, needs to go to the bathroom. At the very beginning, she walks in, "Hey pupper, hey pupper." He's by the door, clearly because he has to go to the bathroom. What does she do? She makes a FaceTime call, and there is no way in the world my dogs are making it through that FaceTime call. They'd be all, "Hey! *Hey!* I need to go potty!"

Nikki: I just want to know more about why all these people think they can be so nosy about her packages. Every single time she gets a package, somebody says, "Oh, so what's in it? You gonna open that?" Brendan Penny, the first time, just stands there at the counter, waiting for her to open it. Who are these people who think that they have a right to be a part of her package opening? I've never experienced that in my entire life.

Bran: I want to know about Clark's podcast. We don't get a ton of info about what the podcast is, and as somebody who creates podcasts, I'm very interested in Clark's podcast. And I can't believe they would give a publishing deal to a podcaster.

Brendan Penny and Jessica Lowndes in Magical Christmas Ornaments

A MAJESTIC CHRISTMAS

WITH GUEST TIERNEY BRICKER,
E! NEWS

PREMIERED DECEMBER 2, 2018,
ON HALLMARK CHANNEL.

STARRING JERRIKA HINTON
AND VINCENT CHRISTIAN.

WRITTEN BY JUDITH BERG AND SANDRA BERG.
DIRECTED BY PAT KIELY.

Jerrika Hinton and Vincent Christian in A Majestic Christmas

Architect Nell (Hinton) returns to her hometown to renovate the historic Majestic Theatre to make it a multiplex for the new owner, Connor (Christian), who's not a fan of Christmas.

"LAST HALF DOESN'T LIVE UP TO THE FIRST HALF, BUT I LOVED IT."—Bran

"LIKE A FIVE-HOUR EPIC THAT GOES NOWHERE."—Panda

"I LOVE OLD MOVIE THEATERS, THE LEAD IS GREAT, AND THIS IS A FACEPLANT OF A MOVIE."—Dan

"PLEASANTLY SURPRISED, MOSTLY BECAUSE OF JERRIKA HINTON, WHO CARRIES THIS MOVIE LIKE A BACKPACK."
—Tierney

Diversity wasn't just a Hallmark problem. It's an industry problem. And lots of different areas in theatrical, and even in television, are catching up and reflecting the United States at large more accurately. We knew we had work to do, and we did it. We admitted it. We started to work on that much more in earnest this year [2018] than in years past, and that is the plan to continue, not only in Christmas but throughout the year. It literally was, "We've got to take care of this." And we did.—**Michelle Vicary**
(Executive Vice President, Programming and Network Publicity, Crown Media Family Networks)

Tierney: There was a moment where she was talking about how much she appreciates being able to go home for the holidays, and that hit me a little bit. And their dance in the street is kind of that essential rom-com moment that we all dream of having. Just not in upstate New York where we're not wearing proper winter gear.

Bran: For me, it was the tableau. I'm not a very cultured human. This is my first experience with the tableau. And I was oddly fascinated by it when it happened.

Dan: A movie that ends on a stage with them doing a tableau, somehow they managed to find a way to make that the scene where they kiss in a snowfall. Impressive, to say the least. And also, the dancing in the street, I think, would have worked better for me if it would not have been just so clear that he's a professional dancer.

Panda: For me, it was the dance scene as well. I think that is a genuinely cool scene, because you have the Majestic sign in the background, and they're dancing down the street. That's actually as close as I've seen a Hallmark movie get to good cinematography.

Tierney: Did you guys see the single shot they tried to do? They tried to pull the single take when Connor was walking into the preparations for the dance, and I was like, Is Hallmark really going for it? They want the Emmy.

MARRYING FATHER CHRISTMAS

WITH GUEST BRIE SCHWARTZ,
OPRAHMAG.COM

PREMIERED NOVEMBER 4, 2018,
ON HALLMARK MOVIES & MYSTERIES.

STARRING ERIN KRAKOW, NIALL MATTER,
AND WENDIE MALICK.

WRITTEN BY DAVID GOLDEN, BASED ON
THE NOVELS OF ROBIN JONES GUNN.
DIRECTED BY DAVID WINNING.

The *Father Christmas* trilogy comes to a close with Miranda (Krakow) finally getting to the altar with Ian (Matter), but not before encountering a mysterious family member from her mother's past.

Brie: I was really confused by the children who were talking about the big pressure of being flower children and ring bearers and they were, like, forty-year-old children.

Bran: Ian tells the ring bearer, "If you have any questions about being a ring bearer, let me know." I feel like it's pretty straightforward.

Dan: It is straightforward for a five-year-old. It is most definitely straightforward for a fifteen-year-old. Yeah, my man's got his learner's permit. He's worried about being a ring bearer?

Bran: There was a scene where Miranda sees the uncle at the coffee shop. She approaches him, and she starts to talk. And one of them says, "Hey, can we can find another place to talk?" And so what they do is take it out front. They go right into the middle of the street and say, "Let's hash this out in the freezing cold."

Dan: Then we finally get to the wedding. The pastor performing the ceremony goes, "Ian and Miranda have these vows they've written," and he walks off. He legitimately just leaves.

Erin Krakow and Niall Matter in Marrying Father Christmas

"THREE MOVIES IN, AND I STILL DON'T CARE ABOUT THEM."—Bran

"FELT LIKE WATCHING A WEDDING-PLANNING MOVIE OF A COUPLE YOU DON'T CARE ABOUT."—Panda

"THE WORST; THIS MOVIE HAD NO PLOT, IT HAD NOWHERE TO GO."—Dan

"DEVOID OF CHARM, PRETTY SOULLESS."—Brie

MATCHMAKER SANTA

WITH GUEST KRISTOFFER POLAHA, HALLMARK STAR

PREMIERED NOVEMBER 17, 2012,
ON HALLMARK CHANNEL.

STARRING LACEY CHABERT,
ADAM MAYFIELD, FLORENCE HENDERSON,
JOHN RATZENBERGER, AND LIN SHAYE.

WRITTEN BY JOANY KANE.
DIRECTED BY DAVID S. CASS SR.

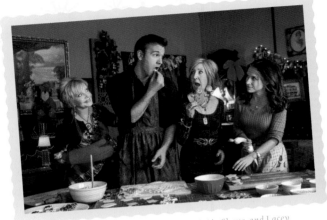

Florence Henderson, Adam Mayfield, Lin Shaye, and Lacey Chabert in Matchmaker Santa

Baker Melanie (Chabert) is dating CEO Justin (Thad Luckinbill), but he spends so much time at work that he's often sending his friend Dean (Mayfield) to entertain her while he's at the office. Melanie flies to Justin's parents' cabin for Christmas; she meets Chris (Donovan Scott) on the plane, and, boy, does he look like Santa. Dean, of course, picks Melanie up at the airport, but they get stuck in a small town where Chris is appearing as Santa. Dean gets trapped in his house with his ex, Blaire (Elizabeth Anne Bennett), by a bear.

"COULD NOT BE MORE IN FOR THE MAGIC,
WHERE THEY HAVE THE GUMPTION TO LET
THE REINDEER FLY."—Bran

"I LIKE THIS MOVIE ALRIGHT; WHAT'S WEIRD
IS THAT IT'S ABOUT A COUPLE WHO EACH FALL IN
LOVE WITH OTHER PEOPLE AND THEN, LIKE—
SHRUG—'SORRY.'"—Panda

"ATROCIOUS; THIS MOVIE ENDS WITH A HANDSHAKE."
—Dan

"THE FACT THAT THEY BROKE IT DOWN THE WAY
THEY DID—I LIKED IT."—Kristoffer

Panda: The fine-dining establishment Sofar's? This place is labeled as legitimately difficult to get into, you need reservations, it's packed. And then on the doors they just have "fine dining" in probably the ugliest font I've ever seen in my life.

Dan: Both windows just say "fine dining." It's like somebody was driving through, and they're like, "If only there was a place in town where we could get some . . . hey, wait a minute."

Panda: I couldn't believe they had this line in a Hallmark movie, but Dean says to the CEO, "Now that you're CEO, you're a target for the fairer sex looking to climb the corporate ladder." Holy smokes! What's happening right now, 2012?

Dan: 2012 at Hallmark is 1962; it is *Mad Men*. It's bad enough that before that, the CEO looks at a girl who walks by and says, "You look lovely today."

Kristoffer: When you're an actor in a movie, especially if it's called *Matchmaker Santa*, you know, and you're the Santa—when your first scene comes up, you don't have to pull so hard. I'm sure he's an amazing guy, and you guys got to meet him at Christmasland Experience, and God bless him. But my God, why would you call that much attention to yourself, like wink-wink-nudge-nudge in the very beginning of the movie, when the whole dang thing is about you?

Dan: If this guy is not Santa, he should be arrested. And if he is Santa, he should be arrested. Listen to some of the things he does: he makes someone get poison oak to get them out of the picture; he impersonates someone working on a road and does so, for some reason, in a Southern accent. To continually use his magic and teleportation skills the way he's using them, that's a real *Watchmen* situation. I'm kind of terrified of Santa. He's a terrorist.

MEMORIES OF CHRISTMAS

PREMIERED DECEMBER 8, 2018,
ON HALLMARK MOVIES & MYSTERIES.

STARRING CHRISTINA MILIAN
AND MARK TAYLOR.

WRITTEN BY VALERIE ALEXANDER,
JAMIE PACHINO, AND JOHN WIERICK.
DIRECTED BY TIBOR TAKÁCS

Noelle (Milian) returns to her hometown from San Francisco to tidy up the affairs of her recently deceased mother. She is awakened by handyman Dave (Taylor) hanging lights on her mother's house, and she presses him into service to deal with various home issues. They team up to save the local lodge, where Noelle's mother hosted an annual Christmas gala.

"LIKED THE MOVIE. I REALLY LIKE CHRISTINA MILIAN; THE GUY WAS KIND OF BORING, WHICH WAS A BUMMER."
—*Bran*

"I LIKED IT; I THOUGHT IT WAS SOLID."—*Panda*

"FORGETTABLE AND BORING; I APPLAUD HALLMARK'S DIVERSITY, IN THAT THEY'VE MADE THESE MOVIES EQUALLY GENERIC FOR EVERYONE."—*Dan*

Panda: The building that they make such a big deal out of—they say there are hundreds of people that come to this gala. Guys, that lodge can maybe hold sixty people, so the big deal is there's not another place that can hold sixty people in the town.

Dan: Well, apparently there are only fifteen carolers; I mean maybe the town only has a hundred people.

Panda: We gotta brainstorm this one out. There's got to be some other place that can hold this.

Bran: If there's one thing I've learned from Hallmark, it's that there's always a barn somewhere.

MERRY & BRIGHT

WITH GUEST JEN KIRKMAN,
COMEDIAN

PREMIERED NOVEMBER 2, 2019,
ON HALLMARK CHANNEL.

STARRING JODIE SWEETIN,
ANDREW WALKER,
AND SHARON LAWRENCE.

WRITTEN BY KAREN WYSCARVER, SANFORD
GOLDEN, AND ERINNE DOBSON, BASED ON
THE SHORT STORY BY MARY KAY ANDREWS.
DIRECTED BY GARY YATES.

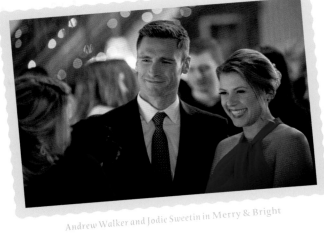

Andrew Walker and Jodie Sweetin in Merry & Bright

Cate (Sweetin) took over her family's candy-cane company, Merry & Bright, which has been around for generations. Corporate fixer Gabe (Walker) comes in to make improvements, and Cate starts exploring the idea of diversifying the company.

"EVERYTHING YOU WANT A HALLMARK
CHRISTMAS MOVIE TO BE."—Bran

"EH, IT WAS FINE, I GUESS."—Panda

"QUINTESSENTIAL HALLMARK: TERRIBLE."—Dan

"LOVED THIS MOVIE, VERY FUNNY, AND THEY LEAVE
THE COUNTRY TO GO TO THE BIG CITY."—Jen

Jen: Why did this company skip a generation? What about her mom? How come her mom was not given this company? She's got nothing to do, clearly. There's something weird going on in that family, and I need to know.

Jen: There's a moment when Andrew Walker's character lights the Christmas tree in the small town, and it wasn't overacting. I really noticed it—he took it in and seemed to really love it, and I got choked up because, I don't know, it was just such a Christmasy moment. There was the barn. And then later in the movie, they reveal that he's always had this painting of a barn in his house that he would look at in New York City as a kid and wish he could go there someday. My feel was sort of force-fed to me, but it works.

Bran: Yeah, I'll piggy-biggy-back off that. My feel is that painting scene, that conversation about the painting. It worked, and to hear him talk about how he had looked at this painting all these years and just knowing that this little town was out there, and he'd stumbled upon it.

Panda: I realize now that this movie might not be so good, and here's why: because I have literally the same feel, which might mean that there are just not a lot of feels to go around in this movie.

Dan: I thought the dance scene worked. And for as much as I didn't like the movie, it's not because the two leads didn't have chemistry. They were fine together.

A MERRY CHRISTMAS MATCH

PREMIERED OCTOBER 25, 2019,
ON HALLMARK MOVIES & MYSTERIES.

STARRING ASHLEY NEWBROUGH
AND KYLE DEAN MASSEY.

WRITTEN AND DIRECTED BY JAKE HELGREN.

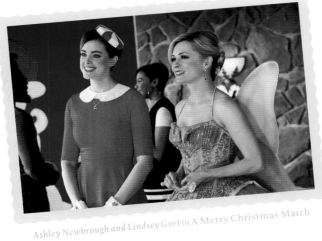

Ashley Newbrough and Lindsey Gort in A Merry Christmas Match

Corey (Newbrough) runs the family antique store at a ski resort, but she dreams of being a theater director. Her high school pal Jillian (Lindsey Gort), now a famous TV actress, returns home with her boyfriend, Davey (John DeLuca), and Davey's best pal, Ryder (Massey), one of L.A.'s most eligible bachelors. Ryder is taken with the antiques, and with Corey.

"I GIVE IT A C; IT FELT LIKE A MIDDLE-SCHOOL PLAY,
AND I LOVE GOING TO REALLY BAD PLAYS."
—Bran

"THE MORE I'VE RUMINATED ON IT, THE MORE I
REALIZE THIS IS ALL-TIME BAD FOR HALLMARK."
—Panda

"I DON'T KNOW IF IT QUITE GETS TO DUMPSTER FIRE;
IT GETS POINTS FOR THE GIRL LEAVING THE SMALL TOWN
FOR THE BIG CITY, WHICH WE DON'T SEE OFTEN."
—Dan

Dan: There is a time when the lead girl comes out in an outfit I called "Candy Striper Express." She's got what we were calling "cleggings," or candy-cane leggings. She's got a red thing on, and then she's got a hat that's off to the side. And that hat is my All the Feels. Did I like the hat? No. But it looked exactly like a Werther's Straw-berries-and-Creme Creme Saver. I can't find those anymore. They stopped making them. Werther's, if you're listening, bring it back. Those Creme Savers were cash. They saved your brand from being terrible and only being grandma candy, and I want them back right now.

Dan: In the movie, no one ever visits the antique store. Literally only the actors who are getting paid to deliver lines; there's nary an extra to be found in the antique store. I feel like most of the movie, whoever was in charge of set and costume was saying, "Oh, time out. We're doing that *today?*" It's half-done the whole way through.

Panda: I have to point out the worst snowball fight in history, from any Hallmark movie we've ever seen.

A MIDNIGHT KISS

WITH GUEST JUSTIN KIRKLAND,
ESQUIRE.COM, MY YEAR WITH DOLLY PODCAST

PREMIERED DECEMBER 29, 2018,
ON HALLMARK CHANNEL.

STARRING ADELAIDE KANE
AND CARLOS PENAVEGA.

WRITTEN BY SETH GROSSMAN
AND MICHAEL G. LARKIN.
DIRECTED BY J. B. SUGAR.

Mia (Kane) and her brother are taking over her family's party-planning business, although she really wants to be a filmmaker. The company doesn't have anything lined up for New Year's Eve, but they get a last-minute call from a fashion designer who's willing to pay them double for their services. When Mia's brother falls off a roof and breaks his leg, his documentarian friend David (PenaVega) has to step in to help her organize the big party.

> "LIKE IT, BECAUSE CARLOS PENAVEGA IS
> SUCH A HAPPY BOY."
> —Bran
>
> "IT'S A LIKE, BUT YOU HAVE TO WATCH
> TWO PEOPLE WHO DON'T HAVE A LOT OF CHEMISTRY
> FIGHT FOR ABOUT AN HOUR AND A HALF OVER
> A PARTY YOU DON'T CARE ABOUT."
> —Panda
>
> "DISASTER."
> —Dan
>
> "DIDN'T GET ME; THERE WERE A LOT OF CRAZY
> PLOT HOLES THAT KEPT CATCHING ME, AND I'M NOT
> ONE TO LET A PLOT HOLE RUIN A HALLMARK
> CHRISTMAS MOVIE."
> —Justin

HOT TAKES

Panda: David goes to the grocery store after Mia's brother falls off the ladder, and I was deeply offended by this line: "They were out of tortilla chips at the store"—which, first of all, what? What store do you go to where they run out of tortilla chips? Then he says, "But I replaced them with these potato chips." Pause. You can't do that. You can't. Potato chips are not as versatile as a tortilla chip.

Justin: I feel like this one in particular hit close to home, because you guys are all originally from the South as well. Have you heard the term "chiggers"?

Dan: For sure.

Justin: So Carlos PenaVega rolls over, brings back some Queen Anne's lace and throws it in a vase, and I'm like, You're going to give everyone at this party chiggers.

Bran and Panda and Dan: Yes, you are.

Justin: I got so nervous, and that's a personal thing. But for anybody who doesn't know, chiggers are little bugs that are typically in Queen Anne's lace, and they get under your skin, and they burrow. They're the worst. Happy Holidays.

Dan: Now, I've never planned a party before, but I do know that if you're the person planning the party, there are a lot of things you can do without bearing any weight on your feet. You can make phone calls, you can schedule, you can do a ton of stuff. You'd be surprised what Google Calendar can do for you if you're a party planner. But Mia's brother breaks his foot, and he's like, "Guys, aside from making a couple calls, I just can't help at all." And most of the things they did—aside from bickering in the van, which was forty minutes of the movie—he could have helped with, and instead he did nothing.

MINGLE ALL THE WAY

WITH GUEST JEN KIRKMAN, COMEDIAN

PREMIERED DECEMBER 1, 2018,
ON HALLMARK CHANNEL.

STARRING JEN LILLEY, BRANT DAUGHERTY,
AND LINDSAY WAGNER.

WRITTEN BY SAMANTHA HERMAN.
DIRECTED BY ALLAN HARMON.

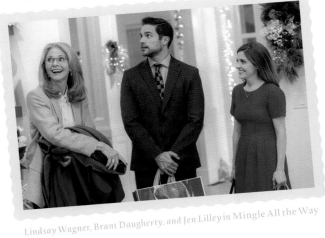

Lindsay Wagner, Brant Daugherty, and Jen Lilley in Mingle All the Way

Molly (Lilley) has been developing an app called Mingle All the Way for single professionals to find dates for holiday work functions so they don't have to keep explaining why they're single. Some potential investors ask if she'd try it out herself, so she signs up and gets paired with Jeff (Daugherty).

"LIKED IT, IT'S JUST THAT SOMETHING WAS MISSING."
—Bran

"OK; JEN LILLEY IS GREAT, THE GUY WHO PLAYS
JEFF DOES A SOLID JOB."—Panda

"DIDN'T LIKE THE MOVIE, ALTHOUGH THE APP SHE
INVENTS ACTUALLY MAKES SENSE."—Dan

"I WAS ROOTING FOR THIS MOVIE, BUT IT DIDN'T
COME TOGETHER."—Jen

Well, we go to a lot of holiday parties. A lot. So if you need some holiday party ideas, if you need some holiday party don'ts, we cover those. It's kind of like you get to go to, you know, thirty parties with us all in one night. So many parties. And the producers kept saying, "Oh my God, there are so many parties in this script." And I was like, Are there? Because I just take everything day by day, right? And then I'm watching the screener, and I was like, Wow—this is a lot of parties. —**Jen Lilley**

Panda: The dancing scene—they're with another couple, and the couple looks at one another, and they go, "Oh, they're playing our song." Guys, the song is "Silent Night."

Dan: That is no one's song.

Bran: Imagine the scene, you're out to eat at a nice restaurant, "Silent Night" comes on, and these two people look at each other. They motion to the floor, and they actually get up and they dance.

Dan: And everybody in the room's just like, "Must be their song."

Panda: How much do you think Jergen's paid to get an awkward close-up of their lotion bottle? This is the most awkward product placement we've seen. She reaches over, and they zoom in on the hand lotion.

Jen: They have no investors yet in the app, but they have gorgeous office space. And they have television ads—they can afford television ads? Before an investor? Because before you get an investor to launch, you're sitting in your pajamas in your living room starting your app, I think. I worked at dot-coms in the nineties, and we were all crammed in one little office with folding chairs, ten people. And we were like, "Someday we'll get investors." And when we didn't, we folded.

MISS CHRISTMAS

Marc Blucas and Brooke D'Orsay in Miss Christmas

PREMIERED NOVEMBER 5, 2017,
ON HALLMARK CHANNEL.

STARRING BROOKE D'ORSAY
AND MARC BLUCAS.

WRITTEN BY JOIE BOTKIN.
DIRECTED BY MIKE ROHL.

Holly (D'Orsay) finds the Chicago Christmas tree every year. This year's tree was destroyed by a crane, so she has to scramble for a replacement. Young Joey (Luke Roessler) writes her a letter, suggesting a particular tree from his farm in Claus, Wisconsin. But when Holly arrives, she discovers that Joey's dad, Sam (Blucas), is unwilling to part with the tree. He and his estranged wife planted it thirty-nine years ago and carved their initials into the trunk.

"DON'T HATE IT; THERE'S A LOT OF GOOD CHRISTMAS IN THE MOVIE TO COVER ITS MULTITUDE OF SINS."—Bran

"DON'T LIKE, BUT IT'S BEAUTIFULLY DECORATED."—Panda

"TON OF CHRISTMAS, TWO VERY CAPABLE LEADS, AND IT'S AWFUL."—Dan

Panda: The thing I'm confused about, and that she drops near the end of this movie, is that she has had a backup tree the entire time.

Dan: The way you say that properly is, "*The backup tree?*" That's me watching this movie. She mentions the backup tree, and I was like, *What?* What is this whole movie about? If your entire job is to secure, transport, and light the Chicago Christmas tree every year, and you can do that job in ten days—you don't have a job.

Panda: I just have to know more about the rotation system of setting up the Christmas festival. He says, "We do it on rotation." If you have a festival that attracts a massive amount of people, this isn't something where, like, "It's Mabel's turn over on Second Street to go set up." If I'm living in this town of Claus, I can tell you for a fact, I will pay money to not have to do that. Can I get out of this by donating? Are you forced into it?

Dan: I imagine a *Hunger Games* situation, where they're just choosing people as tribute to decorate the town. "It's called Claus. Can't not have a decorated town, got to get to it."

THE MISTLETOE INN

PREMIERED NOVEMBER 23, 2017, ON HALLMARK CHANNEL.

STARRING ALICIA WITT AND DAVID ALPAY.

WRITTEN BY MICHAEL NOURSE, BASED ON THE NOVEL BY RICHARD PAUL EVANS. DIRECTED BY ALEXANDER J. F. WRIGHT.

Aspiring author Kim (Witt) gets dumped by her boyfriend for not taking her writing seriously enough, which inspires her to bite the bullet and attend a romance writers' conference just before Christmas at the Mistletoe Inn in New Hampshire. The keynote speaker is H. T. Calloway, Kim's favorite author, who has never spoken in public, and no one knows what he looks like. She befriends fellow writer Zeke (Alpay), who offers good advice and much more.

Panda: I don't want to say this, because it's super cliché, but when he's talking about the spoon, and he says, "The most romantic thing in this room is the spoon because it catches the candlelight's gleam in your eye." Dang it, man, that works. Christmas in New York works for me.

Bran: I would say once you get past the lie of taking her to New York, I have All the Feels for "I'm taking you to New York just to get the details." He's absolutely right; you cannot write about New York unless you've been there. It is a city that demands firsthand details. And I have always wanted to stay at a hotel that decorates every room for Christmas, like the one in New York.

Dan: Her writing is not immediately good. That's great! You think she's going to show up, no one's ever read her stuff, and this famous author is going to read it and be just effervescent with praise, because it's Hallmark. And he's like, "Yeah, the characters are fine. First-draft material. You've got a lot of work to do." It was awesome. It almost saved the whole movie for me.

WAIT... WHAT?

Dan: When they're in New York, and they go up to the hotel room, the view of New York from that window—that is a literal screen. Not a green screen. If you look, that's not a window. There's nothing around it that has a window; there are no shades to draw. It is a literal screen they're projecting New York City onto, and then they're trying to put drapes around it and make it look like a window.

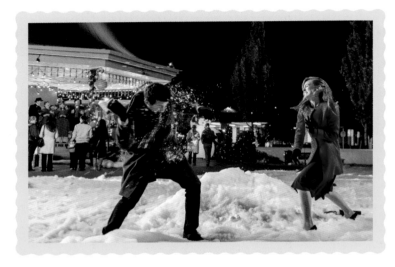

David Alpay and Alicia Witt in The Mistletoe Inn

"WHEN THEY GO TO NEW YORK, I'M SOLD ON THIS MOVIE."—**Bran**

"LOVE IT; ALICIA WITT'S BEST ROLE IN A HALLMARK MOVIE, THE INN ITSELF IS CHARMING AND FUN."—**Panda**

"GRATED ON MY LAST NERVE; SIMULTANEOUSLY THE MOST PREDICTABLE AND MOST UNBELIEVABLE PLOTLINE OF ANY HALLMARK MOVIE EVER."—**Dan**

THE MISTLETOE PROMISE

WITH GUEST ALONSO DURALDE, THE WRAP

PREMIERED NOVEMBER 5, 2016,
ON HALLMARK CHANNEL.

STARRING JAIME KING
AND LUKE MACFARLANE.

WRITTEN BY MICHAEL NOURSE, BASED ON
THE NOVEL BY RICHARD PAUL EVANS.
DIRECTED BY DAVID WINNING.

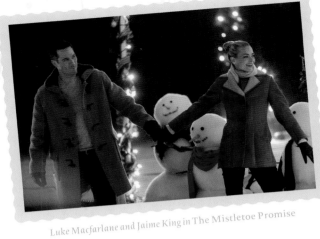

Luke Macfarlane and Jaime King in The Mistletoe Promise

Travel agent Elise (King) and divorce lawyer Nick (Macfarlane) are burned by both love and Christmas, so they decide to pose as each other's significant other to get through a fraught holiday season.

Panda: When they bust out the angel box, and she tells the story for the first time of how she got to where she's at. She does a great job in that scene. It was fairly scandalous, because a lot of times when Hallmark mentions divorce, it's a "We parted on good terms." Here, you have a legitimate, "Man, this guy crushed her." And she carries that weight; she carries that wound well.

Bran: I like the decorating scene. It works for me a lot, that whole scene of them decorating and kind of opening up. And the imperfection of the decorating. So, they light the tree, right? And it's awful. But they're two people who haven't celebrated Christmas in a long time, and they're excited, they're enjoying the decorating of the tree. It works for me.

Alonso: I know that carriage rides are terrible for horses, but you know what, I'm a sucker for a carriage ride, and this one has a really good carriage ride. And I have to say, the little moment they have after seeing *It's a Wonderful Life* felt really genuine. It did seem like two people who are rewarming up to the idea of Christmas after not having it in their lives for a while.

Dan: Hallmark has this thing where they don't just want you to feel good and feel like you've watched something moral. They sometimes shoehorn what "good" is. So you have this boss and he's so big on family, but then they get to the scene where Nick can just lie his way to the partnership, and instead he's like, "I hired this girl to be my girlfriend to impress you guys. But you know what? Family is not the only way to promote goodness." And that is as true a line as has been said in a Hallmark movie.

It's always so funny, the ones that end up popping and becoming popular. You never really know when you're making it. I think that Jaime King is a really amazing actor, and she was committed to making it interesting. And I think it was her only Hallmark film. She just kind of came in there like, "I'm going to put my stamp on this." And as you guys know, Hallmark has a really clear picture about what will and will not pass, and what's good. Especially, I think, when it comes to the way that the girls are going to be. I remember she wanted to wear her hair tight, and they're like, "Oh, mmm, I don't know," and she did it; she really committed to it. She just always came with really strong, bold choices.
—Luke Macfarlane

THE MISTLETOE SECRET

PREMIERED NOVEMBER 10, 2019,
ON HALLMARK CHANNEL.

STARRING KELLIE PICKLER, TYLER HYNES,
CHRISTOPHER RUSSELL,
AND PATRICK DUFFY.

WRITTEN BY RICKIE CASTANEDA
AND MEGAN HOCKING, BASED ON
THE NOVEL BY RICHARD PAUL EVANS.
DIRECTED BY TERRY INGRAM.

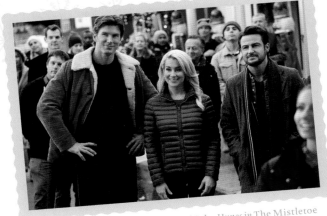

Christopher Russell, Kellie Pickler, and Tyler Hynes in The Mistletoe
Secret

Aria (Pickler), who runs a diner in Midway, Utah, pitches her town as a Christmas destination to popular TV-travel-show host Sterling Masters (Russell). Alex (Hynes) comes to town to scout it out. Unbeknownst to everyone, Alex does all the actual writing and researching, while Sterling, a handsome doofus, is the face of the operation. Alex and Aria start hitting it off as they participate in many of Midway's holiday events, but when Sterling shows up to get Alex to agree to a book deal, he takes one look at Aria, who's an adoring fan, and decides to stick around.

> "LOVE IT, BUT PLEASE STOP CASTING KELLIE PICKLER."
> —Bran
>
> "LIKED IT OKAY; UNIQUE PLOT, GREAT
> PERFORMANCES FROM HYNES AND DUFFY."
> —Panda
>
> "EVERY TIME PICKLER SPEAKS, THE MOVIE GRINDS TO A HALT."
> —Dan

HOT TAKES

The Mistletoe Secret was definitely hot. We're sweating; sets are melting. We were trying to contain scenes to very small areas where we could have some sort of snow, but yeah, these things generally are shot not at Christmastime, obviously, because they've got to come out at that point. So you're usually drenched in sweat, pretending like you're shivering, and that is one thing that I worked hard at as an actor–to pretend I'm cold. Directors really appreciate it. "Look more cold!"—Tyler Hynes

WAIT... WHAT?

Bran: Alex is talking to Sterling: "Four years as your college roommate, five years as your ghostwriter, ten years as your best friend," and then he says the line, "Shall I do more math?" If it is math, it's bad math, because five plus four equals nine.

Panda: At one point, Aria tells Alex, "Hey, I'll pick you up at ten a.m.," and he goes, "Ten a.m.?" Like it's super early in the morning. She takes a picture with him as they're both on a carriage. She goes, "Your city friends won't believe it." I have a feeling that his city friends will, in fact, believe it because—I don't know if you know this—there are carriages in the big city.

Dan: The first scene in the diner is a real doozy, because she has a meeting with the Christmas Council. Is it a real thing? Yes, it is. Is she the president of it? Yes, she is. And they are watching *Masters of Travel* on a VHS tape? She hits rewind, and you hear the tape whir in the background.

THE MOST WONDERFUL TIME OF THE YEAR

WITH GUESTS RACHEL WAGNER AND AMBER NIELSEN, HALLMARKIES PODCAST

PREMIERED DECEMBER 13, 2008, ON HALLMARK CHANNEL.

STARRING BROOKE BURNS, WARREN CHRISTIE, AND HENRY WINKLER.

WRITTEN BY BRUCE GRAHAM.
DIRECTED BY MICHAEL SCOTT.

Single mom Jennifer (Burns) is stressed and overworked this Christmas, and her fiancé, Richard (Woody Jeffreys), is a dullard with nice shoes. Jennifer's Uncle Ralph (Winkler), a retired cop, is traveling to Chicago to spend Christmas with her; at the airport he befriends Morgan (Christie), and when Morgan's connecting flight to Denver is cancelled, Ralph invites him to spent the night at Jennifer's house.

"LOVE IT; ONE OF THE FEW HALLMARK MOVIES THAT GENUINELY MAKES ME LAUGH."—Bran

"WON ME OVER IN THE FINAL TEN MINUTES."—Panda

"REALLY, REALLY BAD; SEEMS TO BE SET BEFORE THE WOMEN'S LIBERATION MOVEMENT."—Dan

"ONE OF MY FAVORITES; I THINK I LIKE OLD HALLMARK BETTER THAN NEW HALLMARK."—Rachel

"JUST OK; A LOT CREEPIER THAN I REMEMBER."—Amber

I have a cabin in Vancouver; it's boat-access only. And when the storms come up, you don't leave, but I had an audition for [The Most Wonderful Time of the Year] and two other ones. My husband and I pounded through all kinds of waves and stormy weather. It was incredible. And I guess because I didn't care so much about the auditions, I went in. Didn't even shower, I just threw something pretty on, slammed some makeup on—did it, boom, did the other one, boom, did the other one, boom, and went back to the cabin. We pounded through the ocean again, and by the time I got back there, I had booked all three.—Rukiya Bernard

Rachel: You just need to learn how to do Christmas; that's the message of this movie. She's doing Christmas wrong. I think you get the feels from things like her throwing out the Christmas cards, and her learning that that's not good to do. I also got total feels from when Morgan goes on the roof and plays Santa. I thought that was really sweet.

Dan: I'm sorry, if you don't have some sort of feels when they make this kid believe in Santa, then I think you're a robot.

Bran: The scene that gave me All the Feels, and I know this is predictable, was at the very end, where he's hearing her over the intercom and realizes that it's him she's talking about. He turns to people and says, "That's me! That's me!" The feeling that he portrayed there of "I wanted this to be me," and then the realization, "Oh, it *is* me," that gave me all those feels.

Amber: Mine's going to be really silly, because I was really creeped out during this rewatch. As a single lady, I thought this sounds like a perfect recipe to be murdered. This sounds like a Lifetime movie. But the closing-credits song made me feel so warm and fuzzy; it made me feel better.

Panda: I think the consensus is that the best scene is where they're trying to get him to believe in Santa; that one got me. But I will say a second scene that I think is understated but is really good is when they go shopping for a real Christmas tree. I love that scene, and the little boy gives Morgan a hug. I connected with that.

THE NINE LIVES OF CHRISTMAS

PREMIERED NOVEMBER 8, 2014,
ON HALLMARK CHANNEL.

STARRING KIMBERLEY SUSTAD, BRANDON
ROUTH, AND GREGORY HARRISON.

WRITTEN BY SHEILA ROBERTS AND
NANCY SILVERS. DIRECTED BY MARK JEAN.

Veterinary student Marilee (Sustad) and firefighter Zachary (Routh) bond over their mutual love of cats. After Marilee's landlady evicts her for having a pet, he lets her move into a house he's restoring and planning to flip; will these commitment-phobes admit their felines for one another?

> **"BEST CHEMISTRY; COULD HAVE USED MORE CHRISTMAS; LOVE IT."—Bran**
>
> **"FINE; WASN'T OVERWHELMING."—Panda**
>
> **"YES, THEY'VE GOT CHEMISTRY, BUT THIS IS A DEBACLE."—Dan**

Dan: At the very end of the movie, there's a Christmas Day pet adoption. I want to say that one more time: on Christmas Day, in beautiful, sunny, green Portland, there are people not opening presents but gearing up to adopt animals.

Bran: Do you think this house caught on fire, and that's when he saw it for the first time? Maybe that's how he gets his houses?

Dan: Does Zach carry his firefighter jacket around with him in his car? That's supposed to stay over at the firehouse. That's flame retardant for up to four hundred degrees. Marilee kept it for a night. You can't do that.

Panda: I think the love story we were all more interested in was between the cats, Queenie and Ambrose. They said they were in love at first sight.

Brandon Routh was at Comic-Con in San Diego, and they have this whole crowd out there, and they do this announcement when Brandon comes out. They're like, "Who's here for Brandon for Superman [Returns]?" And the crowd cheers. And then he goes, "Who's here for Brandon for DC's Legends of Tomorrow?" And more cheers. And then somebody from the crowd goes, "Who's here for Brandon for the cat movie?" Humongous eruption, bigger than the first two. He texted me, "I think I'm more famous for Nine Lives of Christmas." And he said every other person who came to get an autograph at his booth was a woman in her sixties.—Kimberley Sustad

NORTHERN LIGHTS OF CHRISTMAS

PREMIERED DECEMBER 15, 2018,
ON HALLMARK MOVIES & MYSTERIES.

STARRING ASHLEY WILLIAMS,
COREY SEVIER, AND ART HINDLE.

WRITTEN BY JAMES IVER MATTSON
AND B. E. BRAUNER, BASED ON THE NOVEL *SLEIGH
BELL SWEETHEARTS*, BY TERI WILSON.
DIRECTED BY JONATHAN WRIGHT.

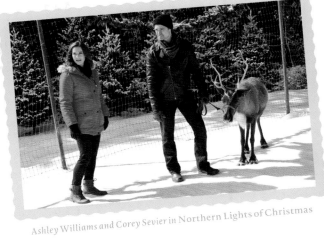

Ashley Williams and Corey Sevier in Northern Lights of Christmas

Pilot Zoey (Williams) has inherited an Alaska ranch and plans to sell it so she can buy her own plane. The current caretaker, Alec (Sevier), isn't thrilled to hear this, since several reindeer are living in the barn. He wants to take off, but Zoey says if he'll stay and help, she'll let him approve the buyer and get a cut of the sale. As Zoey organizes a big Christmas festival on the ranch, and as she gets to know Alec, she has second thoughts about unloading the property.

TOPHER PAYNE, SCREENWRITER

Topher: *My Summer Prince* led to *Broadcasting Christmas*, and *Broadcasting Christmas* led to another movie that I did a rewrite on. And then they ended up going with another writer after that; it was a project that had been in development for a long time. And it's one you've covered.

Dan: Can you tell us what it is?

Topher: I cannot!

Bran: So your version was better, is what you're trying to say.

Topher: I'm just saying: all versions are different.

Dan: That's a good answer. But let me ask you this: when you listen to that episode of us covering the movie that your rewrite didn't get put on, did you take any sort of, I don't know, joy in our take on it?

Topher: I absolutely did, because I never watched the movie. Because what would come out similar to what I had written would be frustrating, and what would come out different would also be frustrating. So I just avoided it altogether. And then I listened to your episode, and I'm like, Mm-hmm, I wonder why they didn't fly, too.

Panda: Guys—reindeer. I'm going to just leave it there. Reindeer are the best. They are like big dogs with horns, and I love it. I friggin' love the reindeer; every single time they were on the screen, I was like, Yeah, reindeer!

Bran: I don't have feels for this movie . . .

Panda and Dan: What?!

Bran: . . . aside from the Northern Lights. Just in theory though. It is on my bucket list.

Dan: All those Christmas trees lit up did nothing for you? I cannot believe this.

Panda: I actually have two in this one, and I can't believe you don't have a single one. As he's flying in the plane with her, and he takes a picture, I thought, "That is a good moment."

Dan: My feels, legitimately, were this guy and his wife planted a Christmas tree for every year they were married. Come on.

Bran: I'm sorry. I just think I let my disdain for the leads take the Christmas joy out of me.

Dan: You know what? The fact that you're willing to admit you don't like one of these, that's why I love you, man. Merry Christmas, dude.

Bran: You know the writers brought it up: do we make the reindeer fly? And somehow it got scrapped.

Dan: Somebody was like, "No, that's too ridiculous."

NORTHPOLE

PREMIERED NOVEMBER 15, 2014,
ON HALLMARK CHANNEL.

STARRING TIFFANI THIESSEN,
JOSH HOPKINS, BAILEE MADISON,
JILL St. JOHN, AND ROBERT WAGNER.

WRITTEN BY GREGG ROSSEN AND BRIAN SAWYER.
DIRECTED BY DOUGLAS BARR.

Santa Claus (Wagner) and Mrs. Claus (St. John) worry that the global supply of holiday happiness, which powers their home base of Northpole, is dying out. Elf Clementine (Madison) travels to a town where young Kevin (Max Charles) and his iconoclastic teacher (Hopkins) try to get Kevin's journalist mom, Chelsea (Thiessen), to embrace the magic of Christmas.

Bran: When we first meet Ryan, the teacher, he's talking about fractions, and he cuts his necktie into pieces. I think we all have had some good teachers in our day. At the end, there's a voice-over where Kelly Kapowski is reading the retraction letter that she wrote, and it's set to all these Christmas scenes. And then the very end of the movie, where they're skating around with the candles, and it pans up, and the candlelight—the happiness from the candlelight—goes to Northpole.

Panda: The Christmas decorating scene where they go out as a little family, and they just decorate the little tree. It's like a *Charlie Brown Christmas* moment where they're throwing ornaments at this tree, and it's fun, but then everyone joins them. That scene shouldn't work because it's so predictable, but I was smiling the whole time.

Dan: I thought the snowball fight was probably the most earned snowball fight; I thought it really worked. And then Mr. Pendleton getting his letter back from Santa fifty years later—it's a good scene. I can't argue with that. I think maybe I was a little too hard on it in the Hot Take—this is a better movie than anything I saw in 2018.

Bailee Madison in Northpole

NOSTALGIC CHRISTMAS

PREMIERED OCTOBER 31, 2019,
ON HALLMARK MOVIES & MYSTERIES.

STARRING BROOKE D'ORSAY
AND TREVOR DONOVAN.

WRITTEN BY RAUL SANCHEZ INGLIS, BASED ON
THE NOVEL *THE HOUSE OF WOODEN SANTAS*,
BY KEVIN MAJOR. DIRECTED BY J. B. SUGAR.

Brooke D'Orsay and Trevor Donovan in Nostalgic Christmas

Anne (D'Orsay), who works for a high-tech toy company, is coming home for Christmas. Her father is planning to sell the family toy shop, where Anne, as a child, hand carved a collection of themed Santas. Keith (Donovan) works at the mill, which might be closing soon. Keith and Anne are thrown together on the Christmas committee, and they solve problems ranging from the disappearance of a forty-foot tree to the absence of the guy who usually runs the pageant. Will Anne's hand-carved Santa figures change hearts and minds? Will Keith figure out a way to keep the mill open? Will Anne tell her high school boyfriend to take a hike so she can be with single-dad Keith?

> "PRETTY DUMB; IT WAS MORE POINTLESS THAN JUST A PARTY-PLANNING MOVIE BECAUSE THE CARNIVAL JUST SEEMS TO HAPPEN."
> —Bran

> "I WISH IT WAS SO-BAD-IT'S-GOOD, BUT IT'S JUST NOT VERY GOOD."
> —Panda

> "A TRAIN WRECK—AND FOR A MOVIE THAT'S CALLED *NOSTALGIC CHRISTMAS*, IT'S MORE ABOUT PLANNING A PAGEANT AND SAVING A MILL THAN THINKING ABOUT THE GOOD OLD DAYS."
> —Dan

Dan: The company that's interviewing all these mill workers in Maine is doing interviews on Christmas Eve, and I just want to know who made that call. "You know what we could do, Dave? We could do the interviews the day before Christmas, have all of these poor people that are going to lose their mill jobs drive away from their family, and if they really want it, they'll show up." That's terrible. Those are the worst people.

Well, visually, I mean, it doesn't get any better, to me. The sets, the backdrops, the lighting, the camera angles and moves—visually, these movies are just on point. They're becoming a little bit more current on topics and things, so I think they're doing so well at walking that tightrope of staying true to the brand and the way they've been making movies for the past decade, and then also always trying to improve and to make adjustments without losing their core fan base. **—Trevor Donovan**

ONCE UPON A CHRISTMAS MIRACLE

PREMIERED DECEMBER 2, 2018,
ON HALLMARK MOVIES & MYSTERIES.

STARRING AIMEE TEEGARDEN,
BRETT DALTON, AND LOLITA DAVIDOVICH.

WRITTEN BY SHANNON FOPEANO.
DIRECTED BY GARY YATES.

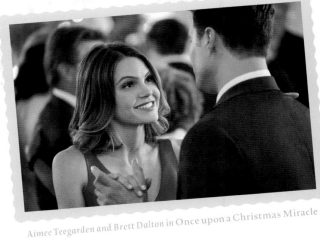

Aimee Teegarden and Brett Dalton in Once upon a Christmas Miracle

Based on a true story: Heather (Teegarden) is a grad student who desperately needs a liver transplant. Former Marine Chris (Dalton), who's just getting to know her, volunteers to be the donor. By next Christmas, they will share more than a tissue type.

"ADORED EVERYTHING ABOUT IT."—*Bran*

"SOME REALLY GOOD SCENES; THE FACT THAT IT'S BASED OFF A TRUE STORY HELPS."—*Panda*

"NOT GOOD, ALTHOUGH IT BEING BASED ON A TRUE STORY DOES GIVE IT MORE OOMPH. SO, I HAVE AN ALTERNATE TITLE OF THIS MOVIE: *CHRISTMAS DE-LIVERED*."—*Dan*

"GO HOME."—*Bran* "THAT'S BAD."—*Panda*

Bran: My All the Feels is, I believe they're getting ready for her to be rolled back for the surgery, and they're holding hands. She says, "How can I repay you for this?" And he says, "You owe me absolutely nothing." And that made me tear up. That, to me, is the heart of this season, the Christmas season. I might get choked up just talking about it.

Panda: It's when he first tells her, "I'm a match to you." That scene is really well done. Their hug is crazy awkward; that's a really weird way to hug, over the table, but it seemed believable to me.

Dan: My What the Hallmark is that these two should not get married, because Heather is setting herself up to lose every marital fight from here to eternity. "You didn't take the trash out." "Well, do you remember that one time I gave you half my liver?" "Why didn't you do the dishes?" "Well, the thing is, I started to, and then *half a liver*." What a guy, to do that and not use it later.

Bran: He hadn't used it yet, but what needs to happen in order for him to use it?

Dan: He needs to forget an anniversary or something. He forgets the anniversary, and then he's going to go straight to the liver.

CHRIS AND HEATHER DEMPSEY

Heather: Hallmark was really great. The writer consulted with us a lot, asking, "Is it OK if we make little changes here and there?" And in October, when they were filming in Winnipeg, Canada, we got to go there for a couple days and be on set and actually meet Amy and Brett and the rest of the cast. So that was a really cool experience, you know, first time being on a movie set. We watched it at my uncle's house; our whole family went over there. We had food and everything. Chris and I could have gotten a copy of it and watched it prior to its first airing on TV, but we wanted to watch it with the whole family.

Chris: The thing that we liked most about it is that it reached so many people, just to get the word out there about organ donation. People contacted us through Facebook, saying stuff like, "We're organ donors now because of you guys." That is really cool to hear.

Heather: It was a hard recovery process, and seeing how much this has affected people in a positive way, and people saying, "I'm going to look into living donation," or "I'm going to register as a donor now, because of you and your story"—that makes me feel so good inside. It gives me a sense of purpose that I really am here for a reason.

ONCE UPON A HOLIDAY

WITH GUEST CINDY BUSBY, HALLMARK STAR

PREMIERED NOVEMBER 5, 2015,
ON HALLMARK CHANNEL.

STARRING BRIANA EVIGAN,
PAUL CAMPBELL, AND GREG EVIGAN.

WRITTEN BY DAVID GOLDEN.
DIRECTED BY JAMES HEAD.

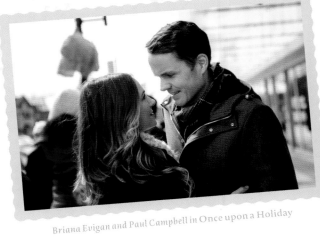

Briana Evigan and Paul Campbell in Once upon a Holiday

Princess Katie (Evigan) of Monserrat visits New York at Christmas and plays hooky from princess duties. Contractor Jack (Campbell) helps her out after her stuff gets stolen. He shows her the town, and takes her to an all-Santa party. Can this royal and this commoner find love?

Hot Takes

"I LOVE PAUL CAMPBELL; HE BRINGS THE COMEDY."
—Bran

"I LOVE THIS MOVIE HARD CORE."
—Panda

"TAKES HALLMARK TO ANOTHER LEVEL OF DUMB—BUT I DIDN'T HATE IT."
—Dan

"WOULD HAVE LIKED MORE ROYALNESS, MORE CHRISTMAS."
—Cindy

The thing about Hallmark movies is there is a very, very specific tone you have to bring to it. They call it a "sparkle." I try not to use that term to describe what I do, but it is a fine line, because you're trying not to make cheesy movies. Hallmark has really tried to distance itself from cheese. The movies are sentimental and they're sweet, but they're not cheesy, and they're not over the top, not broad. It's hard to walk that line of sweet and sincere and not cheesy, and do it all in fifteen days. They're incredibly challenging, but also really fun to make.—Paul Campbell

Panda: At one point, the princess says, "Oh, this song—my mom used to sing it all the time." It's "Joy to the World."

Dan: It's this little family ditty that you may not have heard of, but somehow made its way into the public domain.

Panda: I am most confused by the inconsistency of what she, as a princess, does know and does not know. She seems baffled by the phrase "Call the cops." She has not ever seen a hot dog before, but she does drop a Larry the Cable Guy reference with "Git 'er done." Hot dogs have not made it, but Larry the Cable Guy has made inroads all over their country.

Cindy: I have a list of things that I would love to discuss. One of which is, why doesn't she care that she lost the camera her mom gave her? And then when the bodyguard guys show up, I thought it was the mafia coming in. I was like, Wait, is this a royal mob family? Also very confused as to why she fell asleep at the party. That's the biggest one. She doesn't know anyone, and yet she feels very comfortable to just pass out on a couch with a bunch of strangers.

Bran: Jack seems to give this girl a really hard time for not wanting to hop in his creeper van after just getting robbed. He's like, "Why won't you get in the van? Just get in the van." She just got robbed, Paul! Just relax for a second. She'll get in the van eventually, on her own time.

Dan: I struggle to fathom a princess who's a big enough deal that the press is hounding the royal family about why the princess isn't showing up, but also a small enough deal that no one in New York City recognizes her. No one.

OUR CHRISTMAS LOVE SONG

PREMIERED NOVEMBER 24, 2019,
ON HALLMARK MOVIES & MYSTERIES.

STARRING ALICIA WITT
AND BRENDAN HINES.

WRITTEN BY JULIE SHERMAN WOLFE.
DIRECTED BY GARY YATES.

Alicia Witt in Our Christmas Love Song

Country star Melody (Witt) debuts her new Christmas single at the Grand Ole Opry. Her one-time mentor, who hasn't had a hit in a while, threatens to sue, claiming that the song is ripping off one of her singles. Since Melody wrote the song in high school, she heads home for Christmas, looking for evidence of having written the song as a teen. Her family is delighted to see her, but her ex, Chase (Hines), still feels resentful that his former duet partner went off without him. They collaborate on a new song for the town's Christmas festival, but will she blow it off to sing on a live TV special? And will she find proof that the song is hers?

"JUST OK; I LIKE THE IDEA OF THIS MOVIE MORE THAN I LIKE THIS MOVIE."—*Bran*

"A BIG NOPE FOR ME; NOPE, NOPE, NOPE, NOPE, NOPE."—*Panda*

"BORED TO TEARS; THERE'S SOMETHING ABOUT ALICIA WITT MOVIES THAT JUST LULL YOU INTO SLEEPY SUBMISSION."—*Dan*

Panda: The movie's built around establishing when she wrote this song, and her idea is, "I'm going to go back to my home town to find the original sheet of paper and thereby prove that I wrote this song way back when." I know she says, "Oh, we could get the document age-verified," but I don't think that's how that works.

Bran: And when she finally runs into the other singer at the very end, they make up really quickly for two people who were getting ready to sue one another.

Dan: Alicia Witt quotes somebody saying, "A hit song is just a new song that no one's heard yet." And my question is, shouldn't it be the reverse of that? "A new song is a hit song that no one's heard yet"?

PICTURE A PERFECT CHRISTMAS

PREMIERED NOVEMBER 9, 2019,
ON HALLMARK CHANNEL.

STARRING MERRITT PATTERSON
AND JON COR.

WRITTEN BY TRACY ANDREEN.
DIRECTED BY PAUL ZILLER.

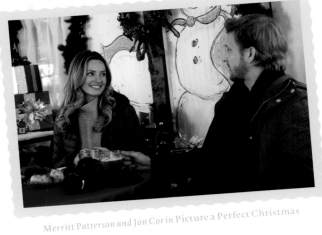

Merritt Patterson and Jon Cor in Picture a Perfect Christmas

Globe-trotting photographer Sophie (Patterson) visits her grandmother, who just hurt her foot, at Christmas. The grandmother often babysits Troy (Luke Roessler), the boy next door, who's being raised by his single uncle, David (Cor). As Sophie steps in to help take care of Troy and spends more time with David, will this Switzerland-bound traveler set down roots and form a new family?

"WHEN YOU HAVE FORTY MOVIES OVER TWO MONTHS, THERE ARE GOING TO BE SOME OF THESE, WHERE THEY JUST EXIST, BUT I'M NOT MAD AT IT."
—Bran

"I LIKED THIS MOVIE, BUT I'M PROBABLY GOING TO FORGET I SAW IT BY THE END OF THE CHRISTMAS SEASON."
—Panda

"FORGETTABLE, RUN-OF-THE-MILL, HALLMARK-LEVEL BAD."
—Dan

Panda: In a relationship, how soon is too soon to invite yourself, and the kid you're taking care of, on a trip to Switzerland?

Dan: If the answer is not in years, then it's too soon.

Panda: The very last scene when she has left, and he's not sure she's going to come back; she comes on out and joins them outside and kind of surprises them. I just love that. I got Christmas chills from that scene.

Bran: There was a scene that gave me feels—it was ridiculous, but it's happened to me, although not as aggressively as in this movie. My homeboy Troy is drinking some hot chocolate, and he either laughs or just breathes in; there's a lot of whipped cream in the hot chocolate, and so when he laughs or breathes in, the whipped cream comes up and hits him in the face.

Dan: This movie has a really good message, which I don't find too often in these movies, which is "Letting others help you is just as much a gift as receiving it." So many people have such a hard time receiving gifts, because there's no way they feel like they can repay, and they're so worried about repaying. That to me is a good, solid Christmas message in a movie.

PRIDE, PREJUDICE AND MISTLETOE

WITH GUEST PHILIANA NG, ENTERTAINMENT TONIGHT

PREMIERED NOVEMBER 23, 2018,
ON HALLMARK CHANNEL.

STARRING LACEY CHABERT, BRENDAN PENNY,
SHERRY MILLER, AND ART HINDLE.

WRITTEN BY NINA WEINMAN, BASED ON
THE NOVEL BY MELISSA DE LA CRUZ.
DIRECTED BY DON MCBREARTY.

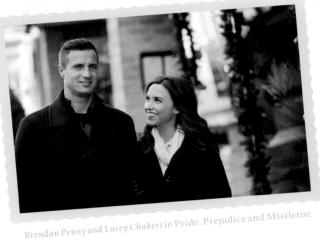

Brendan Penny and Lacey Chabert in Pride, Prejudice and Mistletoe

Investment banker Darcy (Chabert) is having some friction with the partners in her firm, but she hopes to take her mind off it by going home for the holidays. Her mother is throwing a big gala and needs Darcy's help to organize it. The caterer is Luke (Penny), her old high school rival, and even though they're very competitive, they find themselves enjoying each other's company. Will Darcy's partners kick her out? Will the gala come off? Will Darcy's dad stop trying to pressure her into working for him and marrying her stiff ex-boyfriend?

"JUST OK."—Bran "JUST OK."—Philiana

"ONLY OK."—Panda "PURE SCHLOCK."—Dan

WAIT... WHAT?

Panda: The partners are meeting, and they're getting ready to throw out Lacey Chabert's character. Here's what's interesting to me: originally, Lacey's inside person, who's letting her know that the partners are against her, says, "Hey, we're going to go ahead and go espionage, kind of sneaky, into this meeting that the partners are going to have about you." And they don't; instead, literally, for some reason, they're able to hack the system, and they're able to have Lacey pop onto the screen and be like, "Hey." Do you guys ever get the feeling that the world of technology for Hallmark is far more terrifying in Hallmark's mind? People can just pop into meetings whenever they want to!

Philiana: I felt like this was a PSA for being financially secure, like we all need to learn how to take care of our finances or something, because they kept making that be a huge point. And then, who helped Luke cook for the event?

Dan: Or who was running his restaurant while he was catering? Because clearly he was doing everything with Darcy.

RETURN TO CHRISTMAS CREEK

PREMIERED NOVEMBER 17, 2018,
ON HALLMARK MOVIES & MYSTERIES.

STARRING TORI ANDERSON,
STEPHEN HUSZAR, AND STEVEN WEBER.

WRITTEN BY KIRSTEN HANSEN.
DIRECTED BY DON MCBREARTY.

Tori Anderson, Stephen Huszar, and Steven Weber in
Return to Christmas Creek

Developer Amelia (Anderson) comes up with an app to make Christmas shopping easier, but everyone hates it because it's impersonal, and then her boyfriend breaks up with her. To get away from everything, she decides to visit Christmas Creek, where she hasn't been since she was thirteen because of a feud between her father and her Uncle Harry (Weber). Harry welcomes her to town, as does her childhood friend Mike (Huszar).

"LOVED IT; A RARE MOVIES & MYSTERIES THAT HAD ENOUGH CHRISTMAS TO GO AROUND."—Bran

"WELL-THOUGHT-OUT, LEGIT DRAMA; GREAT FILM, FOR HALLMARK."—Panda

"THE STEVEN WEBER SCENES ARE BORDERLINE REAL-MOVIE."—Dan

Bran: There's a scene where Harry and Pamela [Kari Matchett] get together, and they're drinking some wine, and they go to the piano and sing "Auld Lang Syne." It felt super authentic. It didn't feel polished. They were doing some things with harmonies where it seemed as if they were figuring it out on the spot.

Panda: The scene that had me smiling was where Amelia just kind of throws Mike to the ground, and it sounds like she broke his face in the process. But then they start doing the snow angel and they hold hands. It got me.

Dan: When Harry and his brother, Amelia's dad, reconnect and hug and squash their beef, if you will. There's something about the family getting back together that traditionally does work. And it's weird because I thought Hallmark was going to do that all the time, so it still is fresh enough to give me a little bit of the feels.

REUNITED AT CHRISTMAS

PREMIERED NOVEMBER 21, 2018,
ON HALLMARK CHANNEL.

STARRING NIKKI DeLOACH
AND MIKE FAIOLA.

WRITTEN BY DAVID GOLDEN AND MARCY HOLLAND.
DIRECTED BY STEVEN R. MONROE.

The family reads Nana's very detailed holiday diary in Reunited at Christmas.

Author Samantha (DeLoach) and her family—including her divorced parents—travel to her late grandmother's home for Christmas for one last time to participate in their holiday traditions. Her boyfriend Simon (Faiola) shows up and proposes; knocked for a loop, Samantha says yes, although she's not 100 percent sure she wants to marry him. The grandmother's list of activities seems to bring everyone together for a very special Christmas.

Dan: At the end of this movie, how many times in a row do they say "Merry Christmas"?

Panda: It's five.

Bran: Let's go with seven.

Dan: What if I told you it was eleven? It's eleven. They say "Merry Christmas" eleven times, *in a row*, to finish this movie. Literally, it's like everybody in the Walton family saying goodnight to each other. "Merry Christmas." "Merry Christmas." "Merry Christmas." "Merry Christmas." It's eleven times. I counted. I couldn't believe what I was seeing.

Panda: I think one of the creepier things—and I get that they were trying to play it off as sweet—but the grandma essentially *P.S. I Love You*'s the other characters. She's sending everything from beyond the grave; she's plotted out this entire thing of what the family's going to do.

Dan: I was 100 percent with you, but *P.S. I Love You* is not the comparison I would use. Nana is Jigsaw from *Saw*. If Nana had time to put all this together, what did she die of? Did she know she was going to die of old age and just started planning a decade earlier? This is some intricate stuff here. What you didn't see is that after the eleventh "Merry Christmas," Jigsaw comes out and says, "Let's play a game!" I was very put off by Nana.

"REALLY LIKED—SURPRISED THE BOYFRIEND AT THE BEGINNING DIDN'T GET DUMPED BY THE END."—Bran

"REALLY LIKED; INTERESTING PLOT."—Panda

"DUMPSTER FIRE."—Dan

Nikki DeLoach in *Reunited at Christmas*

I had gone home to Georgia for Christmas. We were in Christmas Eve service at the church—this is a huge Southern Baptist church, and usually nothing gets in the way of service. But the pastor was like, "We've got to get out of here early. Nikki's movie is on!" I have never seen my town so excited about something. And I had been in this business forever. It's like I had never done anything before in my life. Anything. And just the reaction that I got was so special, and I was like, Wait, there's something really important happening here. This matters to people. —***Nikki DeLoach***

ROAD TO CHRISTMAS

WITH GUESTS JACKS AND SHAWL, HALLMARK CHANNELS' BUBBLY SESH PODCAST

PREMIERED NOVEMBER 4, 2018,
ON HALLMARK CHANNEL.

STARRING JESSY SCHRAM, CHAD MICHAEL
MURRAY, TERYL ROTHERY, AND CARDI WONG.

WRITTEN BY ZAC HUG.
DIRECTED BY ALLAN HARMON.

Chad Michael Murray and Jessy Schram in Road to Christmas

Maggie (Schram) is head producer for the popular TV chef Julia Wise (Rothery), who's going to do her big Christmas Eve special live this year. Julia brings back a former producer to help out: Danny (Murray), one of her three adopted sons. Maggie and Danny set out on a road trip to shoot Christmas footage, and Maggie decides it would be great to surprise Julia with a family reunion involving her other sons, Derek (Wong) and David (Jeff Gonek).

> **"LOVED IT; THERE WERE LITTLE THINGS THAT MADE IT DIFFERENT."**—Bran
>
> **"REALLY LIKED; I LOVE A GOOD ROAD TRIP."**—*Panda*
>
> **"HATED; ACTIVELY OFFENDED BY IT."**—Dan
>
> **"I LAUGHED, I CRIED."**—*Jacks* **"FREAKIN' LOVED."**—*Shawl*

HOT TAKES

WAIT... WHAT?

Dan: Very off-brand Brittany Snow wants to tell us about the wise men in this movie, and she goes, "Hey, Chad Michael Murray or whatever your name is, do you know why the wise men were called wise? It's because they changed their plans." No, no, no, that is patently false on every level. They were wise, and that's why they were sent in the first place.

Panda: At the very beginning, Julia says, "Listen, we're going to be filming a live show from Vermont, but the television company thinks that's too bold." A live Christmas special from Vermont—what's bold about that? That's literally the place where you would think about having a live Christmas special!

Bran: I don't know if you've heard about a movie called *White Christmas*?

Jacks: I want to see that conversation, when David returns to his partner Bradley (Mat Lo), the weird passive-aggressive tête-à-tête, like, "Oh, was Christmas with your family fun? I was here with the cats. Alone."

Shawl: I'm going to have to go back to my boy Derek, and I want to see what happens with this ukulele career. Bran, you mentioned it, you were in for the ukulele. I could see Derek making his way.

Jacks: Shawl, I love you, but you are coming in hot by calling it a ukulele "career." It's a hobby.

Shawl: What he lacks in singing potential he makes up for in enthusiasm and a sense of gratitude.

JACKS AND SHAWL

Shawl: I think that's one thing I will say about the Hallmark community—whether we poke fun at each other or not, it really is a kind, just cool, chill place.

Jacks: I feel as though I'm still being as honest as I was before. It's interesting. I think some people, and superfans like myself, or like ourselves, will almost feel like, "OK, the Hallmark brand makes their opinion more valid." But I feel like for people who either hate-watch or kind-of watch, maybe sometimes there might be that whole thing of, "Oh, they're part of the establishment now." Well, now that this is my job, like before, I'm going to be real, you guys. I like these movies. Usually I watch 'em twice. Now I watch them three times, sometimes four.

ROCKY MOUNTAIN CHRISTMAS

PREMIERED DECEMBER 22, 2017,
ON HALLMARK MOVIES & MYSTERIES.

STARRING LINDY BOOTH,
KRISTOFFER POLAHA, CHRIS McNALLY,
AND TREAT WILLIAMS.

WRITTEN BY ELENA ZARETSKY, GREGG ROSSEN,
AND BRIAN SAWYER, BASED ON THE NOVEL
UNBRIDLED LOVE, BY JENNIFER SHIRLEY.
DIRECTED BY TIBOR TAKÁCS.

Lindy Booth and Kristoffer Polaha in Rocky Mountain Christmas

Interior designer Sarah (Booth) comes home to Colorado for the holidays. As she tries to cheer up her widowed uncle Roy (Williams), movie star Graham (Polaha) shows up, looking for a chance to work on a ranch as research for an upcoming role. Will he stick around to be grand marshal of the Christmas parade? Will she decide to move back home?

"JUST OK."—Bran

"REALLY, REALLY LIKED; KIND OF CAUGHT OFF GUARD THAT THERE WERE NO VILLAINS."—Panda

"SO BAD IN SO MANY WAYS; HATED IT."—Dan

Panda: For me the immediate one was: How are they going to make the ranch sustainable? Is it going to go out of business? What's going to happen?

Bran: They're getting Sarah, but Sarah only knows how to do interior design very well.

Dan: Is the movie still on? Is Graham still in the movie? Because he's got all this stuff to do, and he bailed on the publicity for it. It's a $50 million picture, he signed up to do the work, and he's all "I'll be your ranch hand, darlin'."

I got a call the day after Thanksgiving, and—I'm not even kidding you—I was on a plane maybe three or four days later, so that means we didn't even start shooting until December. We were done on December 12. [And on the air December 22.] But we did gangbusters when it aired, and then we were the highest-rated movie for Hallmark Movies & Mysteries in the history of the network. We had a really, really cool reception.—Kristoffer Polaha

ROMANCE AT REINDEER LODGE

WITH GUEST ANDREW WALKER, HALLMARK STAR

PREMIERED DECEMBER 17, 2017,
ON HALLMARK MOVIES & MYSTERIES.

STARRING NICKY WHELAN, JOSH KELLY,
ROBERT PINE, AND BETH BRODERICK.

WRITTEN BY NICOLE BAXTER AND RON OLIVER.
DIRECTED BY COLIN THEYS.

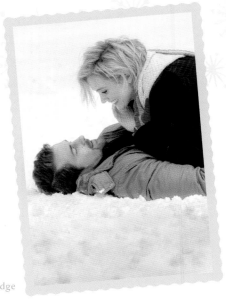

Josh Kelly and Nicky Whelan in Romance at Reindeer Lodge

Workaholic Molly (Whelan) is flummoxed to learn that her office is closing over Christmas. She wins a radio-station-sponsored trip to Jamaica, but doesn't realize she's packing her swimsuits to go to Jamaica, Vermont, where she'll be staying at Reindeer Lodge. Also staying there is Jared (Kelly), whose father runs a firm that wants to buy the lodge.

"NOT MY FAVORITE."—*Bran*

"REALLY COULDN'T GET INTO IT."—*Panda*

"BONKERS BAD; I THOUGHT IT WAS BEING BAD ON PURPOSE."—*Dan*

"VERY FRAGMENTED, AND JUST POINSETTIAS EVERYWHERE,
LIKE POINSETTIA ON TOP OF POINSETTIA."—*Andrew*

Panda: This goes back to the tech company, in general. You know how tech companies are really good right around Christmastime at shutting things down for two weeks? What do we think happens to the tech company in light of all this?

Dan: Clearly, they're doing well. I don't know if you heard—half a million downloads.

Dan: Molly's boss starts talking about how good a year the company's had, and he says, "Our software cleared half a million downloads." Now, even if your software cost a few hundred dollars, the number of people that you have employed, plus the building that you're in and the offices—half a million downloads on one software is not going to run that company. It definitely doesn't amount to a good year.

Bran: I love that he looked around, like, "Are you ready for this? *Half a million downloads.*"

Dan: This podcast based in South Carolina has three million downloads. Half of one million downloads is not an "I'm going to employ thirty people and give them two weeks off" number. It just isn't.

Andrew: And there was no real agenda that Jared had when he arrived there; he was just hanging out at Reindeer Lodge. There was no talking to the owners or looking around the place, you know, just doing his due diligence. He was just a guy hanging out at Reindeer Lodge randomly.

Dan: And what's weird is, if he's come to foreclose, at this point it's just mean-spirited to stay with them for five days and then to wake up on Christmas Eve morning and go, "You know what I got you for Christmas? You're outta here!" That is next-level villainy right there.

A ROYAL CHRISTMAS

PREMIERED NOVEMBER 21, 2014,
ON HALLMARK CHANNEL.

STARRING LACEY CHABERT, STEPHEN HAGAN,
AND JANE SEYMOUR.

WRITTEN BY JANEEL DAMIAN, MICHAEL DAMIAN,
NEAL H. DOBROFSKY, AND TIPPI DOBROFSKY;
DIRECTED BY ALEX ZAMM.

Philadelphia tailor, would-be designer, and hoagie enthusiast Emily (Chabert) is shocked to discover that her boyfriend, Leo (Hagan), is actually Prince Leopold of Cordinia. He brings her home for Christmas, where she meets the stern disapproval of the queen (Seymour). With the help of Leo's love, and some dancing lessons from the butler, Victor (Simon Dutton), Emily may prove she's got what it takes to become the kingdom's new princess, despite the machinations of Leo's aristocratic ex, Natasha (Katherine Flynn).

Panda: Emily walks into the armory, and she pulls out the sword and begins fencing with it, and it slips out of her hand, and it goes flying and it hits the picture. If we brought a scientist in, the trajectory of that sword . . .

Bran: Her hands end up straight up in the air, arms extended . . .

Dan: And behind her is a picture where the sword is at a perpendicular ninety-degree angle . . .

Bran: So the only way that could have happened is if she held the sword straight out and then she throws it like a bouquet toss. But her arms went straight up, there was no raising, it was straight up.

Dan: If she had flung it, it would have gone down.

Bran: The physics are shaky at best.

Dan: It's maybe a trampoline ceiling that hits another angled trampoline?

Panda: That's exactly what they have.

Bran: Classic Cordinia!

Dan: And why are you throwing swords in the Trampoline Room?

Panda: Everyone knows the rules: No food or drink. Take your shoes off. Don't throw swords in the Trampoline Room.

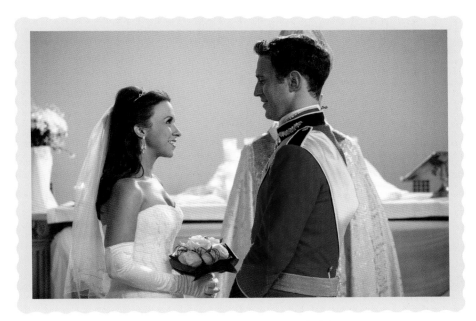

Lacey Chabert and Stephen Hagan in A Royal Christmas

"NOT A FAN, IT HURTS ME TO SAY."—Bran

"FINE; WANTED TO LIKE IT MORE THAN I ACTUALLY DID."—Panda

"NOT ACTIVELY BAD, BUT A TOUGH SLOG."—Dan

SENSE, SENSIBILITY & SNOWMEN

WITH GUEST ALONSO DURALDE, THE WRAP

PREMIERED NOVEMBER 30, 2019, ON HALLMARK MOVIES & MYSTERIES.

STARRING ERIN KRAKOW, LUKE MACFARLANE, AND KIMBERLEY SUSTAD.

WRITTEN BY SAMANTHA HERMAN, BASED ON WORKS BY MELISSA DE LA CRUZ. DIRECTED BY DAVID WINNING.

The Dashwood sisters, Ella (Krakow) and Marianne (Sustad), run a party-planning company, with the practical Marianne wishing that Ella would be more focused. Always on the lookout for higher-profile clients, Ella offers their services to toy-company CEO Edward (Macfarlane), who has to entertain visiting European department-store owners and show them a good Christmastime, even though he's never been much for the holiday.

Panda: The question I have is about the accents of our favorite European couple: where in Europe are they from?

Bran: All of it?

Dan: Those are Canadian actors that thought, "You know what? I've talked to some French Canadians before; I can do this. I can do this accent." And instead, we could all do what they did in the movie. None of what they did took any training at all. It's embarrassingly bad.

Alonso: So . . . why is Edward on the cover of a magazine where the story is about how he's the worst CEO ever?

Dan: That is number one on my list right there.

Alonso: Please, put me in your magazine so you can then write about how I'm failing.

Bran: There's a Christmas market and the Christmas tree lighting, and you know where they hold those in Chicago? The back alley.

Dan: Edward explains how a business plan works, except he doesn't explain how it works at all. He shows you some pie charts and graphs and goes, "All you got to do is input your free-form ideas in here, and you got yourself a business plan." If she puts "I want to be the best party planner in the world" into an Excel spreadsheet, it's just going to come out with nothing.

Luke Macfarlane and Erin Krakow in Sense, Sensibility & Snowmen

A SHOE ADDICT'S CHRISTMAS

WITH GUEST ALONSO DURALDE,
THE WRAP

PREMIERED NOVEMBER 25, 2018,
ON HALLMARK CHANNEL.

STARRING CANDACE CAMERON BURE,
LUKE MACFARLANE, AND JEAN SMART.

WRITTEN BY RICK GARMAN, BASED ON
THE NOVEL BY BETH HARBISON.
DIRECTED BY MICHAEL ROBISON.

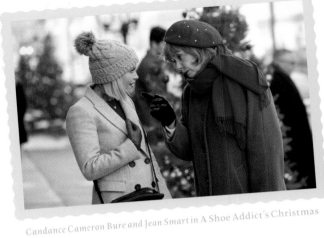

Candance Cameron Bure and Jean Smart in A Shoe Addict's Christmas

Noelle (Cameron Bure) once had ambitions of being a photographer, but now she works in human resources at a department store. When she's stuck in the store alone after hours, she encounters Charlie (Smart), an angel who shows her the points in her life where key decisions put her where she is now. Different shoes take her to the past or show her a potential future, and one of those futures might involve Jake (Macfarlane), a fireman who's working with her on a fundraising gala.

WAIT... WHAT?

Panda: There are a couple of scenes that made me scratch my head, and by a few, I mean most of them. One of the more awkward scenes in a Hallmark movie we've seen in a while is when Jake tries to help her with her bags going into her apartment. He just straight tries to mug her to grab her bags. She's trying to pull him away. It's a borderline assault.

Dan: It looked like a video you would have to watch in the workplace before starting a new job.

Alonso: I love the idea that you're going to a hotel to sample the menu for your gala, but first you're going to decorate a bunch of Christmas cookies. Noelle has that whole speech about how shoes have meaning because of the things that you remember in association with them. Well, you could say the same for pants; it's not exclusively a shoe thing.

Dan: Mrs. Fulton, who owns the store—get off your high horse, lady. I have no problem with you wanting to plan a very upscale gala. But if you're going to plan an upscale gala, maybe don't hire a fireman and a human-resources manager. Like, either hire a professional planner, and plan a big uppity deal, or have your human-resources manager and a fireman break out the snow machine from the attic. Those are your two options, OK?

"LIKED IT MORE THAN I THOUGHT I WOULD."
—*Bran*

"IT'S NOT HORRIBLE; IT'S ACTUALLY FINE."
—*Panda*

"NOT GOOD AT ALL; THEY NEVER COMMIT TO THE BIT,
AND THE RULES SEEM VERY FUZZY."
—*Dan*

"PRETTY TERRIBLE; JEAN SMART IS WAY OUT OF THIS
MOVIE'S LEAGUE, AND THEY'RE LUCKY TO HAVE HER, EVEN
THOUGH THEY DRESS HER LIKE A CHRISTMAS CLOWN."
—*Alonso*

Luke Macfarlane in A Shoe Addict's Christmas

I think the first Christmas movie I ever did was Christmas Land, *and I loved filming in Utah. That was really, really fun. I had a great time. We had an amazing director, Sam Irvin. That was my first under-standing of, Oh, the Christmas movie.*—*Luke Macfarlane*

SINGLE SANTA SEEKS MRS. CLAUS

WITH GUESTS MIKE DiCENZO AND JOHN HASKELL, THE TONIGHT SHOW

PREMIERED NOVEMBER 25, 2004,
ON HALLMARK CHANNEL.

STARRING CRYSTAL BERNARD,
STEVE GUTTENBERG,
AND THOMAS CALABRO.

WRITTEN BY PAMELA WALLACE.
DIRECTED BY HARVEY FROST.

Crystal Bernard and Steve Guttenberg in Single Santa Seeks Mrs. Claus

Nick (Guttenberg) is Santa's large adult son, and he has to get married because Santa is retiring. Nick can only take over the lineage if he has a wife. He travels to Southern California armed with a list of potential spouses, but he bumps into ad exec and widowed mom Beth (Bernard) when she's making a TV commercial with a terrible Santa, whom she replaces with Nick.

"EVEN IN THE HALLMARK WORLD, I'VE NEVER SEEN A MOVIE QUITE LIKE THIS; LOVED EVERY MINUTE OF IT."
—Bran

"ONE OF THE MOST RIDICULOUS HALLMARK FILMS I'VE EVER SEEN, COULD NOT BE MADE TODAY; I LOVED HOW I HATED IT AND HATED HOW I LOVED IT."
—Panda

"TERRIBLE, AND THE MOST PATRONIZING TO THOSE WITH DISABILITIES OF ANY I'VE EVER SEEN IN MY LIFE."
—Dan

"SO MUCH UNINTENTIONALLY FUNNY STUFF."
—Mike

"YOU'LL NOTICE NEW THINGS EVERY TIME."
—John

John: The way that Steve Guttenberg acts toward children and some of the things that he says sound so wrong.

Mike: Yeah, the script is pretty bad. We wrote down a few of his lines. One is, "Little girls do much better when they're relaxed." That's not good. "Seven is a great age." That's weird. And then he says at one point, "I never met a child I didn't like." I know he's Santa, but she doesn't know he's Santa when he's saying these things, so yeah, pretty creepy.

Dan: There are way more contexts when those are inappropriate than when they are appropriate.

Mike: When we would watch it as a staff, we would talk during the movie like it was *The Rocky Horror Picture Show*. Jimmy Fallon had one that he would always mention—anytime Crystal Bernard was saying goodnight to her son and turning the lights off in this room, and it was clearly broad daylight. What is it, four in the afternoon? And then Nick's babysitting the kid, and when she leaves, he goes, "Now where does your mother keep the chocolate ice cream?" Uh, the freezer?

John: And also in that line, that's the first time I've heard someone pronounce ice cream, "ice *cream*." The emphasis is weird.

Dan: Nick's a creeper on a bunch of fronts we've already embraced, but there's another, and it's the fact that he is showing up to random women's houses, knocking on the door, and I presume he's saying, "Hey, I'm Santa. You want to get married?" That's an ADT security commercial.

SMALL TOWN CHRISTMAS

PREMIERED DECEMBER 16, 2018,
ON HALLMARK MOVIES & MYSTERIES.

STARRING ASHLEY NEWBROUGH
AND KRISTOFFER POLAHA.

WRITTEN BY SAMANTHA HERMAN AND DANA STONE.
DIRECTED BY MACLAIN NELSON.

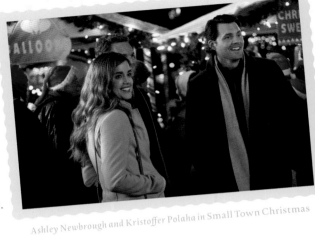

Ashley Newbrough and Kristoffer Polaha in Small Town Christmas

Author Nell (Newbrough) has written a book called *Small Town Christmas*, based on the reminiscences of Emmett (Polaha), with whom she lost touch after he abruptly left New York City. Emmett now owns a bookstore in the real small town, Springdale, and arranges for Nell to visit at the end of her book tour. She falls in love with the actual place, finds out why Emmett had to leave New York, and helps save the town from developer Brad (Preston Vanderslice).

WAIT... WHAT?

Bran: At the Christmas tree lighting, they invite Nell to come up and to do a reading from her book, which is really great. But the portion that she reads, at a very cheerful evening, is just the weirdest thing. It's about lost love. The one that got away.

Panda: Near the end, Brad has decorated this entire banquet, and it looks nice, really top-notch. And somebody comes up to him—it's like, "Brad, you idiot! It looks terrible! You've ruined Christmas for everyone!" It's the one time in the movie I felt bad for Brad. You did your best, and it's terrible!

Bran: "Nice Christmases aren't our tradition!"

Dan: "What are you thinking? We're Kringlefest—with no kringles!" Brad takes it on the chin, and most of it is deserved. But stay with me here, I'm just going to read this sentence off the page so I make sure I don't screw it up: this is a successful venture capitalist who thinks bringing high-end tourists to a small town in Wisconsin in the dead of winter is a no-brainer. He thinks that is going to sell like hotcakes, right?

> **"LOVED THIS MOVIE, FAVORITE OF THE SEASON."**
> —Bran
>
> **"LIKE IT; NOT A LOT HAPPENS, BUT THE LOVE TRIANGLE IS INTENSE."**
> —Panda
>
> **"NOT FOR ME; THERE'S A KRINGLEFEST IN THE MOVIE
> AND ZERO KRINGLES APPEAR ON SCREEN."**
> —Dan

The George Bailey of it all comes from my kids. I kept teasing that I was going to do Jimmy Stewart from It's a Wonderful Life, *and they were mortified. They were like, "No, you're not, Dad." And my manager in New York City was like, "No, you're not, Kris." And my wife was like, "Are you seriously going to do that?" And then when I met the director, he said, "Ha ha — are you really?" And so he created an invisible knob, and when I did too much George Bailey, he would turn it down. Ultimately, what I wanted was that enthusiasm and that feeling of buoyancy; there was an unbridled joy in those movies from those guys in the 1940s. It was egoless, and I wanted to try to do that, because I think that ultimately, when we sit down and watch a Christmas movie, who cares about being cool? You just want to feel good. And I think Jimmy Stewart did that the best ever. So for me, a nod in that direction is an honor.—**Kristoffer Polaha (On Channeling Jimmy Stewart in** Small Town Christmas**)***

SNOW BRIDE

PREMIERED NOVEMBER 9, 2013,
ON HALLMARK CHANNEL.

STARRING KATRINA LAW, JORDAN BELFI,
AND PATRICIA RICHARDSON.

WRITTEN BY TRACY ANDREEN.
DIRECTED BY BERT KISH.

Tabloid journalist Greta (Law) is mistaken for a runaway bride by Ben Tannenhill (Belfi), the scion of the Tannenhill political dynasty, which helps her get close enough to land a scoop. When Ben's ne'er-do-well brother, Jared (Bobby Campo), shows up with Ben's ex, Claire (Susie Abromeit), Ben pretends that Greta is his girlfriend. But after falling in love with him—and befriending his mother, Maggie (Richardson)— Greta regrets the deception and wonders if there's a way to keep the Tannenhills out of the gossip columns. Tom Lenk costars as Wes, Greta's rival yellow-journalist, and Robert Curtis Brown plays Peters, the Tannenhills' butler, who might be harboring feelings for Maggie.

Panda: Two things: When Jill Taylor [Richardson's character on *Home Improvement*] first came on, I was surprised, I got excited. Second of all, when Peters—I love Peters—shares that he's had these deep feelings for Mrs. Tannenhill for all these years but hasn't acted on them, he's just been in the friend zone. I loved that.

Bran: For me, the scene in which Ben walks in when she's just got done reading the book he's written. They stand up, get really close to each other, there's tension there—will they kiss? won't they kiss?—and I wanted them to kiss so badly, and they didn't, and that's OK this time.

Dan: There were a lot of things that really worked for me. The female lead is not perfect by any stretch, and she's impulsive, but she does a lot of things where she's not a damsel in distress, and I think that's really cool. When they first meet, and they determine they're going to do this fake dating thing, Greta pulls him aside, and she just grabs him and kisses him. And basically says, "We had to get our first kiss out of the way." That's one of the best moments, romantically, in any Hallmark movie I've ever seen.

"VERY FUN, SO MUCH GOING ON, THE
PLOTLINES INTERTWINE—GREAT!"
—Bran

"BORDERLINE LOVE; IT DIDN'T FEEL LIKE I HAD
JUST WATCHED A HALLMARK FILM; IT FELT LIKE I SAW
A LOWER-GRADE ROMANTIC COMEDY."
—Panda

"I . . . REALLY LIKED THE MOVIE."
—Dan

Katrina Law in Snow Bride

SWITCHED FOR CHRISTMAS

PREMIERED NOVEMBER 26, 2017,
ON HALLMARK CHANNEL.

STARRING CANDACE CAMERON BURE,
MARK DEKLIN, AND EION BAILEY.

WRITTEN BY TRACY ANDREEN AND
LEE FRIEDLANDER.
DIRECTED BY LEE FRIEDLANDER.

Eion Bailey (as Tom Kinder) and Candace Cameron Bure in Switched for Christmas

Twins Kate (Cameron Bure) and Chris (Cameron Bure) are estranged, and each resents the other's life. They decide to switch places, and both find themselves organizing Christmas events. Chris throws a party for Kate's office, with the help of Kate's coworker Greg (Deklin), and Kate organizes a carnival at Chris's school that's underwritten by Tom Kinder (Bailey), who once had a crush on Kate but now thinks he's working with Chris.

HOT TAKES

"I LOVE THESE MOVIES; THIS ONE'S NOT VERY GOOD."—Bran

"LIKED IT; BEST SWITCHEROO SINCE *THE PARENT TRAP*, LINDSAY LOHAN EDITION."—Panda

"I HAVE TWIN BOYS, I HAVE A SOFT SPOT FOR TWINS AND STORIES ABOUT TWINS, AND THE MOVIE SUCKED."—Dan

WAIT... WHAT?

Bran: Greg and Chris are planning this office Christmas party, and they're all, "We gotta think outside the box," and the things they came up with that are outside the box are an ugly-sweater contest and Secret Santa. It's ridiculous; it's literally every Christmas party in America.

Panda: For the Christmas party—the very fact they take Kate off the Jasper Project . . .

Dan: Look, the Jasper Project is a big deal. That guy is a family man!

Panda: This is a multimillion-dollar project, from everything I can tell. They're trying to push to get it done, and then they pull the person who's pretty much second-in-command at the company and they say . . .

Dan: "No, no, no, this Christmas party's way bigger."

THE TOM KINDER FIASCO, EXPLAINED
AN INTERVIEW WITH *SWITCHED FOR CHRISTMAS* EDITOR RANDY CARTER

The twin Candace Cameron Bure characters make reference to the "Tom Kinder fiasco," but that fiasco is never explained in Switched for Christmas. We reached out to the film's editor, Randy Carter, for answers.

Randy: OK, Tom Kinder fiasco. So, knowing that there used to be flashbacks, let me just give you the story of what happened in the fiasco, and hopefully this will clear everything up. So it's years ago, however many years ago it's supposed to be. Kate meets Tom at an ice-skating rink.

Bran: Can I pause you right there? Tom's from California?

Randy: Tom's in town because his dad's in town on business.

Bran: Got it. OK.

Randy: He doesn't live in town. He's just visiting. Here's what happens: They meet. It's love at first sight. They skate all night; they fall in love. Tom tells her, "Oh, you know, I'm leaving town in a couple of days." And she says, "Well, tomorrow night is the big winter carnival" or whatever it was. "Can you come and skate some more, and we can hang out at the winter carnival? It'd be like our last date." And he says, "I'll be there."

So then later, Kate foolishly realizes she's already agreed to work a booth at the carnival, and she has to work there all night long. So she goes to her sister, Chris, and says, "Can you take my place at the booth?" even though Kate's the only one apparently qualified to work this booth. "We'll do the switcheroo. You'll work the booth, and I can go hang out with this guy who I just met, but I'm falling in love with." And Chris is like, "OK, yeah, I'll switch with you. It'll be fine." So Chris is then leaving the ice-skating rink to go to her booth, and she's talking to her boyfriend. And Tom shows up early and sees Chris, but he doesn't know that she has a twin. He thinks it's Kate, sees Chris kiss her boyfriend goodbye, and thinks it's the girl he fell in love with yesterday, kissing some other guy. So off he goes. And Kate shows up for the date, and Tom never shows up. Cut to fifteen years later. The Tom Kinder fiasco.

TIME FOR ME TO COME HOME FOR CHRISTMAS

WITH GUEST CHARLES GOULD, COMEDIAN

PREMIERED DECEMBER 9, 2018,
ON HALLMARK MOVIES & MYSTERIES.

STARRING MEGAN PARK, JOSH HENDERSON,
AND SUSAN HOGAN.

WRITTEN BY SHEM BITTERMAN AND
MARCY HOLLAND,
BASED ON THE NOVEL *TIME FOR ME TO COME HOME*,
BY DOROTHY SHACKLEFORD AND TRAVIS THRASHER.
DIRECTED BY DAVID WINNING.

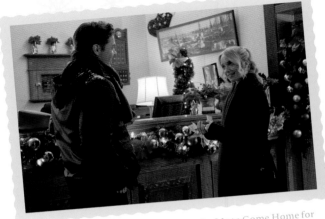

Josh Henderson and Megan Park in *Time for Me to Come Home for Christmas*

Heath (Henderson) is a country singer, and Cara (Park) is struggling to keep her family's preserves business afloat, but they're both trying to get back to Oklahoma from New York for the holidays, and they're both dealing with the recent loss of a parent (her mom, his dad). It's time for them to come home for Christmas.

"ENJOYED IT, IT WON ME OVER."—Bran

**"GOT EXCITED FOR THE ROAD TRIP, BUT IT'S NOT GOOD."
—Panda**

"MOVIE'S NOT GOOD, AND THIS GUY IS A FAMOUS COUNTRY CHRISTMAS CAROL SINGER?"—Dan

"MY FIRST HALLMARK . . . I DID NOT LIKE IT."—Charles

Dan: I want to know more about the banker, because apparently the taste of the candy determines the loan. I don't know how he's still in business, but it does explain why he's a little bit hefty.

Charles: I want to know more about Heath's agent. That way, we could get a Jewish person into one of these movies.

Bran: It wasn't a ton of Christmas feels, even though they were really harping it. But there was a little boy in this movie named Alex. Alex had a stuffed reindeer, and for some reason, the way he loved that stuffed reindeer gave me feels. I can't explain it. I had a stuffed animal that I loved as a kid; I don't know if that was it.

Panda: That scene made me horrified, because any precocious ten-year-old child talking to me while I'm trying to travel is my worst nightmare. If there's a scene that elicits any emotion, it's when they meet the Roamers, and the Roamers are excited to meet Heath Sawyer. I'm stretching because, honestly, this movie did not give me feels at all.

Charles: Did I have any feels? Besides anger? Well, I guess there was. . . . No, I had nothing. Oh, I think I liked Heath's sister. The scene where his sister's telling him he has to come home, that his mom won't tell him, so she's the one who's got to do it. I felt a little feels on that.

Dan: Sometimes, Charles, I just say I don't have any feels, and I will say, when they get stopped in the snowstorm at his buddy's house with the two girls and all that stuff? There was something about those two working with the girls and just giving them time—that worked a little bit for me. That's as close as it got.

TIME FOR US TO COME HOME FOR CHRISTMAS

PREMIERED DECEMBER 5, 2020, ON HALLMARK MOVIES & MYSTERIES.

STARRING LACEY CHABERT AND STEPHEN HUSZAR.

WRITTEN BY MARCY HOLLAND. DIRECTED BY DAVID WINNING.

Seattle-based corporate attorney Sarah (Chabert) is in New York City wrapping up her late mother's pro bono court cases when she gets a letter telling her she's being gifted with a complimentary stay at a country inn. She assumes it's a gift from her bosses in the Pacific Northwest, but it isn't, and she soon discovers that her fellow guests received the same letter from the same unknown benefactor. With the help of handsome innkeeper Ben (Huszar), she sets about unlocking a mystery that's tied to a Christmas at the inn from decades ago.

WAIT... WHAT?

Panda: We have to talk about the Christmas tree lighting. Because it is the worst Christmas tree lighting in a Hallmark movie. They hit one button, and a light in the middle of the tree literally pops on. It's like they have a lighthouse light in the middle of the tree.

Bran: They count down from eight.

Dan: The two leads barely make it to the lighting on time; they just skate in there, and the tree is already lit, aside from a center thing.

Bran: Which is a regular light bulb in the middle. It's odd.

Dan: And then, once again, the cups are empty. We can see halfway down the cup, and there's nothing in it. So why would that dad say the line, "They didn't have marshmallows, so I got you extra whipped cream"? If you got her extra whipped cream, it would at least be at the top of the cup. We can see halfway into the cup. If you got extra whipped cream, then there's nothing in that cup but whipped cream. Don't come out with an empty cup and say you got extra anything in it. That's not going to go well at all.

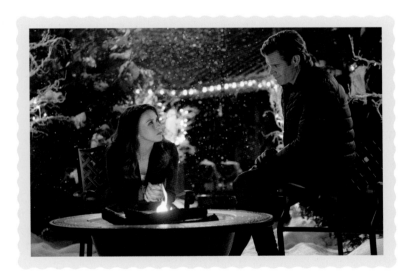

Lacey Chabert and Stephen Huszar in Time for Us to Come Home for Christmas

TIME FOR YOU TO COME HOME FOR CHRISTMAS

WITH GUEST RIANE KONC,
AUTHOR, BUILD YOUR OWN CHRISTMAS ROMANCE:
PICK YOUR PLOT, MEET YOUR MAN, AND CREATE THE
HOLIDAY LOVE STORY OF A LIFETIME

PREMIERED DECEMBER 8, 2019
ON HALLMARK MOVIES & MYSTERIES.

STARRING ALISON SWEENEY
AND LUCAS BRYANT.

WRITTEN BY MARCY HOLLAND.
DIRECTED BY TERRY INGRAM.

Widowed mom Katherine (Sweeney) reluctantly goes home for Christmas with her teenage son. On the train, they meet Jack (Bryant). As Katherine works to help save her family's bakery, Jack has his own mysterious agenda, one that involves Katherine's late husband.

WAIT... WHAT?

Panda: In the flashback, she's baking gingerbread cookies, and she hands one to her boyfriend, Tyler [Sebastian Greaves], and she says she's been working on these Christmas cookies all week. Why is it this difficult for a recipe? And why are you spending all that time on the test batch, decorating them in depth? You don't do that.

Riane: Jack talks about how he got into music and how he became such a mediocre guitar player. He says that he got into it just a couple of years ago, and he says that he got into it because he heard music was good for the soul. This implies that he heard this for the first time in his life, like, two years ago.

Bran: There was so much about that scene with the croissant—namely how he said *kwaah-saaahn*. But it comes straight out of the oven. He picks it up. He does acknowledge how hot it is. But that does not stop him from stuffing that sucker in his mouth.

Dan: I'll piggy-biggy-back off that: it's scalding hot or it's a bad croissant. First of all, it literally just came out of the oven, but second of all, you can say *kwaah-saaahn* one time; if you do that bit more than once, then you're just a goober. It's like, alright, he decided to say "croissant" like a French person. I'm going to act like I've never heard it, give a courtesy chuckle. But if you commit to speaking the normal king's English your entire life except for the word "croissant," you're incredibly weird and off-putting.

"ENJOYED THE MOVIE; LIKED THE IDEA OF THE MYSTERY MORE THAN I WAS INVESTED IN THE MYSTERY."—Bran

"LIKE THIS MOVIE; I LOVE A GOOD BAKING MONTAGE."—Panda

"DIFFERENT, BUT NOT GOOD—IMAGINE THE HALLMARK VERSION OF *RETURN TO ME* OR *SEVEN POUNDS*."—Dan

"DEEPLY UNDERWHELMED; I USUALLY WATCH BECAUSE THESE ARE FUNNY, AND IT'S HARD TO GET JOKES FROM 'GUESS WHAT? MY ARMY HUSBAND IS DEAD.'"—Raine

TWO TURTLE DOVES

PREMIERED NOVEMBER 1, 2019,
ON HALLMARK MOVIES & MYSTERIES.

STARRING NIKKI DeLOACH, MICHAEL RADY,
AND BJ HARRISON.

WRITTEN BY SARAH MONTANA.
DIRECTED BY LESLEY DEMETRIADES.

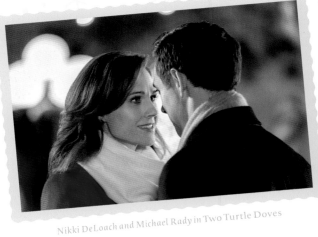

Nikki DeLoach and Michael Rady in Two Turtle Doves

According to her late grandmother's will, neuroscientist Sharon (DeLoach) must spend Christmas at her childhood home, participating in her grandmother's holiday traditions, so that Sharon can decide whether or not she wants to keep the house. Living next door is single dad Sam (Rady), who was also Sharon's grandmother's attorney.

"LOVED IT, I CRIED; I HAD A WONDERFUL EXPERIENCE."—Bran

"GREAT; HAS SOME OF THE BEST WRITING WE'VE SEEN DEALING WITH GRIEF AND THE DEATH OF LOVED ONES."—Panda

"NOT GOOD, BUT IT'S THE BEST-WRITTEN HALLMARK MOVIE I'VE SEEN, WITH THE BEST ALMOST-KISS."—Dan

I know for me as an actor, you can't dive too deep into the sadness because you need to be able to pick yourself up out of it, and you still need to keep it light. So constantly, in each scene, it was, "Where did we come from? Where are we going to after this? What level?" So maybe instead of feeling devastated in this scene, I'm just going to feel nostalgic, or I'm just going to be remembering a moment instead of being gutted. You kind of have to toe the line, and the director is a big part of that. Ashley Squires at Hallmark, who is the creative executive, is a huge part of that. She navigates that in the script with the writer, saying things like, "OK, we just had a sad moment; let's have a variety of moments that make people feel better for the next four scenes, and then we can go back to revisiting something that's real." Not that the other stuff isn't real; it is, but it's not sadness on top of sadness on top of sadness.
—Nikki DeLoach

Panda: In one of the conversations they have, Sam mentions that after he left Manhattan, everyone passed him by, and she says, "Well, how did you feel about losing all that?" He goes, "The thing is, my dreams changed, and so it wasn't settling for something less. When your dreams change and your priorities change, the old dreams that you have, it doesn't mean that you've lost or that you've settled; it's just that your dreams have changed." Maybe I'm just at a point in my life where that resonates more with me, but this is probably some of the best writing in a Hallmark movie.

Bran: Obviously, the part where she goes in and he plays the clip for her of Grandma telling her about stuff. I teared up; that did the job well. And it was the best use of technology in a Hallmark movie—they did good! Voice recorder on my phone, might as well use it. I think it was the first time I've ever gotten a technology feel, because the idea of just being able to hear your grandma's voice tell you about the traditions and to remind you of Christmas was really great. If I had a clip of my grandma, who has also passed away, reminding me of the Christmases that we spent in her house, that would give me feels.

Dan: Best almost-kiss I've seen in any of these movies. In fact, the almost-kiss was so good, I almost gave the entire movie a pass.

A VERY MERRY MIX-UP

PREMIERED NOVEMBER 10, 2013,
ON HALLMARK CHANNEL.

STARRING ALICIA WITT, MARK WIEBE,
AND SUSAN HOGAN.

WRITTEN BY BARBARA KYMLICKA.
DIRECTED BY JONATHAN WRIGHT.

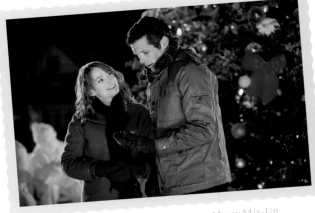

Alicia Witt and Mark Wiebe in A Very Merry Mix-Up

Antique-store owner Alice (Witt) is planning to spend Christmas with her fiancé's family, but because he's a workaholic, he stays behind in New York for an extra day while she flies off to his parents' house. Alice crosses paths with Matt (Wiebe) upon landing at the airport, and through a series of misunderstandings she comes to believe that he's her fiancé's brother. She has a wonderful time with his family—only to discover she's been celebrating with the wrong people.

"LIKE EVERYTHING EXCEPT ALICIA WITT."—*Bran*

"LOVE THE PLOT, HATED EVERY CHARACTER."—*Panda*

"HATED THIS MOVIE—2013 HALLMARK WAS A SIMPLER TIME, WHERE BRAIN INJURIES WERE PLAYED FOR LAUGHS."—*Dan*

Panda: The Christmas awkward feels come when the second family plays the game where you say something nice about everyone else. They don't like each other, and it's like the husband and wife really hate each other. A lot of passive-aggressiveness. For a Hallmark movie, they did a legitimately solid job of making that one of the more uncomfortable scenes.

Dan: I'm confused about how Matt and Alice deal with their concussions after they get into a car accident. Matt's mom is tasked with keeping Matt and Alice awake for twenty-four hours, and here is how she keeps them awake: she gets them on the couch, she gives them a warm blanket, she heats them up chamomile tea to help them relax, and then she goes to bed. That is a road map to death.

A VETERAN'S CHRISTMAS

PREMIERED NOVEMBER 11, 2018,
ON HALLMARK MOVIES & MYSTERIES.

STARRING ELOISE MUMFORD
AND SEAN FARIS.

WRITTEN AND DIRECTED BY MARK JEAN.

Returning veteran Grace (Mumford) is on her way to a new job as a civilian when her car crashes into a snowbank. She is quickly found by Justice, a dog that belongs to local judge Joe (Faris). Grace and Justice bond because she misses Christmas, the combat dog she trained and worked with for years. While her car gets fixed, the town conspires to bring Grace and Joe together.

"THE CHEESE FACTOR ON JOE WAS KRAFT, BUT AT THE SAME TIME, THERE'S SOMETHING ABOUT IT. I LIKED IT."—Bran

"WAS NOT A BIG FAN UNTIL THE DOG REUNION IN THE LAST TEN MINUTES."—Panda

"NOT BAD FOR A HORROR FILM; THIS IS HITCHCOCK TERRITORY."—Dan

Dan: Grace looks at Joe and goes, "So, how did you become judge in your hometown?" And Joe's response is, "Well, I didn't plan to become judge. I wanted to go to Chicago and do all these things." And then he never actually answers. Did you apply? Were you a lawyer? What was the process? And that kind of leads into my second Wait, What—this town is creepy on a number of levels, but they hire the youngest employees for the highest levels of office. These are the judge and the sheriff of the town, and they have a combined age of eighteen, max. There are a couple of toddlers running around banging gavels and holding guns, and it's dangerous.

Bran: I will say the only possible explanation for the sheriff using his power to pull over her bus is that he is a toddler.

Panda: She talks about how she got Christmas, her combat dog, and she chalked it up to a clerical error, because she got the dog at nine weeks old. It was supposed to be a fully trained dog, but she got a puppy. This is a very specially trained dog for search and rescue, and that is a massive clerical error when you're over in Afghanistan. "I'm supposed to get a search-and-rescue dog, and I ended up with a puppy."

Bran: Joe and Grace go Christmas tree shopping, and they find the Christmas tree, and Joe says, "This Christmas tree reminds me of you." You never do that. Christmas trees are large.

WELCOME TO CHRISTMAS

WITH GUEST DALE ERQUIAGA,
COMMUNITIES IN SCHOOLS

PREMIERED DECEMBER 9, 2018,
ON HALLMARK CHANNEL.

STARRING JENNIFER FINNIGAN,
ERIC MABIUS, AND SUSAN HOGAN.

WRITTEN BY RICK GARMAN.
DIRECTED BY GARY HARVEY.

Hardworking Madison (Finnigan) wants to build a ski lodge in Mountain Park, but the town of Christmas, Colorado, puts in its own bid. Madison's firm sends her to Christmas to investigate, and she crosses paths with the sheriff, Gage (Mabius). Christmas has let most of its holiday traditions slip away, but the town revives them to dazzle Madison.

Dan: I will say this, and this is really the crux of all of my Wait, Whats: this is a town named Christmas that has gotten away from the traditions. Just embrace that for a second. You got one job, Christmas. You got one job. Your town's name is Christmas.

Dale: Eric Mabius plays a widower. I'm fifty-five, I've been all over the world, I maybe have met two widowers who are not eighty-five. But in Hallmark, they're always in their early thirties.

Panda: The other thing that just drives me absolutely crazy in these films: when parents cut their kids off in the middle of a really heartfelt conversation. They're like, "Time to go to bed." It happens all the time, but this dad is the king of it. They're in the middle of something deep, the daughter's opening up, and he's like, "Aw, man, go to bed."

Dan: It happened in *Christmas at Graceland* (page 26). The daughter comes out and wants to play the piano with Kellie Pickler, and she's like, "Sweetie, go to bed." And in *Hope at Christmas* (page 126), the kid says, "Mommy, it's Christmas break, can I stay up and read?" And she's like, "No!"

Bran: I think we're all praying each night that we can go through our whole lives without having a real conversation with our kids.

Dan: If Hallmark has taught me anything, it's "Don't take your car to the mechanic," and "Don't let your kids tell you anything."

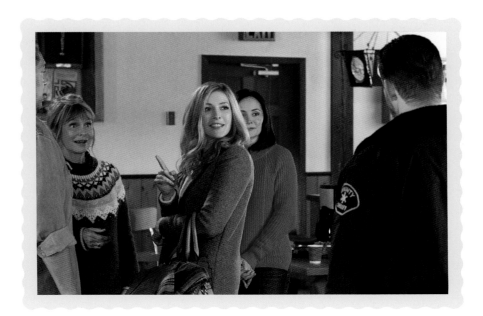

Jennifer Finnigan in Welcome to Christmas

"ENJOYED IT WHILE I WAS WATCHING, BUT THE BOW AT THE END IS BARELY TIED."—Bran

"LIKED IT, BUT JUST LIKE *A VETERAN'S CHRISTMAS* (PAGE 217), IT'S ABOUT A TOWN HOLDING SOMEONE HOSTAGE, AND THAT'S UNSETTLING."—Panda

"REALLY BAD, NONE OF IT MAKES SENSE."—Dan

"LIKED, DID NOT LOVE, EVEN THOUGH THEY GOT IN THE LINE 'THE SKI RESORT MIGHT JUST BE THE CHRISTMAS MIRACLE THAT WE'VE BEEN WAITING FOR.'"—Dale

WHEN CALLS THE HEART:
THE GREATEST CHRISTMAS BLESSING

PREMIERED DECEMBER 25, 2018,
ON HALLMARK CHANNEL.

STARRING ERIN KRAKOW,
PASCALE HUTTON, AND LORI LOUGHLIN.

WRITTEN BY ALFONSO H. MORENO,
BASED ON THE NOVEL BY JANETTE OKE.
DIRECTED BY NEILL FEARNLEY.

Elizabeth (Krakow) is reaching the end of her pregnancy, but she's so distraught over the death of her husband, Jack, that she hasn't been able to bring herself to finish building the nursery. Residents of Hope Valley are hanging their wishes on the wishing tree. A group of orphans on their way to a new orphanage turn up in town for Christmas after their wagon breaks down. Elizabeth goes into labor in the middle of a blizzard, and baby Jack is born.

HOT TAKES

"SORRY, HEARTIES, I WANT TO CARE ABOUT THE THING THAT YOU LOVE, BUT I JUST DON'T."—**Bran**

"ABOUT WHAT YOU'D EXPECT IF YOU DROPPED INTO THE MIDDLE OF A SEASON."—**Panda**

"GLAD JACK IS DEAD (JUST KIDDING)." —**Dan**

WAIT... WHAT?

Dan: The orphans roll in, and the wheel on their vehicle is broken, but they're told, "The blacksmith's off this week." What do you mean the blacksmith's off this week? If you're in a time period that has automobiles, you have mechanics. Also, I don't care if it's 2010, 1910, 1510, you do not take a nine-month-pregnant woman out of town in the evening. These people claim to be her friends, but they clearly want her to go into labor in a cabin out in the woods somewhere.

WHAT THE HALLMARK?

Dan: Why doesn't anyone have any headgear on in this whole movie? No one wears a hat. It's freezing cold. They have lights and everything, but they don't have hats in Hope Valley?

Bran: And how close is the town that has the Burlington Coat Factory? Where do they get all their cool modern coats?

WHEN CALLS THE HEART: HOME FOR CHRISTMAS

PREMIERED DECEMBER 25, 2019, ON HALLMARK CHANNEL.

STARRING ERIN KRAKOW, CHRIS McNALLY, AND KEVIN McGARRY.

WRITTEN BY ALFONSO H. MORENO AND ELIZABETH STEWART, BASED ON THE NOVEL BY JANETTE OKE. DIRECTED BY MIKE ROHL.

Widow Elizabeth (Krakow) is getting close with Mountie Nathan (McGarry) and is saddened to hear that he might accept a posting in another town. Dr. Shepherd (Paul Greene) helps out a traveling salesman. Bill (Jack Wagner) gives Elizabeth's infant son a compass that once belonged to the child's father.

"BETTER THAN LAST YEAR'S; I DID NOT HATE MYSELF WATCHING IT."—*Bran*

"FELT LIKE AN ETERNITY; LAST YEAR YOU HAD A PREGNANCY SCARE, THIS YEAR A POTLUCK."—*Panda*

"TERRIBLE; ABSOLUTELY A DUMPSTER FIRE."—*Dan*

Dan: Jack—who is dead, I want to be clear—and Bill were in the woods at some point. Bill gives this present to Elizabeth—a compass for Baby Jack to use when he's older, and Bill says, "Jack gave me this compass when we got turned around in the mountains." You've lived here your whole life; how'd you get turned around? And you mean to tell me, if I'm Bill, and Jack goes, "Man, we're lost. Here's a gift. It's a compass"—I would be pretty upset that Jack's been holding out on me.

Bran: "You had this the whole time?"

Dan: Classic dead Jack.

WRITE BEFORE CHRISTMAS

PREMIERED NOVEMBER 17, 2019,
ON HALLMARK CHANNEL.

STARRING TORREY DeVITTO,
CHAD MICHAEL MURRAY,
LOLITA DAVIDOVICH, AND GRANT SHOW.

WRITTEN BY NEAL H. DOBROFSKY
AND TIPPI DOBROFSKY.
DIRECTED BY PAT WILLIAMS.

Torrey DeVitto and Chad Michael Murray in Write Before Christmas

When musician Jessica (DeVitto) gets dumped by her boyfriend right before Christmas, she takes the five cards she was going to send him and instead mails them to people who have meant a great deal to her: her brother, who's serving overseas in the military; her mom, who's fostering a dog; her best friend; her old cello instructor; and a boy-band singer who once inspired her. Those Christmas cards will forever change the lives of the recipients, as well as Jessica's, especially after she meets Luke (Murray), her cello teacher's son.

> **"LIKE; IT'S DIFFICULT TO PUT FIVE STORY LINES INTO EIGHTY-FIVE MINUTES AND CONNECT WITH ALL OF THEM."—Bran**
>
> **"LOVE THIS MOVIE; IT'S GOT A DANCE SCENE, A BOY BAND, A DOG—EVERYTHING I WANT FROM HALLMARK."—Panda**
>
> **"IMAGINE IF HALLMARK TRIED TO DO *LOVE ACTUALLY* IN EIGHTY-FIVE MINUTES WITH FIVE STORIES, AND THEY HAD TO MAKE IT A HALLMARK CARD COMMERCIAL AS WELL; NOT GOOD."—Dan**

HOT TAKES

Bran: When she whipped out that cello for the first time. She hadn't played in a long time; she plays, everybody is listening to her, and just being, like, this is amazing. There's something about the music that drew them in.

Panda: There's this bit where she talks about "lasso the moon," from *It's a Wonderful Life*. She originally does that with her ex-boyfriend; the bit does not work with him. He's like, whatever, because he apparently hasn't seen the movie, which is ridiculous. But later on, she's going through the pictures taken by Chad Michael Murray, and she comes across this picture with the moon in the background. She says, "Oh, wow, this is beautiful." He goes, "Do you want it? I'll give you the moon." He quotes the movie and it just hit me. It's like a sucker punch.

Dan: I wrote down, "The *Wonderful Life* quote always works." I'm going to backspace out of that because it works unless you, I don't know, use it six times. I actually laughed in this movie. The dumb coffee shop scene where he meets this actress on a blind date, and she says, "Will you go over these lines with me?" I felt terrible for laughing, but I did laugh when she does the scene, which involves yelling at him and storming off, and everybody in there thinks it's real.

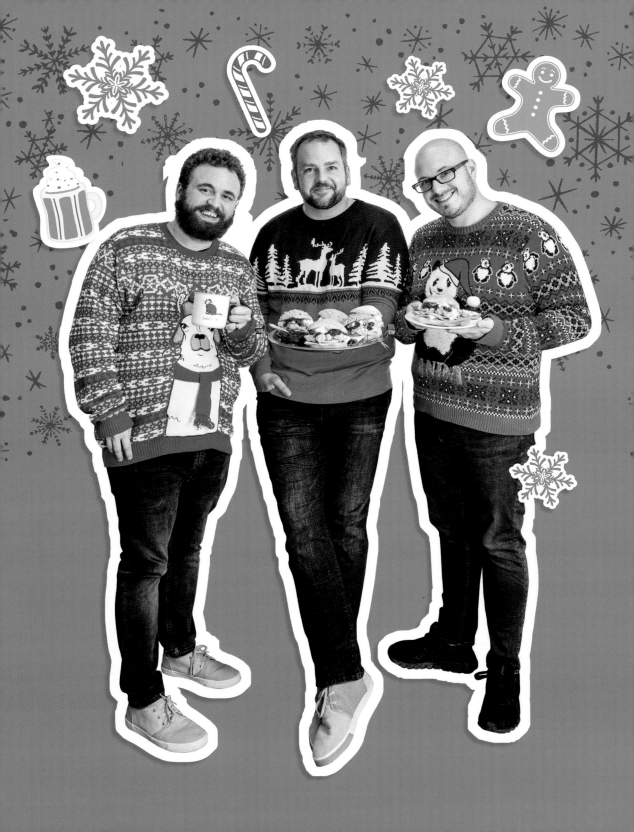

'TIS THE SEASON TO BE JOLLY

THROWING YOUR OWN
HALLMARK CHRISTMAS PARTY

Bran: One of the things we all love about Christmas is entertaining friends and family: spending time with the people we care about, and enjoying delicious treats. And if you can throw a Hallmark Christmas movie into the mix, that just makes the season even more fun and festive!

Dan: Oh, brother. But since my Christmas season is now packed with Hallmark movies, whether I want it to be or not, having people over to watch them with me does at least take some of the pain away from the experience.

Panda: And what's great about Hallmark movies is that you can follow the story whether you're sitting down and paying close attention or whether you're talking to friends and just occasionally checking in with what's going on onscreen. So in a way, they're a perfect addition to your Christmas party.

Bran: In this chapter, we're going to recommend delicious snacks and drinks for you to serve to your guests, and some activities that will make you feel like you're in a Hallmark Christmas movie yourself.

Dan: Assuming that's a place you would ever want to be.

Panda: Just remember, no matter how you host it, there ain't no party like a Hallmark Christmas Party because a Hallmark Christmas Party has… a mark of halls. I don't know.

Bran: One of the many things I love about Hallmark Christmas movies is that people are always doing Christmas activities in them, and you can re-create the magic at your party.

Dan: And like the heroine of a Hallmark Christmas movie, you can sucker your friends into doing work for you, all under the excuse of celebrating the holidays. Need help decorating your tree? Stuffing Christmas cards into envelopes? Making ornaments? Creating gift bags for charity? Invite friends over, feed them, watch a Hallmark movie, and they'll have no idea that you're getting free labor out of them. It's like Tom Sawyer and the fence!

Panda: One activity that's a must in Hallmark movies is cookie decorating, and it's a fun thing for your guests to do while you're all watching a movie together. In this section we've got great recipes for cookies you can ice once they've cooled down, or decorate with sugar and other cool stuff before they go into the oven.

Dan: I prefer to bake cookies while my guests are over—it makes the house smell delicious, and it gives me an excuse to walk away from the TV every so often to take treats out of the oven.

Panda: Christmas is a time of giving, of course, and you might want to check with a local charity to see what they need most at this time of year. Getting your friends together is a good way to make a team effort to help out, whether your guests all make a cash donation or help out in other ways. You may not be able to wrap a hundred presents in ten minutes, like our buddy Emilie Ullerup in *Christmas Bells Are Ringing* (page 36), but many hands make light work if you're, for example, making toiletry kits for the unhoused.

Bran: There are also some fun games you can play around these movies, especially if your guests are as well versed in the ways of Hallmark as we are. In "What's My Next Line?" people yell, "Pause!" when they can predict what's coming next. For example, if the Hallmark Hunk tells the heroine, "I thought you said Christmas was just for kids," someone yells, "Pause!" Then the host pauses the movie, and everyone suggests lines—like, "I said a lot of things I don't mean," or "I guess I'm still just a kid at heart," or "Shut up and kiss me already." Then the host presses play, and you can see if you guessed right or not.

Dan: And if you're like me (or have friends like me) and enjoy hate-watching these movies, check out our *Deck the Hallmark* Bingo Card (page 249), where you can follow along and mark down all your favorite Hallmark tropes and clichés. Maybe offer a prize to the winner? Oh, I don't know…a DVD of a *real* Christmas movie like *It's a Wonderful Life* or *Miracle on 34th Street*?

Cookie Crawl Sweet Treats

(INSPIRED BY *CHRISTMAS JOY*, PAGE 65)

"THAT'S GINGERBREAD FOR YA" COOKIES

Dan: Make our "That's Gingerbread for Ya" cookies a day in advance so they have time to cool. The morning of the party, whip up the icing, and stock up on jelly beans, gum drops, and other decorative items, and you and your guests will be turning out cookies like a regular Jessica Lowndes.

Panda: And here's a tip for gingerbread decorating: don't feel like you have to shell out for those expensive pastry piping bags. Just buy some sandwich-sized storage bags, plop in some icing, cut a tiny corner out of the bottom of the bag, and bingo bango bongo, you're in business.

Makes approximately 18 cookies, depending on the size of your cookie cutter

½ cup unsalted butter, at room temperature

¾ cup sugar

1 tablespoon grated orange zest (if you've got one, use a microplane on a cold orange for easier grating)

1 tablespoon dark corn syrup

1½ teaspoons water

1 teaspoon freshly grated peeled ginger (optional)

1¾ cups all-purpose flour

¾ teaspoon baking soda

½ teaspoon salt

1 teaspoon ground ginger

¼ teaspoon ground cardamom

Pinch of ground cloves

Pinch of white pepper

In a large bowl, cream together the butter and sugar with a hand mixer or a stand mixer. The mixture should be soft and fluffy. Add the orange zest, corn syrup, water, and freshly grated ginger (if using). Scrape down the mixing bowl. Sift together the dry ingredients, and add them to the mixture. Stir until just blended.

Form the dough into a disc, wrap it in plastic wrap, and refrigerate it at least 2 hours or overnight.

Preheat the oven to 325°F.

Cut the dough into halves or thirds, to make rolling out easier. On a lightly floured surface, roll out the dough to about ¼-inch thickness. Cut the dough into shapes with a knife or with cookie cutters.

Bake on parchment-lined or Silpat-lined cookie sheets for 8 to 10 minutes. Transfer cookies to a cooling rack or plate, and let cool fully before icing.

MAKE THE ICING

1 box (16 ounces) powdered sugar

4 teaspoons water (or less)

4 teaspoons light corn syrup (or less)

1 teaspoon lemon juice

Food coloring (optional)

Pour the powdered sugar into a large bowl. Adding each ingredient 1 teaspoon at a time, stir in the water and the corn syrup, blending thoroughly after each addition, until you get a consistency you like. Stir in the lemon juice. Add food coloring, if using.

Going freestyle with a spoon, drizzle the icing on the cookies. Or use piping bags (or resealable plastic bags that you've snipped the corner off of) to make designs. And despite what you may have learned from Hallmark movies, you shouldn't try to ice cookies that are still warm; you'll wind up with a gloopy mess. For your Hallmark party, make the cookies the day before so they'll be nice and cool when your guests decorate them.

SAVE-THE-TOWN PEPPERMINT BROWNIES

Bran: These will make your mouth explode with crazy Christmas awesomeness. They're so good, they'll convince the mean developer not to tear down the bookstore and replace it with condos. (Legal disclaimer: The mean developer might do that anyway and would need to be outmaneuvered by the brilliant, beautiful city lawyer who has just rekindled her love of small towns and the holidays.)

Makes 9 to 12 brownies, depending on how you slice them

5½ tablespoons unsalted butter

¾ cup unsweetened chocolate

⅓ teaspoon instant coffee powder

¾ cup sugar

2 eggs

1 teaspoon vanilla extract

½ cup all-purpose flour

½ cup cocoa

½ teaspoon salt

½ teaspoon baking powder

Preheat the oven to 350°F.

Line an 8 x 8-inch baking dish (or 9 x 9-inch for thinner brownies) with parchment paper. Spray the paper and the sides of the pan with oil.

In a double boiler over barely simmering water, melt the butter and chocolate together. Remove from the heat. Add the instant coffee and stir. Mix in the sugar. Then mix in the eggs and vanilla extract.

In a separate bowl, mix together the flour, cocoa, salt, and baking powder. Stir the dry ingredients into the wet ingredients, but don't overmix (it's OK to leave a few lumps).

Pour the batter into the prepared pan and smooth it out so it's even. Bake for 15 to 18 minutes, until a tester (such as a toothpick) inserted into the middle comes out with a couple of crumbs on it. Set the brownies aside to completely cool in the pan.

MAKE THE PEPPERMINT FILLING

2 tablespoons butter, at room temperature

2 cups powdered sugar

Pinch of salt

¼ cup heavy whipping cream

½ teaspoon peppermint extract

1 or more drops red food coloring

In a large bowl, mix the butter, sugar, and salt until well combined. (If using a stand mixer, use the paddle attachment; if using a hand mixer, use beaters.) Add the whipping cream and peppermint extract, and whip at high speed until the cream forms stiff peaks. Add a drop of red food coloring and stir to combine. Add more coloring, one drop at a time, until the filling is a shade of peppermint pink that you like (light pink is nice).

Smooth the filling over the brownies, cover, and put the pan in the fridge until the filling sets (at least 30 minutes).

These brownies look great, and the dark-chocolate-and-peppermint flavor is undeniably Christmasy.

MAKE THE GANACHE AND PEPPERMINT TOPPING

½ cup chopped dark chocolate

Pinch of salt

⅛ teaspoon light corn syrup (for shine, optional)

¼ cup heavy whipping cream

Crushed peppermint sticks or crushed peppermint chocolates (such as red-and-white Andes Peppermint Crunch Thins)

In a bowl, combine the chocolate, salt, and corn syrup.

In a small pan, warm the cream over low heat until it is steaming but not boiling. Pour the cream over the chocolate, and let the mixture rest about 5 minutes.

Lightly whisk the chocolate (which should now be melted) and the other ingredients, being careful to avoid incorporating bubbles into the mix. Pour the chocolate ganache over the brownies, spreading to cover the filling, and sprinkle the crushed peppermints on top.

Allow the brownies to rest at room temperature for a couple of hours. When the ganache seems set, put it back into the fridge for 30 minutes to 1 hour. Carefully remove the layered brownie from the pan in a single unit, and place it on a cutting board. Dip the blade of a sharp knife into a glass of hot water, dry the blade, and make one cut through the brownies. Dip the blade back into the water to warm it up again, and dry it before making the next cut. Warm and dry the knife every time you're about to make a cut for distinct layers and well-defined corners and edges.

Don't be misled by those Hallmark movies where it snows in Memphis or South Carolina in December—big parts of the country aren't all that cold at Christmastime, and this chilly treat makes a fun party beverage.

PANDA'S FROZEN HOT CHOCOLATE MOVIES & MYSTERIES

Panda: I got to share this recipe on *Good Morning America*, and I learned a very valuable lesson: marshmallow fluff does not want to come off the spoon when you're on live television. As long as you're not broadcasting from your kitchen, you should do fine.

Makes 3 adult or 6 children's servings

1½ cups dark-chocolate almond milk

1 cup hot chocolate mix (about 4 packets)

3½ ounces (about ½ jar) marsh-mallow fluff

3 to 4 cups ice

Cayenne pepper, to taste

Whipped cream, for garnish

Chocolate curls, for garnish

Place almond milk, hot chocolate mix, marshmallow fluff, ice, and cayenne in a blender, and purée until smooth. Pour into glasses, and top with whipped cream and chocolate curls. Serve with a red-and-white-striped straw.

The shortbread cookies can be made in all sorts of shapes and frosted with all sorts of colors and designs.

"SHORTBREAD, SHE BAKED" COOKIES

Bran: You can decorate these before they go into the oven. Sprinkle them with colored sugars or cinnamon hearts, or those little things that look like BBs. If you make them in advance and let them cool down, you can ice them (page 229). Or serve them plain. It's Christmas, which means you get what you want!

Makes approximately 5 dozen cookies, depending on the size of your cookie cutter

4 sticks (1 pound) unsalted butter, at room temperature

1 cup granulated sugar

1 teaspoon salt

5 cups all-purpose flour

In a large bowl, cream together the butter, sugar, and salt with a hand mixer or a stand mixer. The mixture should be soft and fluffy. Use a spatula to scrape down the sides of the bowl. Add the flour, one cup at a time, mixing well between additions. When you're done the dough will be stiff.

Preheat the oven to 350°F.

Use a rolling pin to roll out the dough. You can try to roll it out all at once, but it's easier to do it a chunk at a time. Make sure the rolled-out dough is at least ¼ inch thick and no more than ½ inch.

Use cookie cutters, a glass, or a knife to cut out shapes—whatever makes you happy. Form the scraps into a ball to roll out again.

On a baking sheet lined with a Silpat or parchment paper (or even both if you really want insurance against a bottom that's too brown), space out the dough shapes with about 1 inch between them. These cookies don't spread, but it's never a good idea to crowd them.

Bake 12 to 15 minutes, until lightly golden and slightly firm.

SHOCKINGLY EASY JELLY CANDIES

Dan: Like many a Hallmark movie, there's not much to these— they're brightly colored, have almost no nutritional value, and will somehow make you feel festive anyway.

Makes approximately 5 dozen candies

2 cups ice-cold water

2 ounces powdered unflavored gelatin (8 packets)

2½ cups boiling water

5 cups sugar

Unsweetened Kool-Aid or other unsweetened drink-mix packets, various flavors

Food coloring (optional; use if you want to make the colors more intense)

Sugar for coating, either granulated, sanding, or large-crystal sugar

If you plan to make a variety of flavors, you'll need small pans, one for each flavor, all of them lined with plastic wrap and then sprayed with a fine layer of vegetable oil spray, like Pam. You'll also need several small bowls, one for each flavor.

In a medium bowl, stir together the cold water and the gelatin powder. Stir to incorporate all the powder.

Add the sugar to the saucepan containing the boiling water, and stir to dissolve. Reheat the mixture to a simmer. Add the gelatin mix to the simmering sugar water. Bring to a low boil and cook for about 2 minutes. Remove from heat.

Divide the mixture between as many bowls as you plan to make flavors. Add one packet of drink mix to each bowl. Stir until fully dissolved. Add food coloring if you're using it.

Let the gelatin cool slightly so the plastic wrap won't melt when the liquid comes into contact with it. Hot liquid is OK; you just don't want it to be immediately off the boiling point.

Pour the various liquids into the prepared pans, and refrigerate overnight.

On a piece of parchment or waxed paper, sprinkle a layer of sugar. Invert a pan containing the gelatin onto the sugared surface. Cut the candies into shapes, or bust out the cookie cutters and make holiday shapes. Sprinkle the tops of the candies with more sugar. Repeat with remaining pans of candy. Let the cut candies sit for a few hours before serving so the sugar coating can set.

FRUITITÉS

Panda: "Fruitités" is a word we totally made up, but it also sounds like something that would be the big idea of a caterer played by Lacey Chabert, so we're going with it. What's fun about serving fruit at a Christmas party is that you're eating something good for you, but you can also use it as a carrying device for some decadent treats.

Various types of fruit, cut into "finger food" shapes and sizes

Sweet dips—for example, Nutella, cookie butter, caramel sauce, Peppermint Whip (recipe below)

Dunk those strawberries in Nutella, schmear cookie butter on a wedge of green apple, and keep telling yourself it's health food.

PEPPERMINT WHIP

Bran: This is great to serve with fruit, but you can also dollop it onto hot chocolate or Yule Nog (see page 242), or just sneak spoonfuls out of the bowl while no one's watching.

Makes 1 cup

1 cup heavy whipping cream, chilled

3 tablespoons powdered sugar

¾ teaspoon peppermint extract

Red or pink food coloring (optional)

Place a large metal bowl and the beaters of your mixer in the freezer or refrigerator until cold.

Remove bowl and beaters from freezer/refrigerator. Pour the cream into the cold bowl, and beat until the cream starts to thicken. After it starts thickening, slowly add the sugar and peppermint extract. Beat until peaks form. If you're using food coloring, add it just before you're done whipping the cream.

Savory Stuff

CRUDITÉS AND DIPS

Bran: It's very easy, at this time of year, to subsist on a diet that's entirely peppermint bark and eggnog, so this festive party tray provides a tasty and colorful way to sneak some veggies and fruit into your system. Pretty much any supermarket will sell you a ready-made crudité tray with prechopped and prewashed broccoli, carrots, and cauliflower (and maybe a little plastic container of ranch dressing). But go crazy: check out your local farmer's market, or poke around the corners of your grocery's produce department and throw in some wild-card items. Yellow peppers, purple cauliflower, watermelon radishes, jicama, broccolini—anything in season that works as finger food. Your guests will appreciate the variety, and they'll add some fun colors to the plate. (Want to shape the veggies into a tree or a wreath? Hey, that's on you.) Yes, everybody loves ranch dressing, so you should offer up a big bowl of it, and we've included some recipes below for dips that are great with vegetables or on their own with crackers.

DANG IT, WE'RE MAKING PIMENTO CHEESE DIP

Makes about 4 cups

¾ pound sharp cheddar cheese, grated

¼ pound gouda cheese, grated
(Note: If gouda is unavailable, just use a full pound of cheddar.)

1 jar (4 ounces) chopped pimentos, drained

⅓ cup mayonnaise

⅓ cup sour cream

2 garlic cloves, minced

1 teaspoon cayenne pepper
(more to taste if you like it hotter)

Crackers, tortilla chips, bread, celery sticks, for serving

Mix the cheese, pimentos, mayonnaise, sour cream, garlic, and cayenne in a bowl until well blended. Chill for a few hours. Serve.

SPINACH & ARTICHOKE & MISTLETOE (BUT NO MISTLETOE, BECAUSE IT'S POISONOUS) DIP

Makes approximately 4 cups

1 package (10 ounces) frozen chopped spinach

2 jars (approximately 12 to 14 ounces each) artichoke hearts
(Note: You get what you pay for with these, so splurge on the good ones.)

½ cup grated Parmesan cheese
(divided)

½ cup grated mozzarella cheese
(divided)

1 cup grated pepper jack cheese
(divided)

½ cup mayonnaise

½ cup sour cream

Preheat the oven to 350°F.

Grease an 8 x 8-inch baking dish with nonstick spray.

Heat the spinach in the microwave or in a small saucepan over medium-low heat until it's thawed. Place in a sieve or colander, and press out the water. Drain the artichoke hearts, and coarsely chop them with a knife or lightly pulse in a food processor (be careful if using a food processor, as you don't want purée).

Set aside half the cheeses. Put the rest in a bowl with the prepared spinach and artichokes, the mayonnaise and the sour cream, and combine well with a spatula. Scrape the mixture into the casserole dish. Top with the other half of the cheeses.

Bake for 20 to 30 minutes, until brown and bubbly on top.

CHEESEBALL PLOT TWIST

Dan: I use the word "cheeseball" a lot when talking about the plots of Hallmark Christmas movies, so it's the perfect addition to your Hallmark Christmas movie party.

Makes 1 ball, approximately 2 pounds

16 ounces cream cheese, softened to room temperature

3 tablespoons sour cream

1 package (1 ounce) ranch seasoning mix

¾ teaspoon garlic powder

½ teaspoon dried minced onion

¼ teaspoon kosher salt

¼ teaspoon ground black pepper

¼ teaspoon Old Bay Seasoning

½ cup pepper jack cheese, finely grated

1¼ cups cheddar cheese, finely grated (divided)

8 slices bacon, cooked and crumbled (divided)

⅓ cup chopped green onions (divided)

1 teaspoon poppy seeds

⅔ cup chopped pecans

In a large mixing bowl, combine cream cheese, sour cream, ranch seasoning mix, garlic powder, minced onion, salt, pepper, and Old Bay. Stir with a rubber spatula until well combined.

Add the pepper jack cheese, 1 cup cheddar cheese, half the bacon, and half the green onions. Stir until mixed.

Lay out a large sheet of plastic wrap, and place the cream cheese mixture on it. Cover tightly on all sides, and shape into a ball. Refrigerate for several hours or overnight, until firm.

To make the outer coating, combine the remaining ¼ cup cheddar cheese with the remaining bacon and green onions in a small mixing bowl. Stir in the poppy seeds. Refrigerate the mixture for several hours or overnight.

Right before coating the cheeseball, add the pecans to the topping mixture, and stir well. Line a rimmed baking sheet with aluminum foil, and spread out the coating in an even layer. Remove the plastic wrap from the cheeseball, and roll the ball in the coating, covering all sides evenly. You may have to press some of the topping on by hand to make it stick.

Serve immediately, or cover loosely with plastic wrap and refrigerate until ready to serve.

Tip: *You can freeze the cheeseball without the topping for up to a month before your party. Let it thaw overnight in the refrigerator before coating and serving.*

Opposite: "Cheeseball" means a bad thing when we talk about Hallmark plots but a very good thing when we're talking about party food.

CHRISTMAS PIZZA CUPS

Panda: These are super delicious, and because you make them in a mini muffin baking pan, there's less chance of messing up your oven—and they're easy for people to hang onto as finger food. Like most pizza recipes, you can play around with toppings and cheeses and anything else to make these into exactly what you (and, I guess, your guests) want to eat.

Makes 18 to 24 cups

1 ready-made pie crust

1 package (4 to 6 ounces) pepperoni slices

1 jar of your favorite pizza sauce or marinara sauce

¼ cup finely minced yellow onion

1 package (8 ounces) shredded mozzarella

Preheat oven to 375°F.

Unroll the pie crust. Use the rim of a glass or a biscuit cutter to cut out small rounds, approximately 3 inches in diameter. (Sizes of mini muffin pans can vary, so cut the size that works best for yours.) Press the slices of dough into the cups of a mini muffin baking pan.

Chop the pepperoni slices into very small pieces.

Spoon some sauce into each cup. Sprinkle onion, pepperoni pieces, and cheese into each cup.

Bake until the crust is brown and the cheese is melted, about 10 to 15 minutes. Let cool for at least 10 minutes. The sauce will be hot.

If Hallmark can air Christmas movies before Halloween, then you can serve turkey leftovers before Thanksgiving or Christmas.

TURKEY LEFTOVER SANDWICHES

Bran: Why wait for Christmas to be over to start enjoying those leftovers? Don't worry, you don't have to cook a whole turkey to make these; you can mix sliced turkey from the deli with all the delicious stuff that makes Christmas dinner so great.

Makes approximately 4 sandwiches per pound of turkey

White or sourdough bread or buns, sliced

Butter

Mashed potatoes (optional)

Gravy

Stuffing (nothing wrong with whipping up a box of Stove Top)

Salt and pepper, or Old Bay Seasoning, to taste

Turkey, white or dark meat, chunked, or sliced deli turkey

Cranberry sauce (whether you like it out of a can or all fancy with whole cranberries, either works)

Butter slices of bread and place them butter-side down in a hot skillet, as you would for a grilled-cheese sandwich. Grill the buttered side until it is browned and toasty. Remove from the skillet.

Unless you want a big mess—which is totally valid, although not great at parties—make a spread by combining the mashed potatoes (if you're using them), gravy, and stuffing. Just put them all in one bowl and stir them together. Add salt and pepper, or Old Bay Seasoning, to taste.

Spread a layer of the mixture onto each slice of grilled bread. This will hold everything together. Top one slice with cranberry sauce. Top that with turkey. Top that with another slice of grilled bread. Press down.

EVEN
When Calls the Heart
HAS A TAVERN

Dan: Hallmark understands that people might need an adult beverage to get through these movies: they make Hallmark Channel wine glasses, and heck, in 2020, they even debuted Hallmark Channel wine. If you're looking for something a little more festive than a pinot grigio, we have some suggestions.

YULE NOG

Dan: The easy version of this recipe is to buy eggnog at the grocery store, pour it in a bowl, and now you've got eggnog. But if you're one of those people who likes to sweat the details when you throw a party, this recipe comes out pretty tasty. (The alcohol is optional, but come on, what are we doing here? Still, it's entirely your call.)

Makes approximately 2 dozen 6-ounce servings

12 pasteurized eggs

1 box (16 ounces) powdered sugar

8 cups heavy cream

4 to 6 cups bourbon, brandy, dark rum, or rye, or a combination (half dark rum and half rye does the trick nicely)

Freshly grated or ground nutmeg

Cinnamon sticks or ground cinnamon

Separate the eggs, placing the yolks in a mixing bowl and the whites in a separate bowl. Add the powdered sugar to the yolks, and gently whisk until fully combined. Heat the cream in a large saucepan over medium heat. Do *not* boil. Slowly add 1 cup of the warm cream to the egg and sugar mixture, whisking the entire time. Again, make sure the cream is not too hot or you'll wind up with sweet scrambled eggs.

Slowly pour the cream/egg/sugar mixture back into the saucepan, whisking the entire time. Over low heat, keep whisking until the mixture thickens.

Place the hot saucepan in a large bowl of ice water. Stir gently until the liquid is chilled. Stir in alcohol.

Beat the egg whites with a hand mixer or in a stand mixer until they form soft peaks. Fold the egg whites into the eggnog. Chill for a few hours.

Serve with a sprinkling of ground or freshly grated nutmeg. Add a cinnamon stick, or sprinkle with ground cinnamon.

THE CRYSTAL DANCE

Makes 1 cocktail

1½ ounces vodka

3 ounces club soda

Ice

Cranberries and sprigs of rosemary, to garnish

You stir it once, you shake it twice.… Just kidding. Fill a wine glass (Hallmark Channel licensed merch or otherwise) with ice. Pour in the vodka and soda. Make it look Christmasy with cranberries and rosemary.

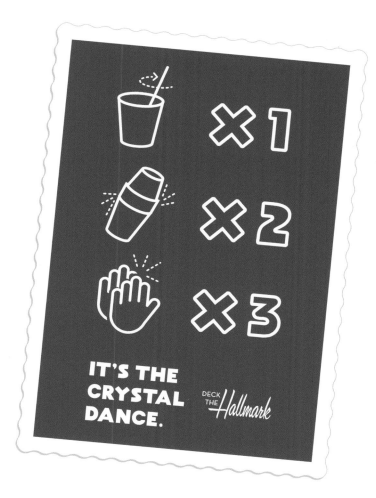

ASHLEY WILLIAMS ON THE SANTA RUN

Every year at my sister's farm in Tennessee, we do something called "The Santa Run" on Christmas Eve. If you're into schedules, it's just *after* morning cookie decorating but *before* naps. We take our cookie-induced sugar buzz and throw on whimsical costumes—usually a Batman cape meant for a four-year-old, a clown nose, and the obvious Santa hat on everyone's head. The kids are usually still in their pajamas, so we patch together anything we can find on top of that. One year we got my brother-in-law, Brad Paisley, to put on a bright blue Captain America costume with padded bulging muscles. Then—we sprint. On the driveway of the farm. We also do some strange screaming and lots of funny singing. It's usually only a little cold outside, and this is a *great* way to get our blood flowing, reducing some typical holiday stress. These are also hands-down the best pictures of Christmas. Brad would actually kill me if I shared the Captain America picture with you! Some things need to be kept within the family, especially during the holidays.

TYLER HYNES ON RAPPIE PIE

My family has roots in Nova Scotia, and there's a Nova Scotian dish called Rappie Pie. It's basically like potatoes grated in such a way to where it becomes a liquid, like a clear glue. And then you put shredded chicken in it, and then you put butter on it, and then you bake it, and it becomes this crusted, gooey prison food that is the tastiest thing you'll ever eat. It's kind of an ordeal to make—you end up having to put a whole bunch of chicken broth in it and stir it, and it's very cumbersome on the arms because you're stirring it forever. And it's just so much gluey liquid that my mom's arm dies, but she makes us all take turns stirring this thing, and this is one tradition that we have every year, where we take the trouble to do it. I always go back home to my parents' neck of the woods in Ottawa, and that's the one tradition that's really maintained. And everybody that I introduce to my family who tries it—they're terrified at first, but then they come back wanting more.

A SALUTE TO THE
HALLMARK WIDOWS

Starting in late October and going through the end of the year, Hallmark fans everywhere are glued to the TV for Countdown to Christmas on Hallmark Channel, Miracles of Christmas on Hallmark Movies & Mysteries, and Home for the Holidays on Hallmark Drama. And the spouses and significant others are left to wonder: Why? How? Who's going to help me address these Christmas cards? What is the point of watching Lacey Chabert make cookies yet again? When are you going to leave room in the DVR for me to record my shows? Will you please turn off the television so we can have Christmas dinner?

The life of the Hallmark Widow (or Widower) has its challenges. And if you've bought this book for a loved one without being a Hallmark watcher yourself—or if you're reading this book in the hopes of understanding the appeal of these movies—rest assured, we see you. The wives of Bran, Panda, and Dan tell their stories here for the first time. You are not alone.

Some couples lean hard into certain holidays (Halloween, July 4), more so than others. As a couple, how Christmas-minded were the two of you before the podcast started?

Katelyn Gray, online retailer (and Bran's wife): I married into Christmas. When Brandon proposed, I asked him if he had a date in mind. "December 15th. Christmas wedding!" I loved Christmas before we were married, but Brandon brought Christmas to life for me. It's so much more enjoyable with him, and we have always celebrated big! And he really did watch Hallmark Christmas movies as often as possible even before the podcast. The July that I was pregnant with our first child, we basically spent the whole month watching Hallmark Christmas movies. And after the podcast started, it amazed me that he still wasn't sick of them. They're constantly on in the background during the holidays.

Hayley Pandolph, COO and online business manager (and Panda's wife): We were all in when it comes to Christmas. Every year we'd decorate a little earlier than the year before. Before *Deck the Hallmark*, we were on a streak of decorating the day after Halloween. Now that I think about it, the year before *Deck the Hallmark*, we started decorating *on* Halloween.

Sarah Thompson, pediatric occupational therapist (and Dan's wife): He likes holidays more than me. I, honestly, don't love a holiday. I feel like holidays come with a lot of obligation, and I don't appreciate it. But I enjoy spending time together as a family, and now that I'm a parent, I enjoy the magic that Christmas brings my children.

When did the show segue from a fun thing your husband was doing on the side to, "Oh man, this is taking over his entire life"?

Sarah: The first season, Dan was still coaching basketball, so I was already a basketball widow. And I remember being like, You're going to add another thing? And we have little kids who need a lot of time. He was really great about saying, "This will never cut into family time. This won't cut into our time together." But at some point, he was just fatigued, and I would say, "It's OK on a Saturday for you to watch one of these. I'm not going to watch it, but you can watch it."

Katelyn: When they decided to watch all thirty-something Christmas movies that second year. It was such a crazy time with them all working full-time, watching the movies after kids were in bed, and recording the episodes late at night in a tiny corner of our thousand-square-foot house. It was a crazy time.

Hayley: My memory is a little foggy, to be honest. *Deck the Hallmark* began just a few months before we had our kid. Then right after she was born, it took off. In my mind I remember him [Panda] starting the podcast, and then all of a sudden both of our lives turned upside-down with a brand-new baby and virality happening at the same time.

Prior to the podcast, were you a Hallmark watcher, at Christmastime or otherwise?

Hayley: Honestly, I was an ABC Family Christmas-movie watcher pre–*Deck the Hallmark*. Does that make me a traitor?

Sarah: Probably with my college roommates? But not really.

Katelyn: Never. I hated them. I would watch them with Brandon sometimes, but ended up doing something else midway through. But now, Hallmark movies are endearing to me. They're so special because they bring so much joy to my husband, and they led to a job that he absolutely loves. So I watch them with him whenever I get the chance—but it's only because of my love for Brandon. I'd never choose to watch one on my own; it's something I only enjoy when Bran is around.

Do you feel you've been saddled with more Christmastime responsibilities because of the time your husband has to spend watching and then discussing these movies?

Katelyn: No, I don't think so. Brandon makes time for it all. He usually does all the decorating. We mostly get Christmas shopping done together before December, and we wrap while watching the movies. I'm just left with the Christmas-cookie baking. Which is for the best.

Hayley: Yes. During the Christmas season, I definitely take on more responsibilities than Daniel. But I have my own busy seasons where Daniel takes on more. We're a pretty good team.

Sarah: No, no, not really, because he's really good about being present with our kids. Although sometimes it does take over dinner talk. "Oh, this is the thing we watched today," but it's usually him talking about the movies like, "These are all the ridiculous things that happened." He's honestly done a pretty good job of not bailing on things that are important.

Deck the Hallmark took off pretty quickly, and now you are married to a podcast celebrity. Have you had any odd moments regarding his relative fame, whether it's hearing from friends you haven't heard from in a while, or people recognizing them in public?

Sarah: All the time. I have one friend that texts me every time Dan's on *Good Morning America*. And I'm like, Yeah, I know. Or it was funny—he got people who wanted him to read their screenplays, and Dan was like, "Really? I can't. I'm not the person for this." I have friends who listen, and they'll talk about the podcast more than I will. And it's like, What are we doing here? This thing? That's what we're talking about? Or they'll talk about when another podcast mentions them; especially in the first season, I think that happened a lot. One of my friends listened to a bunch of those Christian-women podcasts, and she was like, "They were talking about *Deck the Hallmark* on this podcast," and I was like, Huh. OK. I didn't think this was going to be a thing, but alright.

Katelyn: Actually yes. The first time they were mentioned on *Good Morning America*, we didn't know it was happening ahead of time. A friend I hadn't talked to in a year or so texted me and said, "Brandon is on GMA!" I turned to my coworker and said, "What's GMA?" But then Brandon told me it happened, and that they were going to fly up to be on the show the next day. That was crazy. Also, we recently moved, and after talking to our new neighbor about who we were and what we did, we found out that she was a *Deck the Hallmark* fan before we moved in. She was so excited to meet one of the guys and to learn that Dan was her neighbor, too! [Dan and Sarah's family lives on the same block as Bran and Katelyn's.]

Hayley: When the guys first appeared on *Good Morning America*, people came out of the woodwork to ask me questions about what was happening. It was all pretty exciting. But the turning point for me was when someone called him "Panda" in the grocery store. I realized he was definitely a part of something that was more than just going viral one time.

Were you a podcast listener before all this? Are you a podcast listener now, be it the Bramble Jam shows or otherwise?

Hayley: I love podcasts, but I'm into business-related ones. I did listen to some of the original *Deck the Hallmark* season-one episodes, but that's as far as I got.

Sarah: I listened when I was running. I do listen to *History or His Story?*, and I've been listening to *A Film and a Movie*. But I think that's it. I'll listen to a little bit of all the Bramble Jam shows, but not enough to keep up with them. I would listen a lot when I was endurance training. During the first season of *Deck the Hallmark*, I was training for a marathon, and it would get me through a lot of my long runs, which was nice, because there was so much content. And I didn't have to listen that hard, you know what I mean? I'm not really running that long anymore, and if I turn the podcast on in the car, my kids are like, "Why is Dad on the radio again?"

Katelyn: I've mostly listened to my husband's podcasts (prior to DTH), with a couple of exceptions. But I love listening to the Bramble Jam pods. They're the only ones I listen to now.

Do you have a go-to Christmas movie that you like to watch every December?

Katelyn: Brandon and I actually have a movie calendar. In addition to Brandon watching all the Hallmark Christmas movies, we watch about fifteen other Christmas movies every year. It starts with *Elf* on Thanksgiving night, and then we have at least four a week that we try to watch. And we cram a bunch in the week of Christmas. Our faves are *The Santa Clause* 1, 2, and 3, *Home Alone* 1 and 2, *A Charlie Brown Christmas*, *Krampus*, *Christmas with the Kranks*, *White Christmas*, *Four Christmases*, *Fred Claus*, *The Grinch*, *It's a Wonderful Life*, *Jingle All the Way*—just to name a few.

Hayley: *Elf*. It never gets old to me.

Sarah: I love *Elf*. We watch it when we decorate the Christmas tree. Perfect—so that is the one holiday thing we do. It makes me sound like a curmudgeon. I'm not about holidays, but I do enjoy decorating the Christmas tree and watching *Elf*.

Deck the Hallmark Bingo Card

If you've watched enough Hallmark Christmas movies, you start to expect certain plot twists, lines of dialogue, fake-snow fails, and many other moments—it's all part of what we love, and like, and despise about these movies. Next time you watch one, play along with us and see how long it takes you to get a Bingo. Heck, for some movies, you can even play Blackout Bingo. Have fun!

DRONE SHOT of car on lonely, snowy highway	Leads mistakenly (and prematurely) identified as a **ROMANTIC COUPLE** ("Oh, we're not . . .")	Recognizable **CHRISTMAS SONG** that is not "Jingle Bells" or "Deck the Halls" or "Silent Night"	**SNOW,** but no visible **BREATH**	**"FRESH" COOKIES** removed from an oven that is obviously not turned on
Ridiculously **ELABORATE DEVICE** that turns on the town Christmas tree	Person of color sympathetically **TILTING THEIR HEAD**	Visible Balsam Hill, Folger's, Nature Made, Jergen's, *Southern Living*, or **WALMART LOGO**	Leading lady actually **WEARING A HAT** outside, where it's "cold"	Major character with **TWO LIVING PARENTS**
Kindly white-haired gentleman named **CHRIS OR NICK** who is probably Santa	**"HEIRLOOM"** ornament that clearly dates back to 2014	**ALMOST-KISS** (let's just call this one a Free Space)	**SAGE ADVICE** from an elder that makes absolutely no sense	"Christmas" + **NONHOLIDAY NOUN** (e.g., Bachelor, Restaurant, etc.)
Couples dancing to **CHRISTMAS MUSIC**	**SOAPSUDS "SNOW"** visibly clinging to actors' hair	Major business meeting/decision/ opportunity on **DECEMBER 24**	**"I HAVEN'T DECORATED YET"** when room is already garland-festooned	**MOM/** grandma/former teacher of the heroine who is clearly within a decade of her age
SINKHOLE/ flood/roof collapse threatening to ruin holiday party/ carnival/gala	Someone **READING ALOUD** from *A Christmas Carol* or *A Visit from St. Nicholas*	**ENTIRE TOWN** conspiring to gaslight the heroine so she will stay for Christmas	Discussion of **"APPS" OR "GOING VIRAL"** with no understanding of what those are	Packed house for Christmas recital without a **SMARTPHONE** or video camera in sight

ACKNOWLEDGMENTS

The guys of *Deck the Hallmark* would like to acknowledge, first and foremost, the fans of the podcast. This podcast has brought us a lot of joy, and seeing that it has done the same for you has been all the motivation we've ever needed. Together we've built a community that will no doubt last longer than the podcast itself. The gifts, emails, messages, and shout-outs are all incredibly kind and encouraging and never go unnoticed.

Thanks to our dear friend Alonso Duralde for finding, retweeting, and becoming an early adopter of DTH. And thanks for joining in on the fun and making this book happen. We couldn't have done it without you. You never cease to be kind, selfless, and willing to help.

Thanks to Eric Myers and to everyone at Running Press for making us podcasters with a book deal, like that guy in *Magical Christmas Ornaments*.

Thanks to Bob Collins and Brice Smith for taking an inexplicable financial risk on us that actually paid off.

Thanks to Dustin Mason for making sure we have actual money in the bank.

Thanks to Jane Szabaga for providing us with a much needed jolt of organization on a regular basis, and for being willing to help, out of the goodness of your heart.

Thanks to Emily Keown and Brad Deck, our dream-team producers at *Good Morning America*, who continue to find ridiculous reasons to put us on national television.

Thanks to Latia Curtis and Eli Warren for producing some amazing pics of the three of us, as well as that delicious food.

Thanks to Benji Smith of Flagship Properties for giving us dirt-cheap rent in the middle of downtown Greenville for Season 2.

Thanks to Will Keown for being an amazing photographer and videographer, and an even better friend. This book doesn't exist without you.

Thanks to Jonathan Shapiro, Doug Jones, and Jen Kirkman, legends of TV, movies, and comedy. You all had bigger and better things to do but agreed to guest on our podcast before anyone was even listening.

Thanks to Andrew Walker, Nikki DeLoach, Paul Campbell, Tyler Hynes, and the many other Hallstars that have given their time over the years to join our podcast.

A special thanks to Kristoffer Polaha for believing in us since day one and spending countless hours on and off the podcast talking about life. Gal Gadot is lucky to share the screen with you, and we're lucky to call you friend. Next time you're in South Carolina, sushi is on us . . . actually, make that chicken and biscuits. It's for the best.

Lastly, we have to thank Tracy Nolastname and Rigg Dilby. Tracy, you're an awful producer and your voice is unbearable, but you've been with us since before the beginning, and that makes it incredibly difficult to fire you. Rigg, thank you for introducing us to the 4-for-2 George Foreman ++Grill. We still don't understand what it is, and we believe that sums you up perfectly. God bless.

Brandon Gray: I want to thank my wife for her love and support. I told her I wanted to start a podcast about Hallmark Christmas movies, and she told me it was a great idea. That's true love. I want to thank my boys, Grizzly and Gavin. I can't wait to give you fatherly advice like they do in these movies and make Christmas feel like it does in Evergreen. I want to thank my parents, my family, and my friends for all your support. I know you don't all listen to the podcast, but you tell me you love it, and that's all that matters. Lastly, I want to thank Jesus. While I don't know for sure how you feel about these movies, I like to think you'd be on Team Bran. All is calm, all is bright.

Daniel Pandolph: I want to thank my mom and dad. You gave me the gift of a weird sense of humor, childcare, and . . . well, life. So, thanks. Love you guys. Thanks to Dan and Bran for all the endless bits. We trained our whole friendship for this. We did it. To my wife, Hayley: You're my rock and designated driver when I have to watch a Hallmark movie coming home from vacation. Thanks for holding down the fort while I watched romance movies. You're my heart and one of the best ones. To my daughter, Lily: When you grow up, I still don't think I'll know how to explain this time of life to you. Thanks for being the most chill kid ever. I love you. Finally, thanks for Romans 8:1. I cling to that daily.

Daniel Thompson: I'd like to thank my wife, Sarah, who patiently put up with late nights, traveling with toddlers, and hundreds of hours of Hallmark, and then didn't blink when I decided to make it my full-time gig. I'd like to thank my sons, who are still young enough to think Dad's job is cool. I'd like to thank my mom and dad, who have always been proud of me not because of my occupation but just because I was their son, which helps a lot when you leave an established career to *checks notes* podcast for a living. Thanks to my brother, who still, to this day, can't believe that this is a thing.

Alonso Duralde: Thanks as always to my brilliant and patient agent, Eric Myers, who takes my cockamamie ideas and makes them legitimate. The crew at Running Press—particularly Cindy Sipala, Michael Clark, and Jennifer Kasius—made this whole process a delight from start to finish.

I have to express my gratitude to William Bibbiani for putting these movies into my life, and to Rachel Wagner, Dory Benford, Brian Earl, Brian Lynch, Matt Piwowarczyk, Gillian Walters, Illeana Douglas, Tim Babb, Joseph Wade, Witney Seibold, Jesse Thorn, Jeff Graham, and all the other podcasters who've given me the opportunity to talk about these Hallmark Christmas extravaganzas, not to mention the keeper of the flame (and the release dates) at the Ho! Ho! Holiday Viewing blog.

Thank you to Kristoffer Polaha for the moving Foreword to this book; to Tyler Hynes, Jill Wagner, Nelson Wong, and Ashley Williams for going above and beyond in their reminiscences of Christmases (and Christmas movies) past; and to Katelyn Gray, Hayley Pandolph, and Sarah Thompson for the peek behind the curtain. Zac Hug, Michael Varrati, Brian Nolan, Nikki DeLoach, Julie Sherman Wolfe, Joany Kane, Alys Murray, Jim Fall, Kevin Chamberlin, Amber Benson, and Sam Irvin: thank you for your backstage insight. My most delicious thanks to Hank Green, Paul Tran, Kim Usey, P.W., and the Spoon of Linoleum Knife & Fork, Margy Rochlin, for invaluable contributions to the recipe section. Joanna Wilson, your knowledge of Christmas on television is unparalleled; thanks for sharing some of it with me.

I would probably still be digging though all the *Deck the Hallmark* interview episodes without the assistance of the Santa's Helpers among the Double Deckers: Nicole Beatty, Melinda Bouwman, Sheila Calloway, Stacey Coombe, Jennifer Hartshorne, Marin Hoag, Michael Killen, Sara Peterson, River Riley, Lauren Rudowski, Rina Saltzman, Mary Saville, Erin Shea, Colleen Sullivan, Megan Swain, and Karen Thomas.

Big appreciation to Casey O'Brien, Drea Clark, Ify Nwadiwe, April Wolfe, and Ricky Carmona for letting my obsession bleed into the otherwise cinematically serious *Who Shot Ya?* podcast, and thank you to Christy Lemire, Matt Atchity, and Ben Mankiewicz at *Breakfast All Day* for patiently putting up with my holiday yammering. Shout-out to the organizers of ChristmasCon and Christmasland Experience for all they do to keep the holiday magic alive.

And my biggest thanks go to my husband, Dave White, for always being supportive even when being driven up the wall by these movies, and to Bran, Panda, and Dan for letting me join them on this crazy carousel, even if the reindeer don't fly.

Index

Page numbers in italics refer to images.